CHILDREN'S PLEASURES

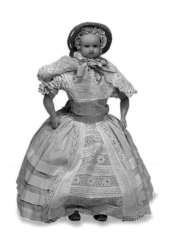

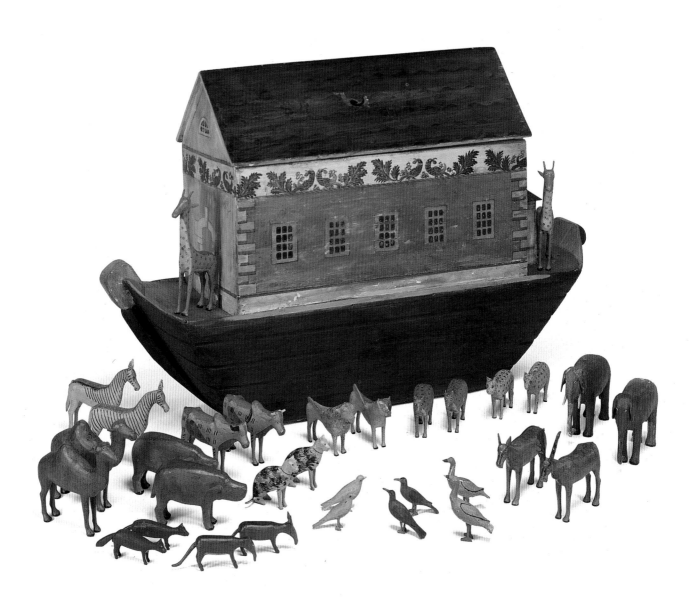

CHILDREN'S PLEASURES

BOOKS, TOYS AND GAMES
FROM THE BETHNAL GREEN
MUSEUM OF CHILDHOOD

ANTHONY BURTON

V&A PUBLICATIONS

First published by V&A Publications, 1996

V&A Publications
160 Brompton Road
London SW3 1HW

© The Board of Trustees of the
Victoria and Albert Museum 1996

The illustrations in this book are of material in the
Bethnal Green Museum of Childhood unless otherwise
stated in the Illustration Acknowledgements, p.186.

ISBN 1 85177 174 3

Designed by
THE BRIDGEWATER BOOK COMPANY LTD

Printed in Italy

Picture opposite title page shows a traditional
German Noah's Ark dating from about 1830

CONTENTS

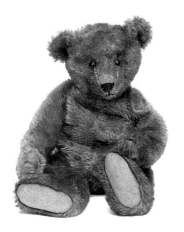

— 1 —

PLEASURE AND PAIN

The murder of a child, from a ballad printed in London in about 1830. Before popular newspapers, 'shock-horror' stories about crime were spread through broadside ballads. These were doggerel poems, printed on single sheets of paper and sold by hawkers in the street. Sometimes they had crude illustrations, which were inevitably imaginary rather than true representations of what went on.

This book is about the pleasures of childhood - reconstructed from what is preserved in the Bethnal Green Museum of Childhood. We hope that it will stimulate happy memories, as readers encounter favourite toys and much-loved books, and that the older objects illustrated here will arouse recognition of some almost forgotten aspects of childhood. The pleasures are offered roughly in the order in which a growing child would meet them. We make no apology for presenting childhood 'as a fortunate island where happiness must be protected, like an independent republic living according to its own laws', to use the words of Paul Hazard. But it is only right to acknowledge that there is a dark side too, as the illustrations on these two pages show. It is worth pausing a moment to ask how we can find out what really happened to children in the past.

The idea that childhood is a time of uncorrupted innocence, when growing human beings are still in touch with their divine origin, was a product of the Romantic movement. Wordsworth wrote: '...trailing clouds of glory do we come...Heaven lies about us in our infancy!' Very different was the view of the poet Thomas Gray, only a generation earlier, as he watched the schoolboys of Eton College playing. The best he could say for childhood was that it was a time when one did not realize what unhappiness was in store in the future.

It has been claimed that for most of history, until the 19th century, childhood was not treated in any way differently from the rest of the human lifecycle. Indeed, many readers of the pioneering book (1960) on the history of childhood, by Philippe Ariès, were left with the impression that he believed childhood did not exist at all in the Middle Ages. As soon as children were on their feet, they had to involve themselves in the hurly-burly of life.

Ariès thought that a great change happened in history, as humankind realized that children had their own ways of thinking, feeling and doing. Adults began to construct childhood for their children as a privileged state of being. Following Ariès, historians speculated on when and why the crucial change happened. The Jesuits' influence on French education in the 17th century, the growth of family affection within the middle class in the 18th century, the effects on family structures of industrialization in the 19th century: these, and many other factors, have been studied.

The 'psychohistorians', who applied modern psychoanalytic theory to the past, took an optimistic view. For them, parent-child relationships moved, over time, through a series of modes: from 'infanticidal' in ancient history progressively forward to the 'helping mode', which only arrived in the mid-20th century. But most historians are more tentative about the type of changes that happened over time.

It is only over the past 25 years that childhood has been intensively studied, as historians have shifted their focus from kings, battles and laws to the private life of ordinary people and their attitudes. As the data has built up, simplistic views have been qualified.

Some kinds of data are easier to find than others. On the whole, good things for children were remembered and cherished, while the shameful and painful things tended to be hidden, until reformers and lawmakers exposed them. History is usually reconstructed from written records, but pictures and objects are also useful evidence, as Ariès himself believed, and it is these that are the business of a museum.

After a last glance at pain and shame on these pages, you are invited to turn over to see the evidences of joy.

1.3

Grown-ups rule, no. 2. The child-eater still on the rampage in 19th-century France, where he is called 'Father Flog' and is appropriately equipped with a birch. This is one frame from a strip narrative on an Epinal children's print (see section 16).

1.3

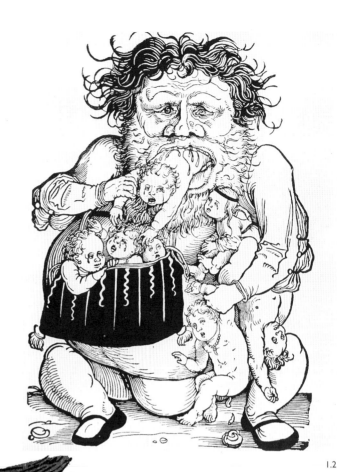

1.2

1.4

Grown-ups rule, no. 3. Heinrich Hoffmann is famous for his picture book *Struwwelpeter* which was first published in German in 1845 with the title 'Merry Stories and Funny Pictures'. It has, however, very frightening images of what happens when children do bad things like sucking their thumbs.

1.2

Grown-ups rule, no. 1. The Kinderfresser ('Child-gobbler') is a bogey figure who appears in German popular prints from the 16th to 18th centuries. This image is from a woodcut by Hans Weiditz (1495-1537). Folklorists think the bogey may derive from the god Saturn in Roman mythology, who ate his own children. However this may be, real children must have found the child-eater very frightening when adults threatened that he would come for them if they were naughty.

1.4

— 2 —
WARMTH

Putti from A. Browne,
Ars Pictoria (1669).

A baby's pleasures are almost all to do with bodily well-being. The comfort of warmth is now taken for granted in advanced societies. It was not always so: many children learn from their schoolbooks that the grim inhabitants of Ancient Sparta exposed weak new-born babies on bleak hillsides, to test whether or not they were tough enough to survive in the world. Fortunately, most of humankind looked after their babies more carefully. The first experience of life for most babies is of a bath, to wash away the traces of birth. A child's first bath gives back to it some of the warmth of its mother's womb, lost on entering the world.

A baby's first bath is a very tender moment, so it is not surprising that it was often recorded in Roman and medieval art, and for some centuries after. Depictions of Christ's Nativity sometimes focus on this moment, charmingly showing the Virgin Mary testing the temperature of the water.

The first bath does not seem to have figured so importantly in the birth experience in recent centuries, perhaps because medical authorities took control of the delivery process. But warmth has to be sustained, so the next pleasure a baby needs is to be comfortably wrapped up. For centuries humankind made a practice of wrapping babies up uncomfortably in swaddling clothes. 'Swaddle', like the word 'swathe', simply means to wrap up in cloths or garments. Various coats, nappies and small blankets were successively folded round a child and pinned in place, but then the bundle was strapped up by binding around it long swaddling bands: strips of cloth a few inches wide and perhaps ten feet long. There were various ways of arranging these bands so that they made a neat pattern.

One motive for tight swaddling was good: to ensure that the child could not throw off its coverings and get cold. Another was not so good: it was believed that the baby's limbs

Nativity scene, from a Book of Hours made in Paris in about 1400. This medieval manuscript prayer book is in the V&A collection.

should be kept straightened out, as near as possible to the shape of an adult human body. So the legs were strapped together, and the arms strapped to a baby's sides. In fact, this probably encouraged rather than prevented distorted bones. Nowadays swaddling is viewed as a kind of imprisonment.

It is odd that while everywhere in art, from the Renaissance onwards, you can find naked, cavorting cherubs or putti, yet in real life children were wrapped up like parcels (and sometimes, we learn, even hung up on hooks).

An added discomfort with swaddling was that it made it difficult to change a baby's wrappings after it wet or soiled itself. Careless mothers and nurses often did not bother, so many babies lay for long periods in their own mess. Swaddling began to go out of favour in the 18th century, especially after Rousseau attacked it, but in some countries it continued into the 20th century.

To keep babies and infants warm before the days of central heating, they were kept near the fireside. This had obvious dangers, as one children's book records:

'Rosa is very fond of the baby, and takes great care of it; but one day when she left it for a few moments at play on the hearth-rug before the fire, a coal flew from the grate ... and when Rosa came back ... the infant was all in flames. But Rosa did not run away shrieking, as some children would have done ... No, she had the good sense to roll the hearth-rug quite round the baby, and to throw herself down upon it, so as to smother the flames ... To be sure, she burnt her hands and arms a little; but then she saved the baby's life, and also the house from being burnt to the ground.'

Eventually, this hazard was checked by the nursery fireguard; the rise and fall of this useful object deserves further research.

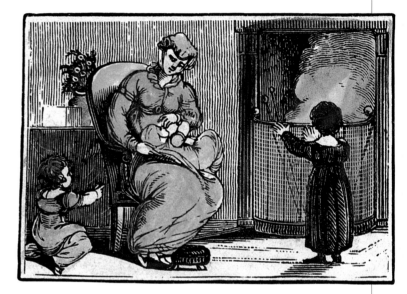

2.4

Illustration from an 1840s reprint of *Short Poems for Young Children*, a children's book by Elizabeth Turner first published in about 1820. The picture shows a nursery fireguard which is not big enough. The accompanying poem tells how a coal flies out and burns the baby. The mother proposes to apply to the blister 'some scraped potato, or some ink./ A little vinegar, or brandy .../ But nothing's better than cold water'.

2.3

Baby-clothes of the 17th century. The baby's head was not, of course, covered by swaddling, and its arms were usually released from swaddling after a month or two. Thus caps, collars and mittens were the sort of clothes that were worth making with care.

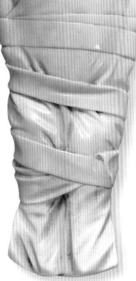

2.5

Small ivory sculptures. These two are in the V&A, dating from the mid-18th century, and are by Johann Christoph Ludwig von Lücke. The swaddled child (right) looks very much less comfortable than the unswaddled one.

— 3 —
FOOD

Nature has provided the mother's milk as a baby's first food. Nature does not endow all women equally, however, and women's health and circumstances affect their ability to give milk. If a mother cannot or will not feed a baby, the obvious substitute is another woman who is producing milk. It is remarkable to how large an extent, in the history of humankind, mothers have delegated breast-feeding to wet nurses. As soon as they were born, children would be handed over to the nurses, thus depriving them of their parents' care and depriving the wet nurses' own children of their mother's milk.

An alternative to the mother's milk is of course milk from animals, and throughout history it has been known for children to suck directly from goats or cows.

Detail (reversed) from an engraving by Pieter Brueghel the elder, 'The Fat Kitchen'. A woman of stupendous proportions is feeding an infant from her ample breast, recharging her capacities with a glass of something strong.

Usually, over the centuries, animal's milk or artificial milk has been fed to children through some sort of device. A hollow cow's horn seems to be the most primitive feeder. It was followed by vessels of metal or pottery, and later of glass, taking many forms.

One crucial design problem was caused by the part which the baby sucked. Not until rubber teats were invented could an adequate substitute for the human nipple be found. Another problem was cleaning. Early feeding bottles tended to have odd corners and tubes which could not be cleaned properly and were a fertile breeding ground for bacteria, so bottle-feeding often made babies ill. Improved scientific knowledge ultimately provided the remedy: sterilization.

Children eventually begin to take solid food: the age for weaning has always been a matter of controversy. Nature's way of managing this transition is for a mother to chew food until it is a smooth paste and then transfer it from her mouth to her baby's with a sort of kiss. Alternatively, mothers can use a spoon, or a shallow, pointed vessel called a pap-boat ('pap' being semi-solid, porridge-like food made to various recipes).

Pap-boats, which have a simple curvaceous elegance, have become popular collectors' items, especially those made of silver or gold. Feeding bottles have also been collected, but usually by those with a professional interest in babies' nutrition. Even more collectable are *veilleuses*, a sort of miniature ceramic stove for warming

3.3

pap, often prettily decorated in the 18th and 19th centuries. Pottery specially designed for children became available from the early 19th century, and is very popular with collectors.

When children are old enough to feed themselves, they can join the rest of the family around the table, provided they have a raised chair (see illustration 20.5). In design, highchairs on the whole mimic full-size chairs, with the difference that their seats are smaller and their legs longer. However, in the later 19th century collapsible chairs were devised, which could change from a highchair into a low chair combined with a table. More recent developments in highchair design have made them more easily adjustable to the gradually increasing dimensions of a growing child.

After food has gone in, it must come out. Obviously children need the same equipment as adults, but on a smaller scale. So, before the water closet, chamber pots were the norm. They could be contained within close chairs, small enough for a child to feel secure.

On top of a flushable lavatory pan, a child might well feel nervous, so in the middle years of this century Americans devoted much ingenuity to devising contraptions that would help to accustom a child to modern sanitary systems.

The diet of most people through most of history has been dull and inadequate, and children often got worse fare than adults. Perhaps this is why sugarplums, spicy cakes and other sweetmeats have appealed so much to children.

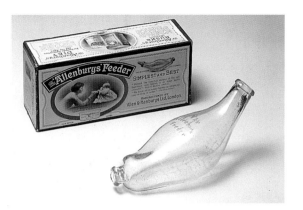

3.4

Feeding bottle, 1911. This was a great advance on earlier, curlier models because water could flush straight through and clean it effectively.

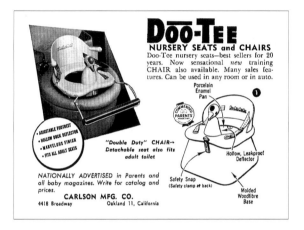

3.5

American advertisement, 1955.

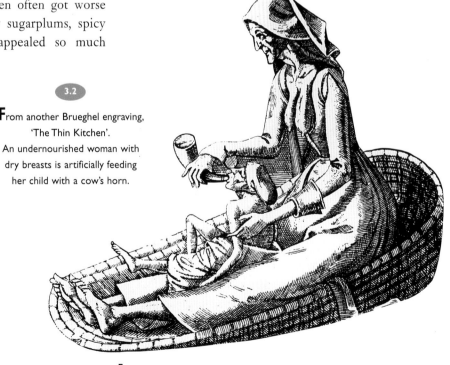

3.3

A pretty feeder, dating from 1840. By placing a stopper over the hole in the middle, the mother could control the flow, but she would not have been able to see inside to clean the feeder properly.

3.2

From another Brueghel engraving, 'The Thin Kitchen'. An undernourished woman with dry breasts is artificially feeding her child with a cow's horn.

— 4 —
SLEEP

It is doubtful whether all organisms alternate between being 'awake' and being 'asleep', but humans certainly do sleep, and need to do so. New-born babies need more sleep than adults. Satisfying needs is usually enjoyable, so perhaps we can count sleep as a pleasure, although we are not conscious of it at the time. When we are asleep we lose our awareness of our environment, so we need to be somewhere safe. Adults have felt this on behalf of their children, and have clearly taken pleasure in devising for them comfortable and decorative sleeping-places. Royal babies were sometimes honoured with very elaborate and expensive cradles.

4.1

Late 18th-century American cradle, which preserves the form usual in Europe. Such cradles were often elaborately decorated, in a folksy style, with carving or painting. Notice the knobs for the safety straps.

The obvious place for a mother to put a sleeping baby is in her own bed. But this practice has often been condemned, for instance in *The Nurse's Guide* of 1729:

> A Nurse [and presumably a mother] should not take a Child to Bed with her, before he has his hands and feet at Liberty; and is able to turn himself, for fear she should happen in a deep Sleep, to lye upon him, or push him to the Bottom of the Bed, under the Cloaths, and so smother him.

Many deaths of infants in past centuries were attributed to 'overlaying' in this way, but the still unsolved mystery of cot deaths suggests that other explanations are possible.

In Renaissance Florence, a piece of safety equipment called an *arcutio* was devised: a strong frame about 3 feet long, which went over the child. It could be used with a cradle to keep heavy bedding off a child, or in bed as a crash-barrier against restless adult bedfellows. But the *arcutio* did not catch on elsewhere, and is now remembered only as an unsuccessful invention.

The best way of keeping a baby safe was to give it a little bed of its own: in its earliest years, a cradle; later, a cot. In the Middle Ages cradles took the form of a swinging box hung between two posts attached to a stable base. Perhaps only a couple of such cradles survive; there is a 15th-century example in the Museum of London. Quite a lot of miniature cradles can be found, however, made as devotional objects to contain toy figures of the Christ Child.

For most of the early modern period, the usual form of cradle was a box on rockers. In Europe, the sides usually sloped inwards. In England, however, cradles tended to be rectangular, and to have hoods over the end where the baby's head rested. Other countries seemed to do without hoods, although it is clear from illustrations that some sort of bracket could easily be rigged up, over which a cover could be draped to protect the baby's face - presumably from both bright light and cold draughts. Rocking soothed babies, especially if they were swaddled and could not move themselves at all.

In the 18th century the earlier type of post-cradle returned, and in the 19th this form was adapted in light, collapsible metal structures. From here developed the carry-cot and its descendants.

Even in cradles babies were not always safe. To stop them falling out, most cradles had knobs or slots to secure restraining straps over the bedding. Left unattended, babies sometimes fell into the fire, or were attacked by animals. (See 4.2, for example). Such incidents are sometimes recorded in pictorial *ex votos* (paintings donated to a shrine to thank a saint for mercies received).

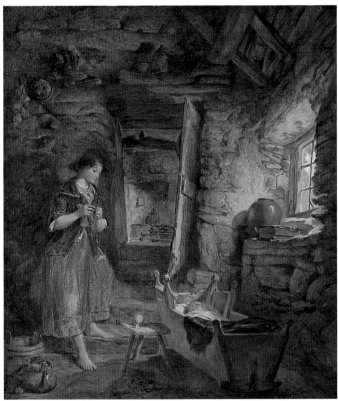

Painting by Alfred Provis, 'Minding Baby'(1857). This subject has been used countless times by artists, from early representations of the Virgin Mary and Jesus onwards. It is an archeteypal image of mother-love.

4.4

The most famous cradles in the history of furnituré (really beds rather than cradles) were made for Napoleon's son, the King of Rome, in 1811. Variant versions, now in Paris and Vienna, followed a design by Prudhon, shown here in a contempory engraving.

4.2

Wicker cradles were popular everywhere because they were light, cheap and disposable (few survive). This one is shown in a wood engraving in Catherine Parr Traill's *Fables for the Nursery* (1825). It illustrates a story, 'The Faithful Hound', which tells how a dog saves a baby from a wolf. This is a modern version of a medieval tale in which a dog, protecting a child from a snake, overturns the cradle. The returning parents think that the dog has attacked the child and kill it.

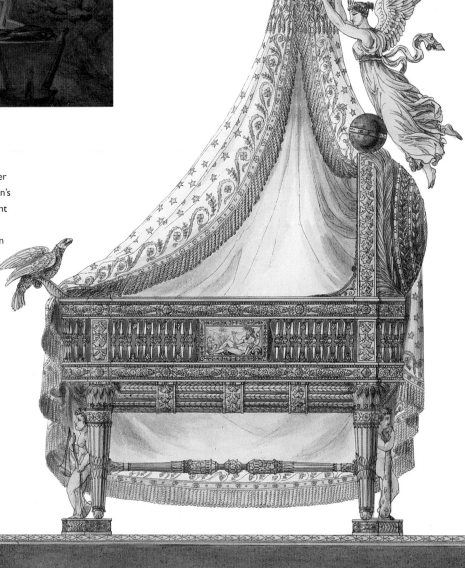

— 5 —

MOVEMENT

At first moved by the strength of adults, babies soon learn to control their own limbs. They begin to explore movement while still stationary in their beds, for they see that the world is moving around them. It is only relatively recently that adults have taken to providing something mobile for babies to focus their eyes on, and it is considered all the better if the moving object makes a sound. As early as 1826, Friedrich Froebel recommended a bird in a cage as a suitable way to occupy a baby's attention. In 1884, in America, a patent was taken out for an early pram toy with bells and a teething ring.

Nowadays, a mobile comes at the top of any list of toys for the earliest months of a baby's life. The mobile began as an art form, with Alexander Calder's moving sculptures in the 1930s. As these became well known in the '40s, they were copied in American art colleges and schools. In the '50s books and articles on how to make your own mobile were published, and the *Oxford English Dictionary* cites a reference of 1957 as the first mention of the mobile as a toy - here said to be suitable for children of 10 years.

Hilary Page's Kiddicraft firm produced a very simple mobile, the 'Cradle Companion' ('to prevent baby developing a squint') in 1947, but it was not until the early 1960s that other developmental toy specialists adopted the mobile as a cradle toy. An alternative genealogy for mobiles suggests that they derive from Danish folk art.

As babies experiment with their own limbs they are encouraged if their movements bring results, such as a sound; hence the popularity of the rattle throughout the ages. Rattles can

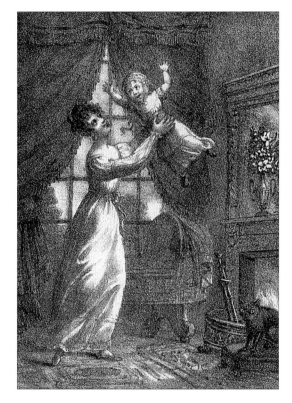

5.1

Title page of a song, 'The Little Baby's Dance' (c.1820). A baby's first exciting experience of movement will doubtless be provided by its mother, when she picks it up, dandles it on her knee, or even throws it in the air. Making the baby 'dance' in this way might have its dangers, but the practice is often illustrated. The words of the song run: 'Dance little Baby, dance up high, never fear Baby, Mother is nigh. Crow caper, and caper and crow, there little Baby there you go up to the ceiling and down to the ground, and backward and forward and round and round'.

be made of almost anything that makes a noise when shaken, and anyone interested in the ability of humankind to create gadgets could profitably make a collection of all the variants of the rattle.

From the 17th century, a type of luxury rattle evolved, intended more as a gift than for heavy use. Made of silver, such a rattle had a cluster of tiny bells in the middle, and from one end projected a whistle while at the other was something on which a baby could cut its teeth - a piece of pink coral, or a ring of ivory. Such rattles were ornamented according to the taste of the time, so a collection can be made that illustrates a succession of art-historical styles. Consequently these rattles have become collectors' items. Many other toys that combine sound and movement have been invented for babies, a fairly new development being soft toys encasing noise-making devices.

The obvious way to move a baby from one place to another is to carry it in one's arms. This

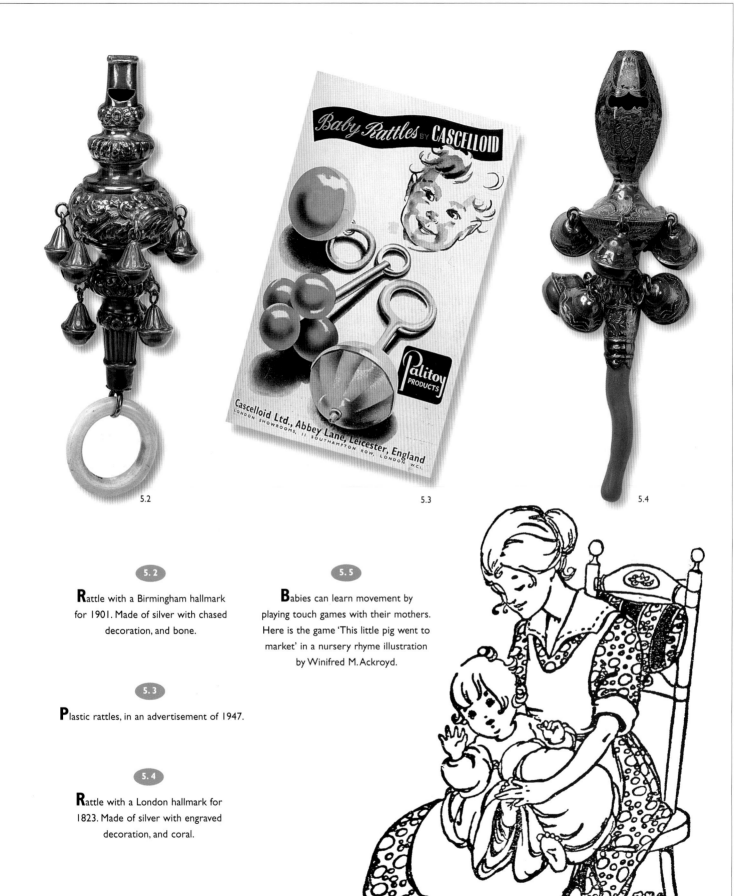

5.2

5.3

5.4

Baby Rattles BY CASCELLOID

Palitoy PRODUCTS

Cascelloid Ltd., Abbey Lane, Leicester, England
LONDON SHOWROOMS, 11 SOUTHAMPTON ROW, LONDON W.C.I.

5. 2

Rattle with a Birmingham hallmark for 1901. Made of silver with chased decoration, and bone.

5. 3

Plastic rattles, in an advertisement of 1947.

5. 4

Rattle with a London hallmark for 1823. Made of silver with engraved decoration, and coral.

5. 5

Babies can learn movement by playing touch games with their mothers. Here is the game 'This little pig went to market' in a nursery rhyme illustration by Winifred M. Ackroyd.

5.5

seems to have sufficed for most people throughout history. No trace of special wheeled vehicles for children is to be found in antiquity or the Middle Ages. If babies had to be carried long distances they could, of course, be fitted into any available vehicle which adults used.

When no vehicles at all were available, the strain of carrying a baby could be considerable. In nomadic societies, various slings and papooses were common. While these would have been unthinkable in developed, urban societies for several centuries, they have come into use in a big way during the last generation, when increasing informality in adult dress has made them a more practical proposition.

The history of wheeled vehicles for children seems to begin, in the 18th century, with expensive miniature carriages made as luxury items by rich parents for quite old children. There are examples of these scaled-down versions of the real thing in the carriage museum at Schönbrunn Palace in Vienna.

Vehicles specially designed for children can often be seen in 18th-century paintings or found in aristocratic houses like Chatsworth, where there is a splendid child's carriage designed by William Kent in 1730. These were meant to be pulled by a pony, a goat or a dog. As they became more popular among the middle classes, they might be pulled by a father, a servant or a sibling.

Prams became available in the early 19th century. These were pushed, not pulled, and the person pushing was referred to as the *peramulator* (i.e. the walker). The name soon passed to the vehicle, and then became shortened. The advantage of prams was that the person

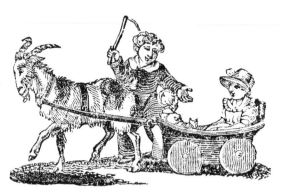

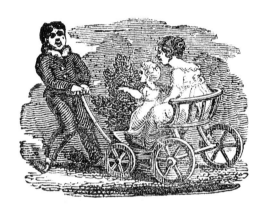

5.6

Woodcuts showing children in carts. Below: a cart pulled by a boy, from *The History of Fanny Thoughtless*. Above: a cart pulled by a goat, from *The History of Harry Heedless*. These are titles of chapbooks (little books of popular ballads and stories - see section 18), printed respectively for J.Davis of London and for the Religious Tract Society in the 1820s. Such chapbooks used woodcuts like these over and over again: clearly they were meant to be instantly recognizable as representations of ordinary child life.

pushing could easily keep an eye on the passenger.

There are basically two types of prams: those that are cradles on wheels, and those that are seats on wheels. Seats came first. Some followed the pattern of adult bathchairs, and became known as 'Victorias'. Others were called 'mailcarts' because they were modelled on postmen's delivery carts. The prams for very small babies, modelled on cradles, were called 'bassinets', this word being a synonym for cradles.

The wheels and springs on these vehicles were varied according to the taste and ingenuity of the carriage-makers. One powerful design influence in Britain was the law which, until 1875, prohibited four-wheeled vehicles on footpaths. Prams had to be designed, inconveniently, with three wheels.

Many combinations of materials were used for the coachwork of the prams, including metal, wood, wicker and leather. A glance through old pram-makers' catalogues shows that great inventiveness was devoted to ornamenting Victorian and Edwardian prams. The classic English deep pram had its heyday from 1920 to the 1960s. Streamlining was more popular, from the 1930s to the '50s, in Europe than in Britain.

A patent for a folding pram was taken out in 1853, but these came into their own between the two world wars, when life without servants put at a premium such labour- and space-saving conveniences.

Advertisements show trim, capable mothers deftly folding and stowing their prams as they board trains, buses or even aircraft in the new age of worldwide travel.

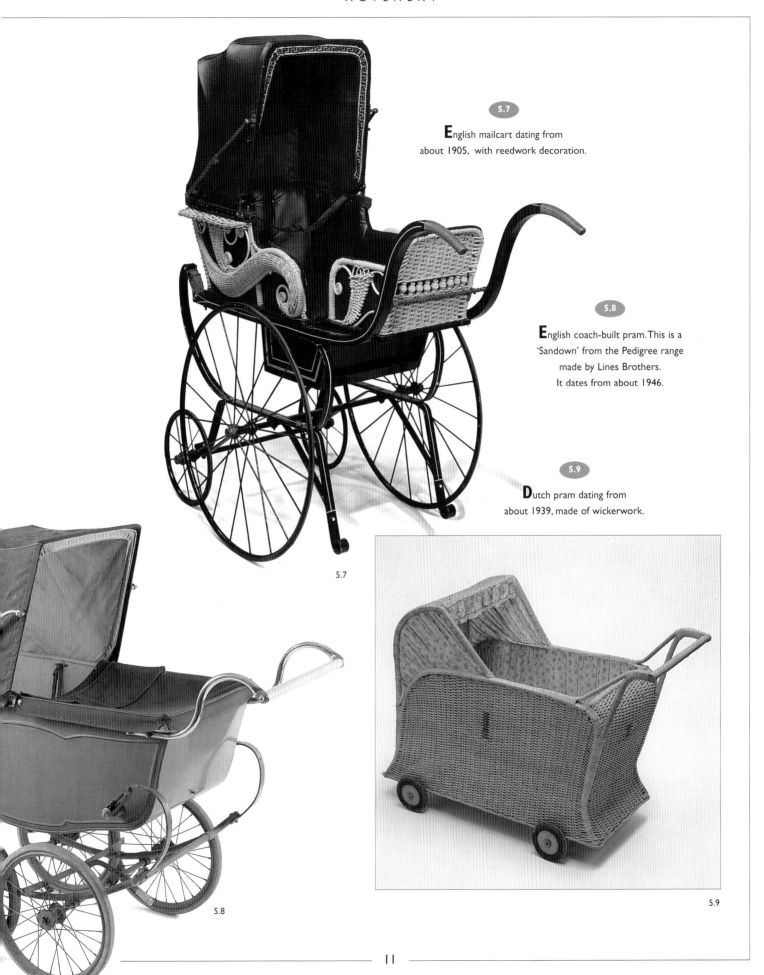

5.7

English mailcart dating from
about 1905, with reedwork decoration.

5.8

English coach-built pram. This is a
'Sandown' from the Pedigree range
made by Lines Brothers.
It dates from about 1946.

5.9

Dutch pram dating from
about 1939, made of wickerwork.

5.7

5.8

5.9

As babies learn to walk, they need all the help they can get. Leading strings were common in the 17th and 18th centuries: long straps attached to the shoulders of a child's dress, often made of the same cloth. As with toddlers' harnesses, popular in the 20th century, these were probably more used for restraining children than for propping them up. A way of getting babies used to their leg muscles was to hang them up in some sort of harness, so that their feet just touched the ground and they could bounce up and down. These were a novelty from America in the 1840s and are still made.

The most usual piece of equipment for learning movement was a walking-frame, usually called a baby-walker, but in the 18th and 19th centuries often called a go-cart. Babywalkers were in use from the Middle Ages. Manuscripts and embroideries often show the baby Jesus or the young St Mary pushing in front of them a simple wheeled frame, but the baby could let go and fall over.

From the sixteenth century a more efficient design was known. This was a wheeled frame with a superstructure in the form of a ring that enclosed the child around its chest. It provided support under the shoulders or, if it had a seat, between the legs. The child could move and the frame moved with it, keeping the child upright. Such frames were not difficult to make from wood. A square pattern was easiest, but polygonal or circular shapes were more manoeuvrable. Many survive, and show pleasing variations in the treatment of the members, especially when these were turned on a lathe. Sometimes the walkers would have a ledge on which a child could place toys or food.

Technological improvements were eventually made. The *Illustrirte Zeitung* of 4 January 1879 pictures a metal version, which is rather a complicated piece of ironmongery. This enabled a child to sit down at a table which, when the child rose to its feet, sprang up to support it as it walked. The twentieth century has seen the development of metal and plastic versions.

The merit of the wheeled frame was that it allowed a baby to choose its own route. There were less accommodating forms of support. One looked rather like a miniature ship's gangway: the child, gripping the handrails and also perhaps supported by brackets round its body, could totter from one end to the other and back. In another type, a body-supporting bracket projected from a vertical post which would revolve – this condemned a child to walk perpetually in circles.

At the time when children are learning motion, the greatest fear on the part of a carer is that they will wander into harm. An easy answer to this problem is the playpen, and it is remarkable that this device only caught on at the beginning of the 20th century.

5.10

Illustration showing a basket support. This is light enough for a child to carry as it walks, but prevents the child from falling over. Taken from a children's book, *Bilderlust für die Jugend,* published in Vienna in about 1820.

5.11

Advertisement, 1914.

5.12

18th-century babywalker. Made of ash and mahogany.

5.13

Miniature babywalker. Part of the contemporary fittings in the Nuremberg House of 1673 (see illustration 29.4).

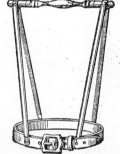

THE "TEACHTOWALK"

This successful invention gives a perfect balance and support to a child when learning to walk.

Made of
BEST ENGLISH LEATHER.

POLISHED WOOD HANDLE.

NICKEL PLATED FITTINGS.

ENGLISH PATENT
2966/13.
D.R.G.M. 558249.

Send for
Supplies.

THE **"TEACHTOWALK"**
MANUFACTURING CO.,
129, CONSTITUTION HILL, BIRMINGHAM.

5.11

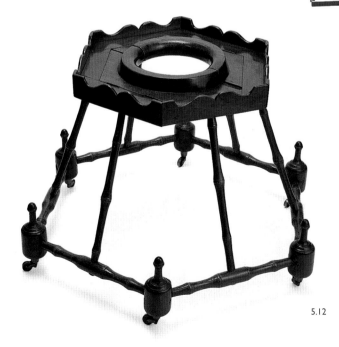

5.12

5.13

— 6 —

SOUND AND SONG

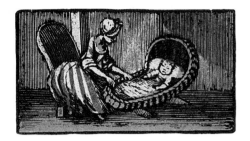

6.1

Detail from an early 19th-century edition of *Mother Goose's Melody or Sonnets for the Cradle*. Important as one of the fullest (51 pieces) and most often reprinted collections among the rare early printings of English nursery rhymes, the earliest known edition is of 1791. The edition here re-used the woodcuts from previous editions (hand-coloured in this copy).

How we learn to understand and speak language remains one of life's great mysteries. To introduce babies to this we have amassed a repertoire of lullabies and simple rhymes. B.F. Skinner (in *Verbal Behaviour*, 1951) thought that children learned language by observing how others used and reacted to it. Noam Chomsky suggested, to the contrary, that children have an inherent understanding of the deep structures of language. Much debate followed on this issue. Whatever the exact process of language-learning, there is no doubt that it involves the exchange of sounds and speech between children and those around them, especially their mothers. In their children's earliest years, parents find very simple, repetitive noises and phrases to amuse them.

Some of these chants have been so widely used that they have gained classic status, as lullabies or nursery rhymes. The simplest lullaby is a crooning sound, which soothes a child and helps it to fall asleep. Each language seems to have its own sound. 'Lully' or 'lalla and 'bye-bye' seem to be the usual English noises. 'Dodo' is the French, 'arroro-ro-ro' Spanish, 'ninna-nanna' Italian, 'ei-a' German; 'su-su-su-su' comes from North-Eastern Europe, 'yo-yo-yo' from Africa - though, of course, it is up to the singer in the end. The point of a lullaby is to relax rather than stimulate, so the lack of meaning in these formulas is an advantage.

If only to add interest for the singer, however, such chants begin to pick up verbal phrases and formal tunes, resulting in the nursery rhyme or song. (The use of the term *nursery rhyme* in England seems to date from the 1820s.) Most nursery rhymes are very simple and short, perhaps only four lines of rhyming verse, and they are always easy to learn.

For a very young baby, nursery rhymes can be used to accompany movement. The baby is lifted up to the words 'Dance, little baby, dance up high', or jogged on the knee to the song 'This is the way the ladies ride'. Amused with hand movements to 'Two little dicky-birds', the baby can be encouraged to recognize its own movements with 'This little pig went to market' and 'Pat-a-cake, baker's man' (see illustrations 5.1, 5.2).

Nursery rhymes also help with the early stages of conceptual learning. They enable a child to learn the alphabet ('A Apple Pie'; 'A was an archer') or to learn to count ('One,

I HAD a little nut-tree, nothing would it bear,
But a silver nutmeg and a golden pear ;
The king of Spain's daughter came to visit me,
And all was because of my little nut-tree.
I skipp'd over water, I danced over sea,
And all the birds in the air couldn't catch me.

6.2

First published by Tabart in 1805, *Songs for the Nursery* is another important collection of nursery rhymes, because it is comprehensive. It was frequently reprinted. Here is an illustration from an 1851 edition, published by Darton.

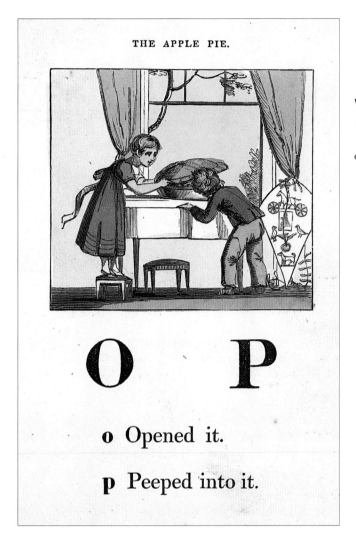

THE APPLE PIE.

O P

o Opened it.

p Peeped into it.

6.3

With its narrative tied to the letters of the alphabet, *A Apple Pie* is one of the nursery rhymes substantial enough to be published on its own as a booklet. The version shown here was published in about 1840, by Darton and Clark.

6.4

Some nursery rhymes have traditional tunes but, once the texts were in print, composers began to provide new tunes. Dr Samuel Arnold (1740-1802) composed these, published about 1820.

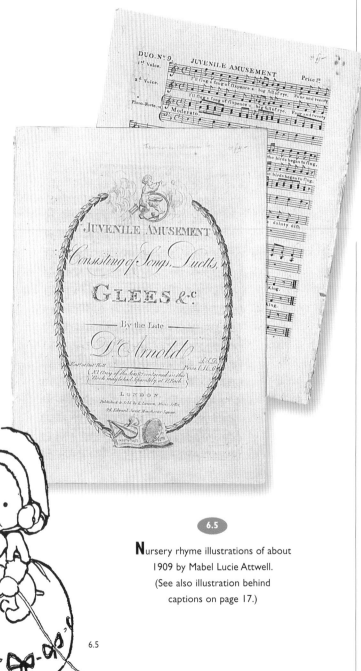

two, buckle my shoe'). Many use counting-out formulas ('Eeny, meeny, miny, mo', 'Tinker , tailor, soldier, sailor') - gibberish systems which exist in many countries and are used in the games of older children. Quite a lot of nursery rhymes, such as 'Humpty Dumpty', are riddles.

As children get older they can remember more, so can enjoy longer nursery songs. These usually have a strong element of repetition from stanza to stanza (such as 'A frog he would a-wooing go'; 'London Bridge is falling down'), and sometimes they are cumulative ('This is the house that Jack built'; 'On the first day of Christmas').

The best nursery rhymes, whether about people or events, tend to be pleasingly inconsequential but full of visual images: 'Mary, Mary, quite contrary,/ How does your garden grow?/ With silver bells and cockle shells,/ And pretty maids

6.5

Nursery rhyme illustrations of about 1909 by Mabel Lucie Attwell. (See also illustration behind captions on page 17.)

6.5

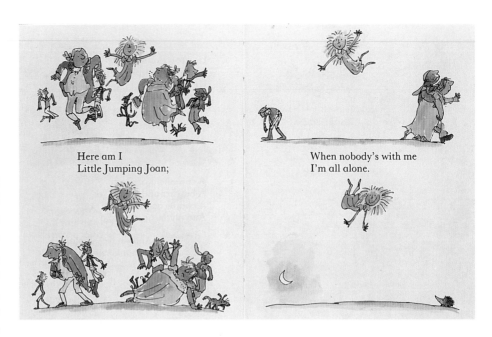

6.6

Quentin Blake's *Nursery Rhyme Book*, first published in 1983. 'Little Jumping Joan' is typical of Blake's style (once aptly described as 'careless rapture'), that catches the giddy, inconsequential nature of nursery rhymes.

Here am I
Little Jumping Joan;

When nobody's with me
I'm all alone.

all in a row.' Children do not worry about such illogicality, and are happy to admit to their acquaintance such odd but interesting friends as Little Bo-Peep, Little Tommy Tucker, Wee Willie Winkie, Old King Cole, Georgie Porgie, and Margery Daw. Adults often have difficulty with nonsense, and try to prove that songs such as 'There was an old woman tossed up in a blanket' are coded references to historical people or events. Most such theories are nonsense themselves.

Nursery rhymes have been collected and printed since the 18th century. The earliest English collection seems to be *Tommy Thumb's Pretty Song Book*, of about 1744. Only a single copy of the second volume of this (presumably) 2 volume work is known to exist, and is in the British Library. It measures only 3 by 1¼ inches, and is probably the most precious childhood relic in the world.

This little book has illustrations, and most subsequent anthologies of nursery rhymes have been illustrated too. There seem to be two ways of picturing nursery rhymes: some artists reflect contemporary life, while others provide illustrations in a historical idiom. You can do both in the same book, of course. Old King Cole seems to demand a historical setting, but this would be much less appropriate for 'Girls and boys, come out to play'.

Early illustrations were unselfconsciously contemporary. But in the mid-19th century, nursery rhymes became respectable enough to enter literary history. In 1842 James Orchard Halliwell published his collection, *Nursery Rhymes of England*. After this, there was a tendency to regard them as heritage and to illustrate them accordingly. The V&A's first director, Henry Cole, was a pioneer publisher of children's books and brought out a tasteful volume of *The Traditional Nursery Songs of England* in his 'Home Treasury' series of the 1840s (see illustra-

tion 20.8). James Burns published *Nursery Rhymes, Tales and Jingles* in 1844, setting the slight texts in elegant, Germanic surrounds.

Colour printing offered new possibilities. Nimmo of Edinburgh, in the 1870s, published *Marcus Ward's Royal Illuminated Nursery Rhymes*, which were 'gorgeously illuminated, after the mediaeval manner, in colors and gold'. In 1877 Walter Crane used colour wood engravings in *The Baby's Opera*: the title, meant to be amusing, nonetheless signals that this is an up-market book with pretensions. There were, of course, many nursery rhyme books with unpretentious illustrations, but the tasteful tradition continued, in the work of Kate Greenaway, Randolph Caldecott, Arthur Rackham, Henriette Willebeek le Mair and many others.

Owing to the element of nonsense in them, nursery rhymes are difficult to translate. Each nation has its own. The great German collection is to be found in the folk-poetry anthology, *Des Knaben Wunderhorn* (1806-8). In America, sharing its language with Britain, they are called Mother Goose rhymes. Mother Goose probably became linked to nursery rhymes because she was already known to children as a supposed teller of fairy tales. But Americans have more complicated explanations involving a real Mrs Elizabeth Goose of Boston.

The texts of English Nursery rhymes are now enshrined in Iona and Peter Opie's great *Oxford Dictionary of Nursery Rhymes*, but their tunes are still transmitted orally.

Little maid, little maid,
Whither goest thou?
Down in the meadow
To milk my cow.

GOOSEY, GOOSEY, GANDER
Goosey, Goosey, Gander, whither shall I wander,
Upstairs, and downstairs, and in my lady's chamber.

6.7

At the turn of the 19th and 20th centuries, Kate Greenaway and other British illustrators set nursery rhymes and tales in a never-never land of winsome charm.

6.8

From *My Book of Nursery Rhymes* by Muriel Dawson (1942). which has 'Goosey, goosey, gander', unpretentious illustrations of convincing contemporary children.

6.9

Nursery rhymes re-rooted in a local context: *Mother Goose Comes to Cable Street* (1977). This is an illustration by Dan Jones, showing how the nursery rhymes are pictured in London's multicultural East End.

Three babes in a basket
And hardly room for two,
One was yellow and one was black
And one had eyes of blue.

6.8

— 7 —

OUTDOOR GAMES

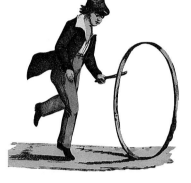

7.1

Trundling a hoop. From Adam White and Robert M. Stark's *The Instructive Picture Book* (1857).

In the Art History Museum in Vienna hangs Pieter Brueghel the Elder's painting, *Children's Games*, a broad, low-flying bird's-eye view of more than two hundred scurrying, tumbling little figures, playing (it has been estimated) over ninety games. Many of the activities are still recognizable to us: leapfrog, headstands, follow-my-leader, somersaults, swimming; games played with marbles, tops, hoops, knucklebones, windmills, hobby-horses. Others are unfamiliar, such as 'wink-egg' (in which one blindfolded child with a pole tries to hit a stick held by another) or 'plum tree' (in which one child acts as the tree, fending off others who try to pick the plums by pulling his hair). Some children are mimicking adults, by playing shop, getting married, taking a baby to baptism, building with bricks. Making mud pies, defecating, or simply hanging upside down are other occupations visible. Brueghel's painting could be seen as a kind of research project, to record all he ever knew about play. Or you might see the painting as a remarkable early celebration - it was painted in 1560 - of 'the republic of childhood'.

In fact, although the painting remains one of the most remarkable representations of childhood, it is not a unique expression, but a link in a long chain of representations of children's games in western visual media. Before Brueghel, children at play frolic in the margins of the prayer books called Books of Hours, both in the medieval manuscript versions and in the later printed versions. Often the context for these illustrations is the Calendar, where activities apt for each season are recorded, or where the traditional notion of the 'Stages of Life' (see section 54) is explored. When later artists continue to treat these themes in engravings, children again crop up: a print (captioned in Latin, French and Flemish) entitled 'Infancy', by Marten de Vos, a contemporary of Brueghel, is a good example. Brueghel's painting was copied by his son Pieter and imitated by Martin van Cleve.

7.2

Illustration of games from an English version of Joannes Amos Comenius's *Orbis Sensualium Pictus*, first published in Nuremberg in 1658. This was a children's dictionary-cum-encyclopaedia with pictures, renowned as the first textbook which tried to be attractive to children.

In the following century Jacob Cats, Dutch poet and statesman - a sort of Poet Laureate of Holland and immensely widely known - wrote verses on children's games, which were illustrated by engravings reminiscent of Brueghel's painting. Children's games became a favourite subject for blue-and-white Dutch tiles. From now on, children's games were often depicted by artists when they wanted to compose a set of diverting pictorial variations: by Hubert Gravelot and Augustin St Aubin in 18th-century France, for instance. In England, Thomas Bewick, father of wood-engraving, used the theme in a series of sixteen characteristic vignettes at the start of the 19th century. Naturally, the theme found ready reception in children's books (and in jigsaws and children's china) and can be traced right up to today.

When using pictorial material as evidence for history, we must always

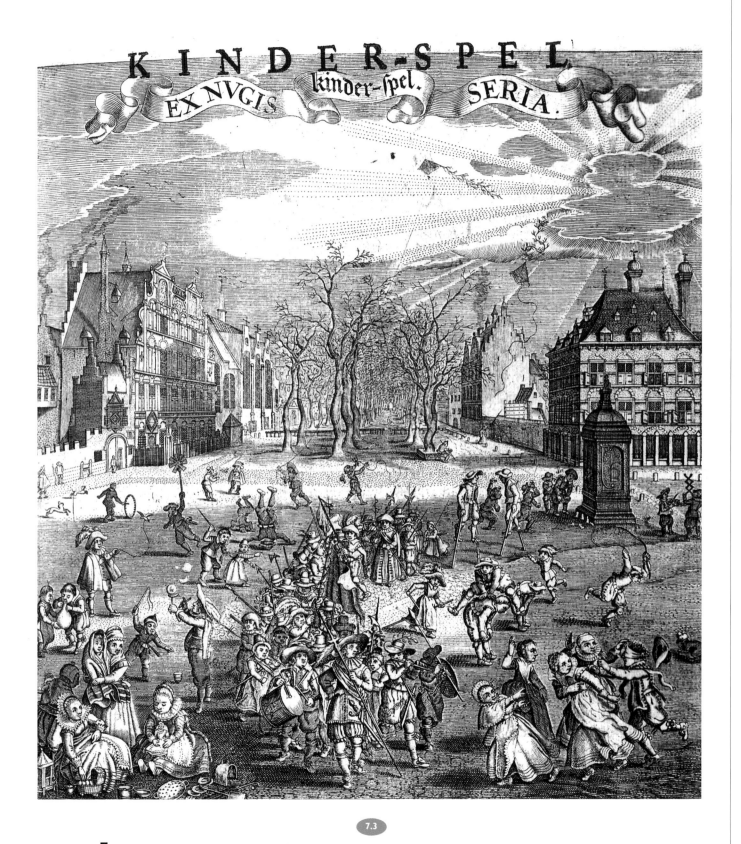

KINDER-SPEL

EX NVGIS kinder-spel. SERIA.

7.3

Engraving for Jacob Cats's poem *Kinderspel*, which was published as a preface to his poem *Houwelijck* in 1628. The 1628 engraving was by Experiens Silleman, after Adriaen van de Venne. This is a later version of that engraving from an edition of Cats's complete works of 1665. A similar illustration in landscape format was used to illustrate the poem in other editions.

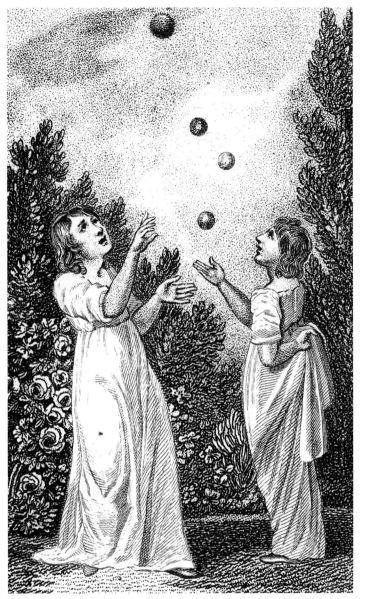

7.4

7.5

Battledore and shuttlecock (a game dating back
to the Middle Ages) in one of Thomas Bewick's
wood-engraved vignettes.

7.4

Girls playing at ball, from *The book of games,
or a history of juvenile sports*, published by
Tabart in London (1810).

7.6

Cricket, from *A little pretty pocket book*, published
by John Newbery in 1744 (see section 19).

ask: is this an accurate record of actual life, or is the artist
making a point which we may be missing? Since Brueghel
left no words to explain his painting we shall never know
exactly what he intended, and there are rival theories
among art historians. The illustrations to Jacob Cats's
poem are a different matter, however. Cats was a moral-
ist, and his point was that children's games were a sym-
bol of human activity in the world: 'the world and its
whole constitution/ Is but a children's game'. Everything
that the children are doing in the picture can have a
moral hung on it. To make a top work you have to whip
it: the same with children. Bladders signify vanity, stilts

pride, bubbles transience. Prominent in the Cats illustra-
tion shown as 7.3 are two kites. One flies high, the other
is crashing to earth: this sort of reversal of fortune is what
life will bring you unless you watch out.

We know the Dutch moralized like this in the 17th
century because of the many emblem books that were
published - these were books with symbolic illustrations
interpreted by verses. At the same time, though, we can-
not miss a sense of sheer enjoyment of life in the paint-
ings of the time. Often, says historian Simon Schama,
'their moral weight has been shaken loose in the playful-
ness of their execution'. In later centuries children's

games were represented and enjoyed for their own sake. To be sure, writers of the 19th century sometimes tried to moralize them in a characteristically bossy way. The publisher John Marshall included a tiny volume on children's games in one of his miniature libraries. Beside a picture of girls on a swing is the comment: 'This is a very dangerous play and very improper for young ladies'. Children's games are illustrated in *The Youth's Best Friend* (1828). The picture 'Trundling the hoop' inspires the reflection: 'This is indeed a very good sport for little boys, but only in cool weather; some little boys make themselves very hot, and then drink cold water or sit down on the damp ground, by which they often become very ill'. The many 'boys' own' and 'girls' own' compilations of things to do, published in the Victorian period, are more sympathetic in their treatment of games.

7.6

Where do children's games come from? Philippe Ariès proposed that they were handed down by adults. Common sense assures us that there is something in this but, as with his treatment of children's clothes (see section 24), Ariès insists that childhood is 'the repository of customs abandoned by the adults'. This has to be taken with a grain of salt. Some believe that 'children's games are the ghosts of ... ancient mysteries'. This is the phrase of Henry Bett who, in his book *The Games of Children* (1929), claimed that: 'Nothing can exhibit the amazing tenacity of popular tradition more clearly than the relics of prehistoric belief and custom which are fossilized in the games that are played by children, generation after generation'. He goes on to classify the games in terms of their relation to weddings and funerals, springtime and verdure, sunshine and fire, fairies, goblins and sacrifices.

7.7

Hopscotch, illustration by Pauquet in *Jeux et exercices des jeunes garçons* (Paris c.1850).

An idea that is often raised in speculations along these lines is that children's games relate to the calendar. It is clear that some do: you can only go snowballing in winter, and you can only play with conkers when they grow on chestnut trees. Older people certainly remember that some games had 'seasons'. But again, this is an idea that can be pressed too far. Leslie Daiken's delightful book *Children's games throughout the year* (1949) takes the months as a framework. January 'calls for games that keep you warm', February for ball games, March for hopscotch and tops, April for skipping games, May for games of courtship and marriage, June for midsummer customs, July for nature games, and August calls for games to do with death and burial 'for no reason that we can explain'. Is not this somewhat arbitrary? September features harvest games, October fireside games, November indoor party games, and December of course brings Christmas. Another pinch of salt should be taken.

If tracing the origin of games is a chancy business, perhaps folklorists are better employed in recording games as they are played. This is the direction in which most effort has gone, from Joseph Strutt's *Sports and*

Pastimes of the People of England (1801) onwards. Collections of children's games have been made for almost all countries. Folklorists are willing to try to document behaviour and the material circumstances of life, but they have always tended to be happiest with texts. So the games they have concentrated on have been those in which rhymes or chants accompany a ritual. Lady Alice B. Gomme's *Traditional Games of England, Scotland and Ireland* (1894-8) provided encyclopaedic coverage of Britain. For the present generation, however, the work of Iona and Peter Opie, in *The Language and Lore of Schoolchildren* (1959) and *Children's Games in Street and Playground* (1969) has been a revelation. If a key to happiness in this life is to notice and enjoy what is often disregarded, then the Opies have given this key to countless readers.

Folklorists might once have taken their stand on village greens to observe children's games. But after 300 years of urbanization, the games must now be sought in city streets. Already in the mid-19th century, *Punch* had a line in cartoons of street urchin-pests at play. When Norman Douglas set out in the 1920s to indulge 'a pastime that grew on you like a fever - collecting these outdoor sports', he went to the boroughs of London. He published his findings in *London Street Games* (1931). This was not a treatise, but a 'breathless catalogue' in the idiom of the children, like an outside broadcast in advance of its time. He wondered if the games would survive. At the end of the 20th century that seems an urgent question, as life (adult life as well as children's) is driven off the streets and into 'safe havens' of defended privacy.

7.9

Organized games, such as running, archery and football, are recorded in Britain as far back as the 12th century, but they came into their own in the English public schools in the 19th century, when they were adopted as a means of instilling group solidarity in pupils. This is an illustration (from the 1930s) of rugby football, developed at Rugby School after a boy in 1823 picked up a football and ran with it instead of kicking it.

7.8

Improvised football in a street in the Whitechapel district of London. Illustration by Hugh Thomson in *The English Illustrated Magazine*, vol 7 (1889-90).

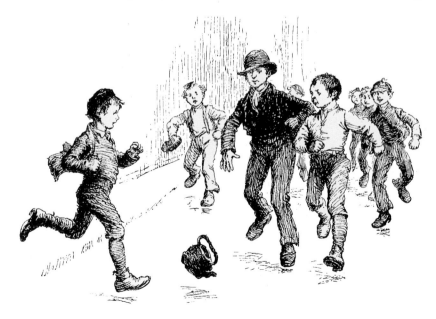

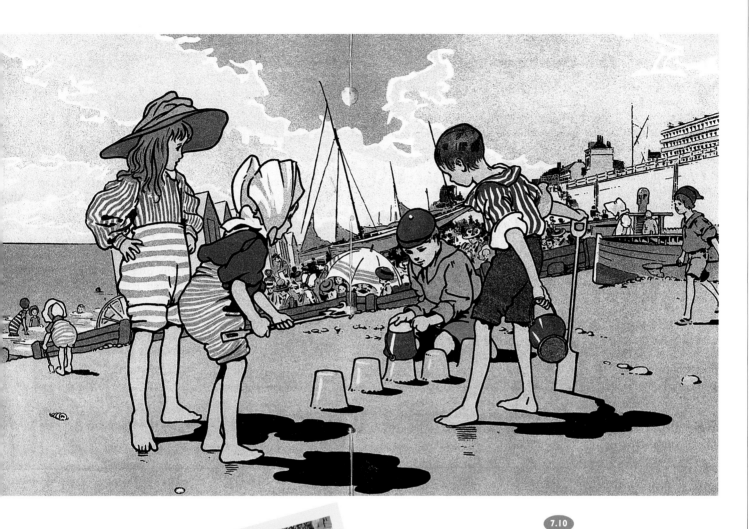

Seaside games go back a long way. In the 1150s Gerald of Wales played on the beach near his father's castle. While his brothers built castles and palaces, he built churches and monasteries, thus foreshadowing his adult career in the church. (Medieval stories about children often make edifying points like this.) Seaside holidays at 'watering places' became popular in the 18th century, proving convenient for families. Already in 1803 it was noted: 'To observe the little animals, in the greatest degree of health and spirits, fabricating their pies and their castles in the sand, is a treat for the philosopher'. This illustration by Charles Robinson is from *The Roundabout Book*, published by Blackie in about 1915.

Making dens is something children must always have done. The 15th-century poem *Ratis Raving* describes how children build houses with sticks and branches. This pastime was still as absorbing in Northampton in 1984, when John Heywood took this photograph.

— 8 —
INDOOR SPACES

8.1

Very early nursery wallpaper of about 1860 with scenes of child life.

One of the great historical projects of recent years has been the 5 volume *History of Private Life*, written by a consortium of French scholars under the editorship of Philippe Ariès and Georges Duby in the 1980s. They felt they were exploring almost uncharted waters, for history had previously focused on public events - political, and later economic. Only now did scholars feel the urge to explore what went on in ordinary people's lives and minds. One reason for this increased interest is, no doubt, that there are much greater opportunities for privacy today. In the Middle Ages, at every level of society (apart from hermits), everyone lived among a crowd of others. Over succeeding centuries, more and more people obtained private space, until today, in developed countries, almost everyone can claim 'a room of one's own'. Perhaps the last people to get private space were children.

A glance at the dictionary reveals that in English the idea of the nursery was current from 1499: 'Norcery, where yonge children be kepte'. But there must have been very few rooms set apart for children. The next citation (1532) in the dictionary refers to 'the nourcery and the womens lodgyng, diuided from the mens lodgyng', which suggests that, as so often, women and children were expected to stick together. Whether or not children were able to retreat to a private space, it is clear that usually they had to fit into the fringes of adult space.

The 17th-century painting *The Egg Dance* by Jan Steen illustrates this shared space. It shows a scene of adult merry-making, and at the centre of this domestic tornado is a small child - only a toddler, because he is dressed in long coat and pudding (see sections 24 and 25) - who is able to take care of himself and interact socially. Art historians have taught us not to read Dutch pictures as straight

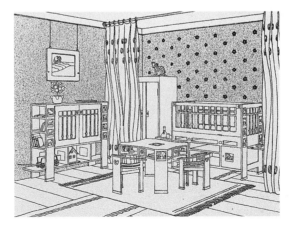

8.2

Design for a nursery by Franz Messner, with harmonizing wallpaper, rugs, hangings and furniture in the Art Nouveau style. Published in the Viennese magazine *Das Interieur* in 1901.

transcripts of real life, because they are often loaded with moral lessons. But, allowing for this, we can still see the painting as making a point about children's lack of privacy in the past.

Children acquired privileges in the 18th to 19th centuries. The earliest illustration of a room set apart for children seems to be a drawing in an album of 1740 from Augsburg (Weber-Kellermann p.14). Later, in a series of engravings of interiors of about 1820 by Michael Voltz, there are illustrations of a boy's room, a girl's room and a children's bedroom. This last shows a cradle, an early pram and a pair of interesting cots, while in the boy's room there is a clothes horse on which his 'smalls' are drying. But apart from these features, there is nothing that marks these out as children's rooms except that they are cluttered with toys.

Children's rooms, then, were becoming functionally desirable,

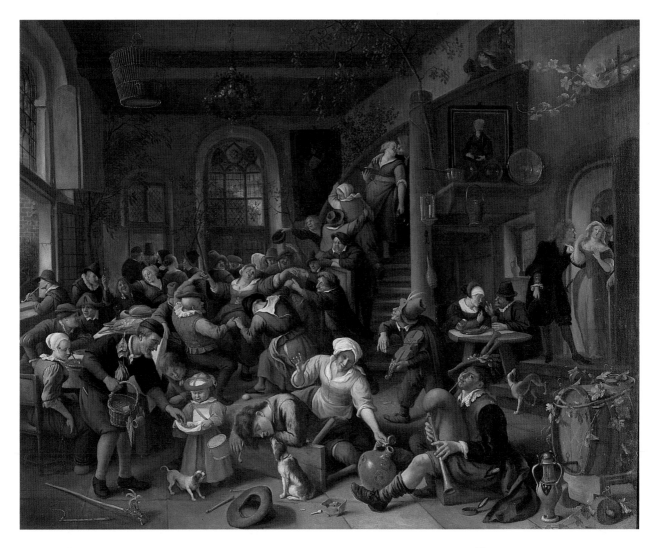

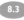

Jan Steen's *The Egg Dance*, which
hangs in the V&A's branch museum,
Apsley House.

The Scottish artist Jessie M. King
designed this doll's house as part of a
total nursery décor for the L'art pour
l'enfance exhibition in Paris in 1913.

but no-one was yet trying to design them specially for children. Function seems to have ruled in England. During the 19th century, the English gentry and nobility became well-known for the way they kept their children in the background in their country homes, usually locating the nurseries in a distant wing next to the servants. 'The main part of the house must be relieved from the more immediate occupation of the Children', said the foremost manual on house planning, Robert Kerr's *The Gentleman's House* (1865), and in the *Builder* magazine in 1853 an article stated that in Germany too 'the nursery ... cannot be distant enough from the abode of polite parents'.

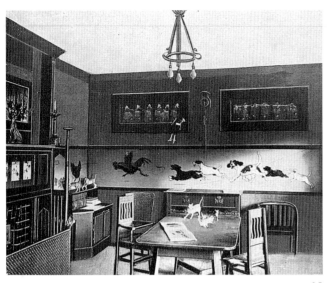

8.5

Some people, however, began to think about their children's surroundings. At first, they wanted to do their children good. In 1789 John Marshall published Mrs Trimmer's *Prints of Roman History, Designed as Ornaments for those Apartments in which Children receive the first Rudiments of their Education*, advertising that they were available 'pasted on Boards, for hanging up in Nurseries, 5s.'. The edifying impulse persisted. W.J.Loftie, in *A plea for art in the house* (1876) recommended that 'a child's taste may be greatly influenced by the habitual contemplation of a print after Raffaelle, or Rembrandt', while Edith Wharton in *The Ornamentation of Houses* (1898) recommended for nurseries 'a good reproduction of one of the Tanagra statuettes, a plaster cast of some French or Italian bust, or one of Cantagalli's copies of the Robbia bas-reliefs'.

More sympathetically, *Beeton's Housewife's Treasury* (1880) inisted that nurseries should be 'pretty and colourful', and this doctrine quickly took hold. From the 1870s nursery wallpaper was available, based on the book illustrations of Walter Crane, Kate Greenaway and Randolph Caldecott. The Child Study Movement (see section 17) stimulated interest in the development of children's perceptions, to which nursery decoration was obviously relevant. A series of exhibitions put actual examples before the public. At the Earls Court Woman's Exhibition of 1900, a through-designed nursery suite by John Hassall and Cecil Aldin aroused international interest. Other important exhibitions were 'L'enfant à travers les ages' at the Petit Palais, Paris, in 1901; the 'Art in the Life of the Child' travelling exhibition shown in Vienna in 1902, with nursery designed by Joseph Urban; the childhood section in the Vienna Kunstshau exhibition of 1908, with nursery by Joseph Hoffmann; and the exhibition 'L'art pour l'enfance' at the Musée Galliéra, Paris, in 1913. The architectural and design magazines of Europe during the first two decades of the 20th century were full of illustrations of nurseries designed with harmonizing furniture and decoration.

What was new in these was a desire to give children an imaginatively stimulating world of their own. The Viennese critic, Ludwig Hevesi (in *Altkunst-Neukunst*, 1909), writing of the children's playroom in the attics of Josef Hoffmann's Villa Brauner in 1905, says: 'The whole roof structure is visible, providing a host of secret crannies for the playful fancy of the little ones. A secret staircase even leads to a concealed chamber up above... Anyone who has been a child, or has even read Dickens,

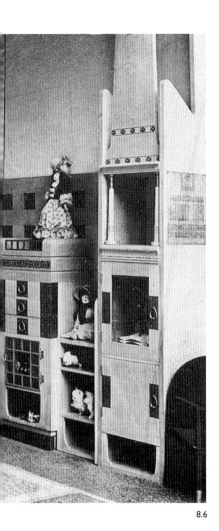

8.6

The Hassall and Aldin day-nursery at the Woman's Exhibition, 1900: walls in two shades of green, friezes and pictures showing 'laughter-inducing conceits' by Aldin.

8.6

Josef Urban's day nursery in the Art in the Life of the Child exhibition at Vienna, 1902.

Nursery designed by André Hellé, exhibited in the decorative arts section of the Salon d'Automne, Paris, 1911.

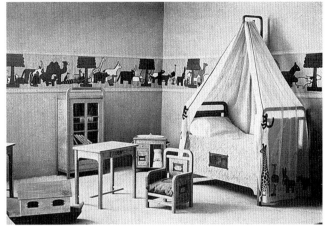

8.7

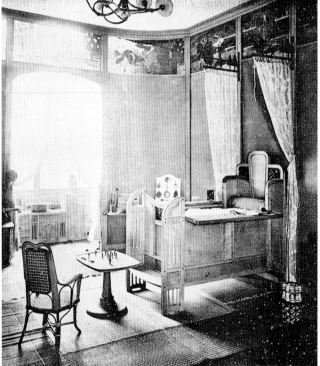

8.8

Nursery designed by Abel Landry, shown at the second exhibition of the Société des Artistes Décorateurs, Paris, 1906.

knows what an important part such spaces play in childhood, and in forming its unforgettable atmosphere'.

In England Lawrence Weaver, inspired by Robert Louis Stevenson, praises 'the children's attic' in *The house and its equipment* (1911). Elsewhere he shows how one of these houses, Larkscliff at Birchington in Kent, has not only an attic playroom but an architect-designed pirate's cave in the garden (*Small country houses of today*, 1931).

By the 1920s, the battle for the pretty and comfortable nursery had been won. Tastes changed, of course. For instance, in 1936 Exton and Littman, in their *Modern Furniture*, forbade pictorial wallpapers because 'in the half-light before bed-time they get distorted and sometimes rather frightening'. But few would have disagreed with the comment in the *Girls' Own Annual* of 1930 that 'the playroom will be the very young child's universe, and his feelings toward the nursery will largely influence his feelings toward life in general'.

— 9 —

DOLL PLAY

9.1

This illustration, from *Cobwebs to catch flies* (1783), seems to be suggesting that the relationship between mother and child is parelled by the relationship between child and doll.

According to the first major historian of dolls, Max von Boehn, a doll is 'the three-dimensional representation of a human figure'. This does define a doll, but could include many other things too. So von Boehn goes on to try to distinguish dolls from miniature human figures which are made as works of art. Over the last two centuries people have believed that works of art have a special magic quality, which is unmistakeable to those sensitive enough to recognize it. But more recently, people have become less confident about what constitutes art; things move in and out of the realm of art more casually. A useful definition of art could now be: 'Artistic things are things that are meant to be looked at'.

Certainly, some dolls were made just to be looked at, rather than played with, and are accepted as art, such as the 18th-century Italian figures for cribs. And some dolls are made today with the intention that they should be regarded as art and displayed in art galleries.

Van Boehn also tries to distinguish play dolls from other miniature human figures that have been used in special ways in different cultures. He deals with prehistoric idols, ancestor images, fetishes, amulets, talismans, votive images and funeral effigies.

The essence of a play doll is that it is up to a child to use the doll in any way it wants - the child is active, the doll passive. The doll receives all the feelings and thoughts a child wants to project

on it, without making claims in return. Dolls that do make claims, those with religious or ritual significance, have power and are not considered play dolls. A doll representing the baby Jesus (to take an example from Western culture) demands a certain respect, even veneration, from whoever encounters it.

It seems that children begin to understand at about the age of 12 months that miniature objects which are given to them as toys relate to full-size objects in the real world. By the age of two years they are ready for dolls. Having learned to co-ordinate their skills of seeing and moving, children proceed to practise social skills with their dolls.

There are no correct routines to follow; nonetheless, adults often try to prescribe them. In 1804

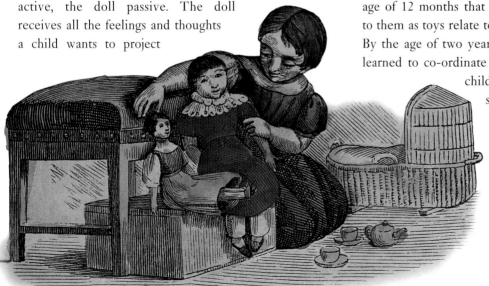

Like the child, the doll learns the basic skills of sleeping and eating. Illustration by Otto Speckter in W. Hey's *Fünfzig Fabeln für Kinder* (about 1833).

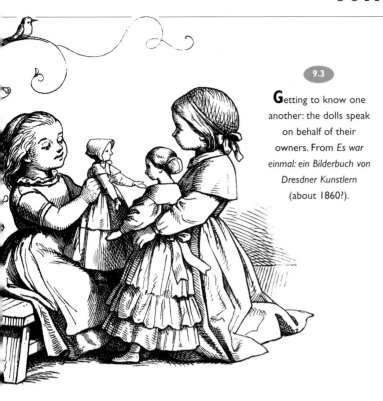

9.3 **G**etting to know one another: the dolls speak on behalf of their owners. From *Es war einmal: ein Bilderbuch von Dresdner Kunstlern* (about 1860?).

9.4

Like children, dolls take instruction. 'The Lesson' by I. Topham. Illustration in *The Chummy Book* (10th Year).

Mrs Fenwick, in *Presents for good girls*, urged every girl, when playing with dolls, to 'imitate the gentle and affectionate duties of her mother', and claimed that this was 'the foundation of habits of regularity and industry'. When modern developmental psychologists set up experiments involving doll play, they usually have preconceived notions about how children should relate correctly to the dolls.

Dolls may be very elaborate, but these are best for older children. Infants need simple, cuddly dolls. Oddly, the toy industry has rarely bothered to provide these. Hilary Page, the pioneer of developmental play, did try to market a doll for one-and-a-half to three year-olds, 'but the trade did not take very kindly' to it. Since it was 'made from sail-cloth and tightly stuffed with a hygienic water-repellent filling … double hand-sewn with nylon thread … absolutely indestructible', it may have lacked charm. Perhaps even play dolls are not entirely passive, but benefit from some kind of personality.

9.5 **T**he doll learns to walk. Illustration by Otto Speckter in W. Hey's *One hundred picture fables* (c.1877).

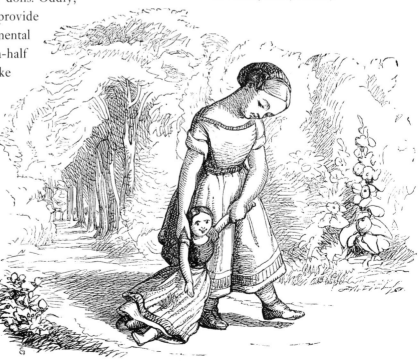

—10—
MOVABLE TOYS

A motionless toy, like a doll or a teddy, can please the senses and stimulate the imagination, but a toy that moves is much more fascinating. The more varied and long-lasting the movement, the more fascination, especially for the child who instigates this movement. Even dolls or teddies, if articulated, can be moved to the extent that they assume varied poses, like artists' lay figures. Children like their anthropomorphic toys at least to be able to sit down or stand up.

10.1

Jacob's Ladder toy. Made in Germany in the later 19th century.

More interestingly, toys on wheels can move along with children, keeping them company. Furthermore, the motion of the wheels can be made to impart motion to other parts of the toys. By placing the axles on a bias an irregular or sinuous movement can be produced, which is amusing if applied to toy animals like crocodiles or caterpillars. The turning wheels might touch cogs which then produce movement in another direction, as when the occupants of a toy train jump up and turn around as it trundles along. Toys of this kind are found in the earliest German catalogues at the beginning of the 19th century, and have been made, with many variations, ever since. It is only a small step from this to simple mechanical toys, worked by turning a handle on the end of a crankshaft (see section 51).

This section deals with toys in which a straightforward, repetitive movement is caused by a very simple movement from a child. Such elementary toys appeal to small children, and might be expected to bore more sophisticated beings. However, they seem to provide inexhaustible interest to adults too.

For some, the main motive force needed is gravity. All the child has to do is to move the toy enough for gravity to

do the rest. The tumbler-doll is an example: a figure whose lower extremity is a weighted hemisphere. If pushed over, it rolls back upright. There are other tumbler figures who somersault down a slope. Their bodies are a closed tube containing a spherical weight, perhaps a marble. If, when the toy is laid on a slope, the marble is at the top of the tube, it will run down to the bottom and the tube will flip over. The process then repeats itself. The tube can be made into a manikin by sticking on a face, hat, arms and legs, made of felt or other flexible cloth. A more sophisticated version of this toy consists of two manikins clutching parallel bars. The bars contain the moving weights, and when the whole contrivance is put on a slope, or perhaps steps, the two manikins jump over and over each other. Early 19th-century versions of these survive, using mercury for weights.

Another gravity toy is a ladder, on the top of which a double slotted block is placed. This block, which can be shaped as a manikin, falls from rung to rung: gripping a rung, turning over, falling

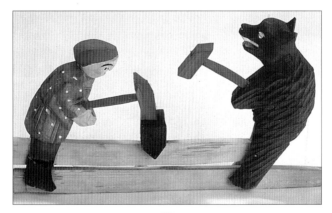

10.2

A 'tit-for-tat' toy from Russia, of fairly recent date.

10.3

from the rung, and gripping the next below. Similar but more puzzling is the 'Jacob's Ladder', a series of slats attached to each other by ribbons. The ribbons are interfolded in such a way that when the series is held upright the slats turn over successively, giving the impression that the whole series has made a somersaulting descent.

Gravity, combined with some directional movement on the child's part, governs toys activated by a hanging weight. The classic example is the 'pecking birds' toy. This can be a single bird, with articulated neck and tail, held in balance by strings attached to a weight. If the bird is moved so that the weight swings around, the head and tail will twitch up and down alternately. With three birds, or other figures, each with a moving part, the toy has to be moved so that the weight swings round in a circle, thus activating each bird in turn.

Not dissimilar is the balance toy in which toy and weight are connected by a rigid wire. The toy appears to perch magically on a pin-point, but it is the weight below which holds it stable. Wire features again in a toy which is basically a pierced bead on a vertical wire. If the bead were dropped from the top of the wire, it would fall straight to the bottom, meeting minimal resistance.

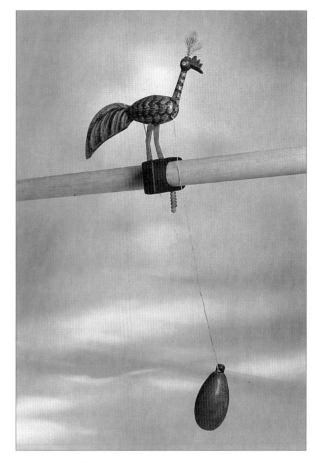

10.3

Pecking birds. The date and place of origin of this folk toy are not known.

10.4

Tumblers. Weighted by mercury, these were made in Germany in about 1850.

10.5

Pecking bird. A 19th- or 20th-century German toy, perhaps from the Grödnertal.

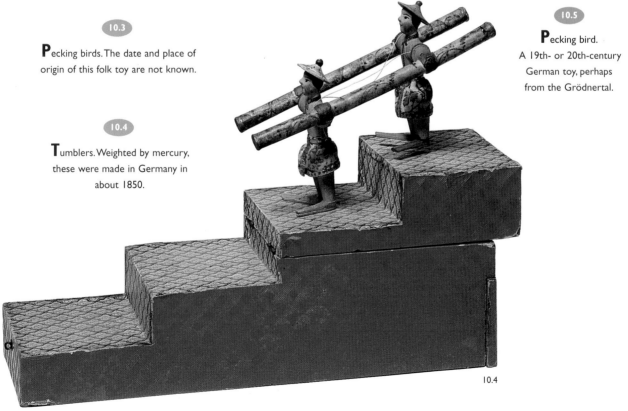

10.4

By turning the bead into a bird with the addition of beak and feathers, more air resistance is created. If the wire is twanged so that it oscillates around the vertical, the bead's progress downwards is hampered and the bird seems to flutter down. Simple physics can be learned from toys like these.

The bird fluttering down the wire may not seem so very different from the monkey that climbs a string. But the monkey is defying gravity, and is able to do so (with the benefit of hidden pulleys and springs) because human energy is providing a motive force. Other toys which are moved by human force include the 'Pantin', or Jumping Jack, a figure with articulated limbs which move spasmodically if you pull a string. These toys were extremely popular in France in 1746, but they were known earlier. They work by leverage, as do the monkey or acrobat on a stick (really two sticks connecting with a jointed figure) and the push-pull toys (two sticks with two rigid figures). These combine two opposed figures in endless 'tit-for-tat' altercation. The performance of the figure on a stick is similar to that of torsion acrobats: those whose arms are linked to an H-shaped frame by twisted string. When the lower end of the frame is pressed, the string straightens and tosses the acrobat around. Movable toys like these turn up all over the world.

Toy historians might well wonder if these are archetypal toys which humankind will always make anywhere, drawing from deep springs of human invention. There is no sure answer to this, as the origins of toys have never been fully investigated.

10.6

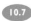

Jumping Jack. These toys were made with many elegant variations in traditional German toymaking regions. This rather lumpy version seems peculiar to England. Several like it are known in other museums.

10.7

Balancing fisherman, made by the contemporary toymaker, Tony Mann.

10.6

10.7

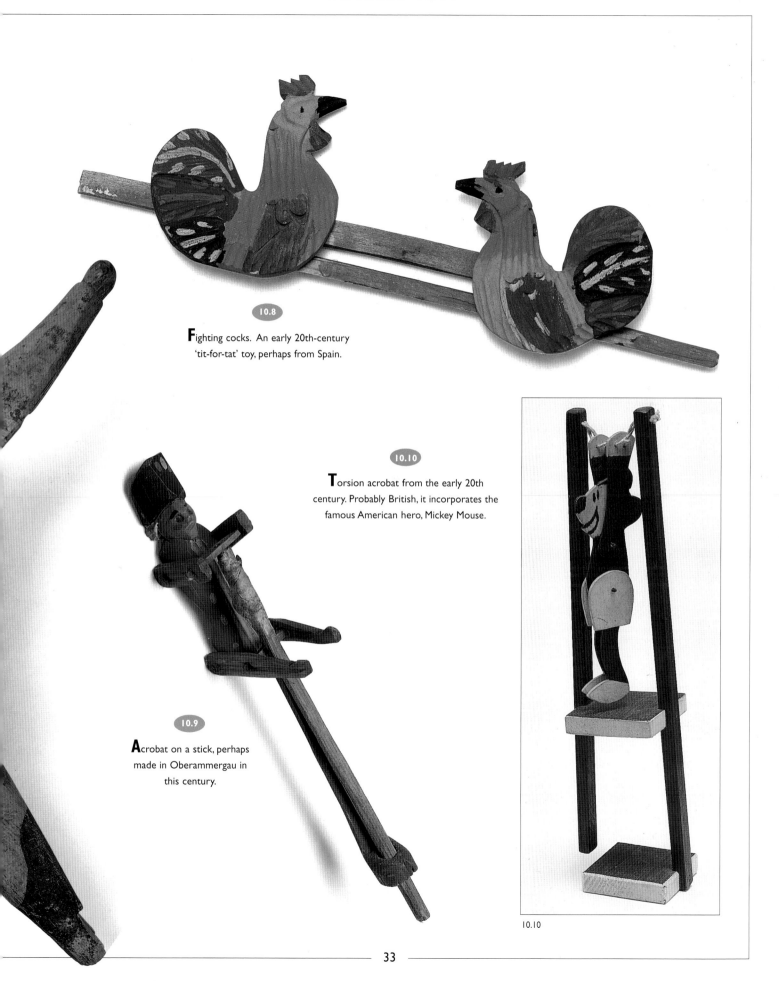

10.8

Fighting cocks. An early 20th-century 'tit-for-tat' toy, perhaps from Spain.

10.10

Torsion acrobat from the early 20th century. Probably British, it incorporates the famous American hero, Mickey Mouse.

10.9

Acrobat on a stick, perhaps made in Oberammergau in this century.

10.10

— 11 —
SOFT TOYS

Soft, cuddly toys are to us a basic need for infants, but such toys have not easily survived from the past because cloth soon wears away. The history of soft toys seems a short one. In a very few places, where the climate is right, old cloth items have survived in burial sites, for example in Egypt, from the 8th century, and in Chile from the 13th-15th centuries. So there is evidence that rag dolls existed in the remote past, and there is some mention of them in Europe in later centuries, but it is almost impossible to find one dating from before about 1850.

11.1

Steiff monkey, dating from about 1910.

Whether soft fabrics have always provided a tender sensation for human beings is perhaps doubtful. One indicator might be the level of domestic comfort that has been available throughout history. Historians have often said that there was no comfort for anyone in the Middle Ages, and the poor have always slept and sat on hard surfaces, wearing rough clothes. It was the rich who, gradually over the centuries, got downy beds, cushions, carpets, curtains, and soft fabrics next to the skin. What you do not know, you do not miss, so is there any reason to think that a poor medieval child, in a hard, rough world, would not have been satisfied with a hard, rigid, wooden doll?

It was in the 19th century that the upholstery of furniture reached its most luxurious level of bulging softness, so it is no surprise that at this time soft toys began to be made successfully as commercial products.

Though cloth dolls had been produced in England and America from the 1850s onwards, the invention of cuddly toy animals is usually ascribed to Margarete Steiff (1847-1909). A dressmaker in the South German town of Giengen, not far from Ulm, she made a felt pincushion in the form of an elephant and found that it was pounced on by children and parents as

a toy. So she made more. Other members of her family came in on the business, which quickly developed a worldwide trade.

Margarete's nephew Richard seems to have made the main contribution to the design of the toys. As with dressmaking, so with soft toys: it is the cloth and the cut that matter. Steiff toys were made of felt and mohair plush cloth, and eventually of the various synthetic furs that have become available during this century.

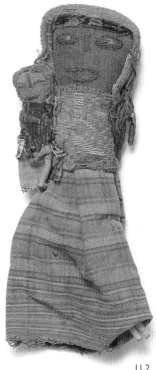

They were noticeably pert and jaunty in silhouette and posture. Richard Steiff might have picked up this slightly satirical style (especially striking in Steiff dolls, but also in their animals) from German artistic toymakers of the time (see section 40), though most of them worked in wood. The Steiff firm showed their wares alongside these artists' work at exhibitions and fairs. Indeed, Steiff became famous for large-scale tableaux of soft dolls arranged by the painter Albert Schlopsnies, who joined the firm as an artistic adviser in 1910. Schlopsnies believed that 'nothing gives children more fun than a certain naive humour in the representation of animals and people'. Whether or not this is so, the Steiff firm has retained its style, which even now keeps it at the forefront of the soft toy business.

11.2

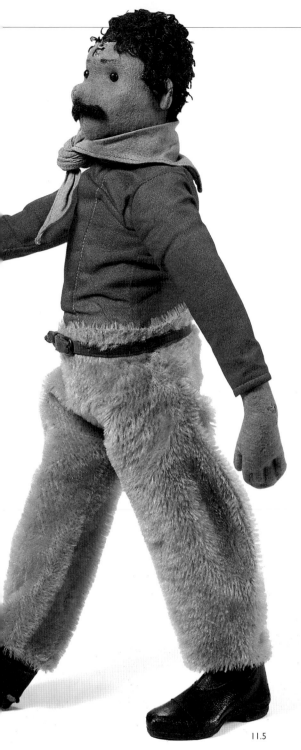

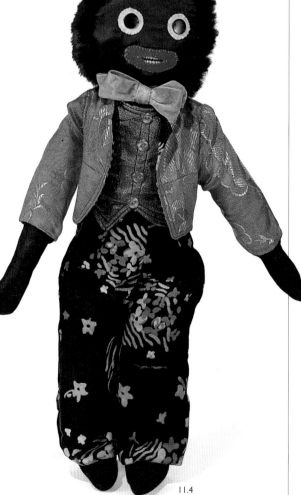

11.3

A beige velvet bulldog made by Chad Valley, 1930.

11.5

Steiff 'character' doll: a Mexican cowboy, first produced in 1913.

11.4

Golliwogs were among the most popular soft toy characters, inspired by the children's books of Bertha and Florence Upton. This one is home-made, but many were commercially produced. These toys betray a prejudiced view of black people (a view that those who made and played with them were probably not aware of at the time), and are thus out of favour today.

11.5

11.2

Peruvian grave doll. Cloth items, including dolls, survive in some quantity from graves of the original inhabitants of Peru before the Spanish conquest in the early 16th century. Many old cloth fragments have been used in recent times to make dolls in the traditional form, which appeal to the tourist trade. This use of authentic cloth has made it difficult to tell imitation dolls from originals, and so we are not sure if this doll is genuinely old.

11.4

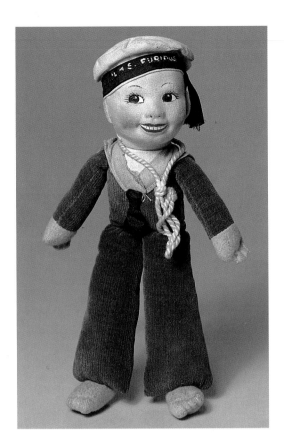

11.6

Among the successful firms who made soft toys in England was that of Norah Wellings, which flourished from 1926 to 1959. Her toys had a cheeky style. Some were aimed at adults, like this sailor, which was a souvenir of a sea voyage.

Not only do today's parents still buy Steiff toys for children, but collectors snap up all the old ones that survive, and cultivate minute expertise ('Jointed bears received five claws on their paws ... until 1905/6, after which they were given only four', is a typical example.)

Soft toy-making soon spread, especially when the First World War cut back German exports. In England in the 1920s, the firms of Dean, Chad Valley and Merrythought emerged as leaders of a group that also included 'Chiltern', 'Fondle', 'Jungle' and many other brands of soft toys. There has always been pressure in the trade to produce more types of animals, both domestic and wild. Nature programmes on TV have greatly increased the range of wild animals suitable for portrayal, and these animals can seem very real if made as glove-puppets and ingeniously manipulated.

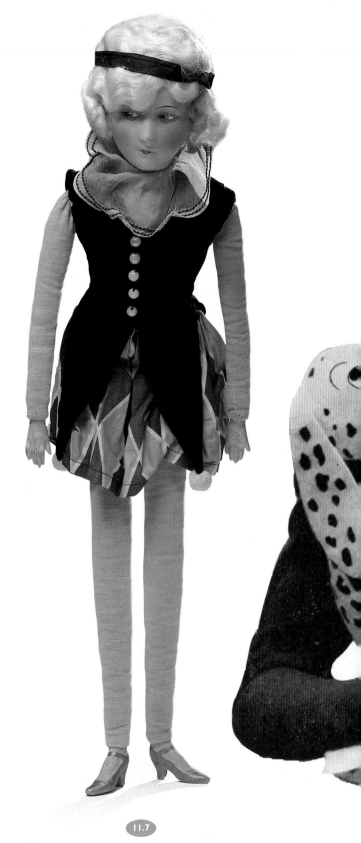

11.7

Boudoir dolls, intended to adorn the rooms of young ladies, were popular in the 1920s and '30s. Many (probably including this one) were made in France.

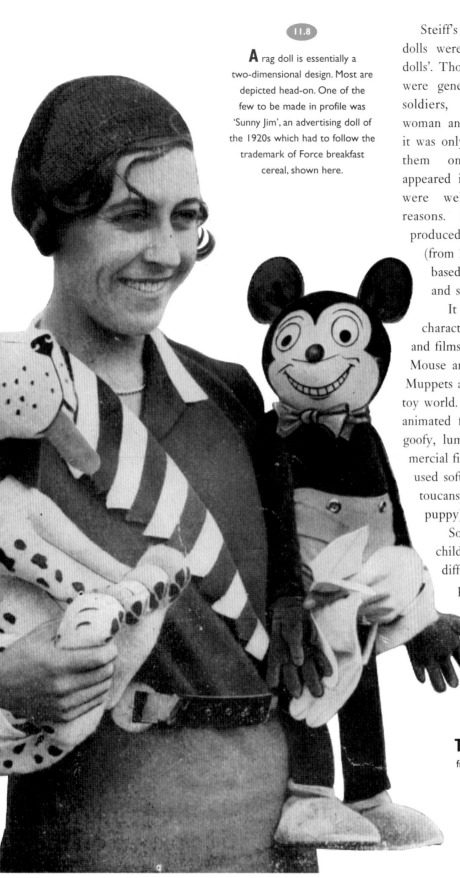

11.8

A rag doll is essentially a two-dimensional design. Most are depicted head-on. One of the few to be made in profile was 'Sunny Jim', an advertising doll of the 1920s which had to follow the trademark of Force breakfast cereal, shown here.

FORCE

11.8

Steiff's slightly caricatured dolls were marketed as 'character dolls'. Though to begin with they were generalized types, such as soldiers, policemen, peasant woman and village schoolmasters, it was only a short step to basing them on characters which appeared in children's books or were well-known for other reasons. Steiff, for instance, produced Struwwelpeter dolls (from 1908), Max and Moritz dolls based on Wilhelm Busch's characters (from 1909), and several based on American characters.

It was no wonder, then, that when cartoon characters achieved fame through newspapers, comics and films, they should be re-created as soft toys. Micky Mouse and friends, Felix the Cat, Bonzo, Snoopy, the Muppets and countless others have moved over into the toy world. In 1996 Walt Disney are launching their 34th animated feature, *The Hunchback of Notre Dame*, with a goofy, lumpy soft doll Quasimodo. Furthermore, commercial firms with little connection with childhood have used soft toys in their advertising: Guinness stout (toy toucans) and Andrex toilet tissue (a cuddly white puppy) are recent examples.

Soft toys have, however, lost ground in the children's market. The manufacture of them is difficult to automate, since sewing is involved, and production has tended to shift to the Far East. On the other hand, soft toys are increasingly successful in the gift market, where they appeal to adults.

11.9

Three celebrated characters. In this photograph from 1930, the famous air-pilot, Amy Johnson, is holding soft toys of Micky Mouse and Dismal Desmond as her mascots.

—12—

TEDDY BEARS

The teddy bear is one of the few toys we know to have been invented at a precise moment. This is the story. The American President Theodore Roosevelt took a hunting trip to shoot bears in December 1902, but found no prey except for one small bear-cub, which he scorned to kill. This moment was captured in a newspaper cartoon, and 'Teddy' Roosevelt became associated (for years afterwards) with bears. Toy makers spotted a marketing opportunity, and in 1903 the 'teddy bear' toy was born. The first teddy-maker might have been Morris Michtom, owner of a small-time novelty shop in Brooklyn, New York. Or it might have been the German firm, Steiff (see section 11) which in 1903 accepted from America a big order for toy bears. It does not much matter who was first: what does matter is that teddies were soon all the rage.

12.1

German teddy bear, dating from about 1910. He is suffering slightly from 'teddy's slump', as his stuffing has evidently moved about and left his skin loose.

Real bears are not naturally friendly. So, though many children, up to the present century, must have seen dancing bears as a street entertainment, they probably would not have wanted to get close to a bear. What was it that made teddy bears acceptable in the nursery?

Part of the answer is that bears had a foothold in children's literature before they were known as a toy. The story of *Goldilocks and the Three Bears* introduced to young children a group of bears which lived in a domesticated setting, though they were meant to be scary. The story is, oddly enough, one of the few fairy tales to have an exact date. It was first put into print by the poet Robert Southey, in his essay series *The Doctor*, in 1837. (It probably had an earlier origin in folklore.) This story was often illustrated, and in Harrison Weir's representation of the bears in an edition published by Joseph Cundall in 1850, we can see the spitting image of the cuddly bear half a century before the toy was invented.

While the image of the bear had thus been softened for children, the toy itself must have had powerfully appealing qualities. It looks human, since it stands upright with arms and legs, and it is soft and cuddly. On the other hand, it differs from humans and offers a child an allegiance independent of the world ruled by adults.

The bear's 'dual nationality' is well illustrated in the incident which is said to have sparked off A.A. Milne's Winnie the Pooh stories. Milne's son Christopher Robin made a rude personal remark about a visitor. When reproved, he blamed the discourteous remark on his bear. The bear was human enough to have childish thoughts, but sufficiently inhuman not to have to account for them.

Like dolls, bears can assume many troubles on behalf of children, and it is often said that a bear is a boy's doll. As any student of bear memorabilia knows, however, there are many old photographs of bears in the clutches of little girls. Curiously, the little girls are often lightly clad, and there seems to be some sort of sexual frisson here. Rarely is it exposed nakedly (as in postcards captioned 'Mary and her little bear behind', for example) but it lurks disturbingly, a hint of Beauty and the Beast.

12.2

Small Steiff teddy of about 1920. He still maintains the early shape, with his hump and long arms.

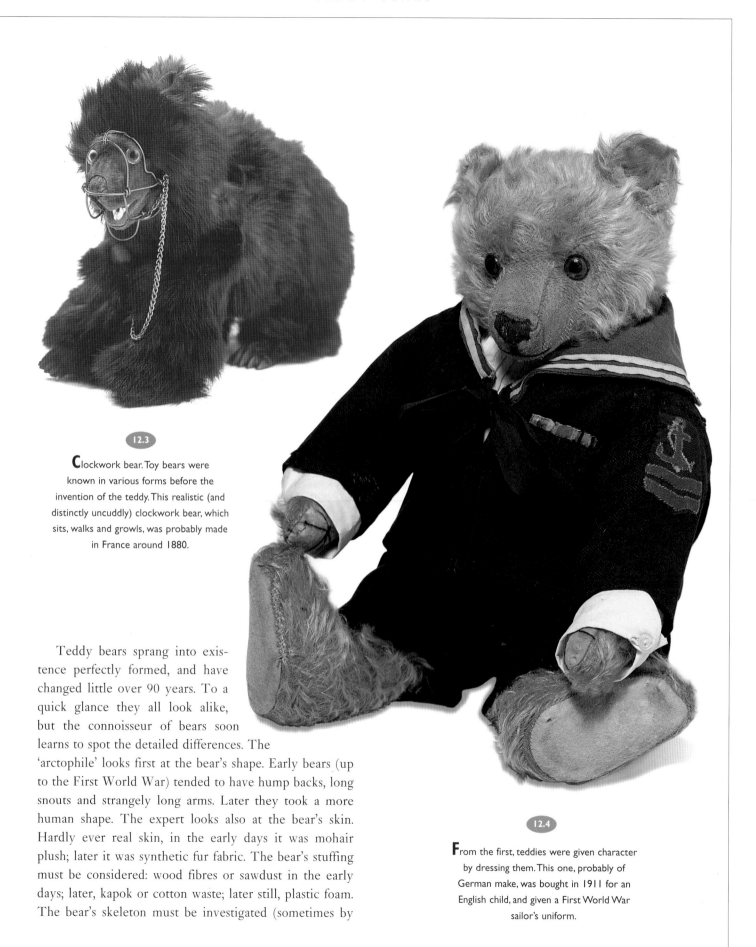

12.3

Clockwork bear. Toy bears were known in various forms before the invention of the teddy. This realistic (and distinctly uncuddly) clockwork bear, which sits, walks and growls, was probably made in France around 1880.

Teddy bears sprang into existence perfectly formed, and have changed little over 90 years. To a quick glance they all look alike, but the connoisseur of bears soon learns to spot the detailed differences. The 'arctophile' looks first at the bear's shape. Early bears (up to the First World War) tended to have hump backs, long snouts and strangely long arms. Later they took a more human shape. The expert looks also at the bear's skin. Hardly ever real skin, in the early days it was mohair plush; later it was synthetic fur fabric. The bear's stuffing must be considered: wood fibres or sawdust in the early days; later, kapok or cotton waste; later still, plastic foam. The bear's skeleton must be investigated (sometimes by

12.4

From the first, teddies were given character by dressing them. This one, probably of German make, was bought in 1911 for an English child, and given a First World War sailor's uniform.

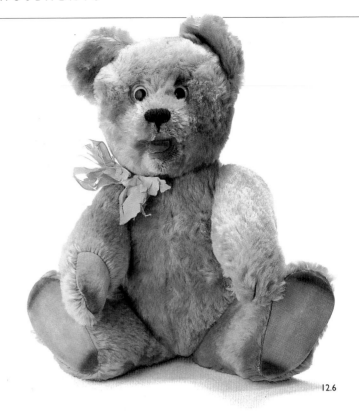

12.6

X-ray): how do the limb joints work, is there a wire frame inside? For obvious reasons, washable bears are usually made without metal parts.

The bear-lover may look at smaller features, such as the shape of the head and the placing of the ears. What are the eyes made of: wooden or metal boot-buttons, or specially made glass eyes? What is the nose made of? Stitching, sealing wax, metal, plastic? How is the mouth represented? This is done usually with stitching, but may take the shape of a curving smile, or a fretful zig-zag. How are the claws indicated (usually by stitching) and what are the pads made of? These tend to wear out quickly and are often replaced during the life of an elderly bear. Finally, are there labels or trademarks (like the Steiff button in the ear) which show who made the bears?

It is extraordinary that a child's toy can inspire such minute study. But bears have become a prized commodity. They broke into the prestigious art auction houses in the 1980s. In 1982 the top price for a bear at Sotheby's was £360. In October 1985 a Steiff bear sold for £3,740. Four years later the Steiff bear 'Happy' was sold to an American collector for £55,000. In 1993 the South Kensington branch of Christie's staged what they claimed was the first ever sale to be entirely devoted to bears. In December 1994 a Japanese businessman bought a Steiff bear for £110,000.

The success of bears in the market reflects a widespread enthusiasm among collectors, as witnessed by their magazines. *Teddy Bear and Friends* emerged from the same American stable as the established *Doll Reader* in 1983, and was followed in America by *Teddy Bear Review* in 1986. In England, *Hugglets Teddy Bear Magazine* started in 1990. In Germany, the established *Puppen und Spielzeug* started a teddy bear section in 1993. These magazines review new products (especially 'artists' bears' and replicas), advertise conventions and fairs (collectors love to get together), and give advice on repair and restoration.

Manufacturers of teddy bears depend on new ideas for putting bears in funny costumes such as Christmas bears, or in amusing tableaux such as the ever-popular picnic. Underneath, however, bears remain resistant to variation. Bears will surely never lose their charm as a children's toy, but can they provide that infinite variety which will ensure that their charms do not grow stale to collectors?

12.5

Young girl and her teddy. One of a series of photographs of a lightly clad girl and her bear. These pictures were widely reproduced, as both postcards and lantern slides.

12.6

Bear made by the German firm, Schuco (see illustration 11.4) in about 1935. His red, open mouth gives him a cantankerous air.

12.8

Two Merrythought bears, made in 1935 (right) and 1976. When the First World War halted German exports, English makers started to produce teddies. W.J. Terry and J.K. Farnell were among the pioneers. In the 1930s, the soft toy firms such as Chad Valley, Deans, and Merrythought made bears.

A bear for the future? This contemporary toy bear with built-in musical box (musical and growling teddies have been around from the beginning) is not furry, but made of other attractively coloured and textured fabrics. It is produced by Westfalenstoffe of Münster, Germany.

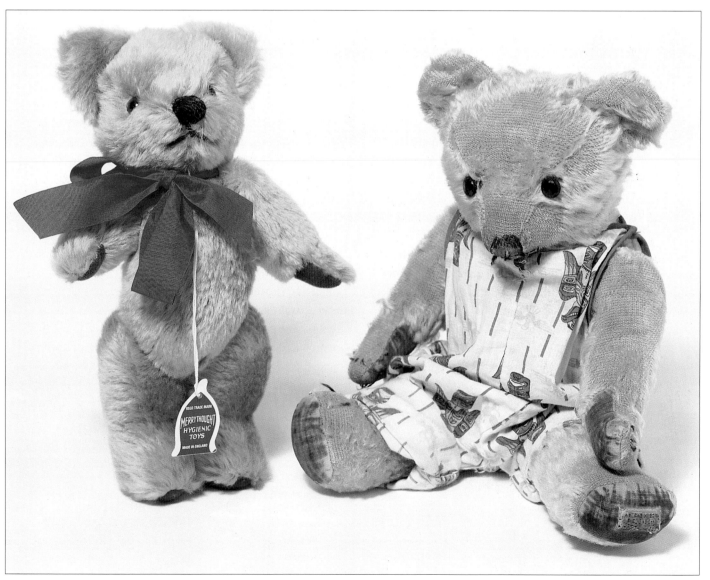

—13—

BLOCK TOYS

Building bricks - now generally known as blocks, following American usage - have achieved great prestige with educationists. Many think that blocks are the fundamental toy, which a child must have above all others. Observation shows that children can begin to do things with them towards the end of their second year, and as they learn to do more complicated things, they continue to use them up to the age of about eight. There is an easy transition from simple blocks to more ambitious forms of constructional toy.

13.1

Mid-19th century set of geometrical blocks. This has quite complicated diagrams of how to make the blocks up into buildings.

Very small children seem to get as much fun from knocking blocks down as from piling them up, but this has not interested researchers nearly so much as constructive activity with blocks. It seems reasonable to assume that any children anywhere might have fun piling small things, one upon another, to make bigger things. There is a famous passage in Robert Roberts's *A Ragged Schooling* (1976) in which he recalls making miniature buildings out of pieces of soap, candles and gas-mantle boxes in his mother's shop.

Once educationists became aware of block play, they started to systematize it. John Locke suggested using cubes with letters of the alphabet on their sides to build words. Alphabet blocks have been around ever since. You cannot do very much with cubes, so another way of making them more interesting is to paste segments of pictures on their sides, so that they become a sort of jigsaw puzzle in three dimensions.

But there are many other shapes besides cubes. It was Friedrich Froebel in the early 19th century who developed a strictly logical system of varied blocks. As a man of the Enlightenment, he believed that the world worked on scientific principles, and he tried to evoke this for children in the second of his series of toys (or 'Gifts'): this was a kind of mobile made of a cube, a sphere and a cylinder. These were to impress the child as archetypal forms. After that, the Gifts presented progressively more complex sets of blocks, each standing in a mathematical relationship to the rest. Playing with these, Froebel claimed, a child 'begins to tread the road of rational analysis'. Thus were children inducted into the tradition of Western rationalism.

Blocks became a commercial success when Richter's Anchor Blocks appeared in about 1878. First produced in Rudolfstadt in Germany, they were made of 'stone' - actually moulded from a kind of cement - and were heavier than wooden blocks. They came in three colours and various shapes which, though abstract and geometrical, could easily be built into quite convincing architectural forms that included arches and columns.

13.2

Alphabet game. A pleasing variation on alphabet blocks, these build up into a little house. Made in England in the mid-19th century.

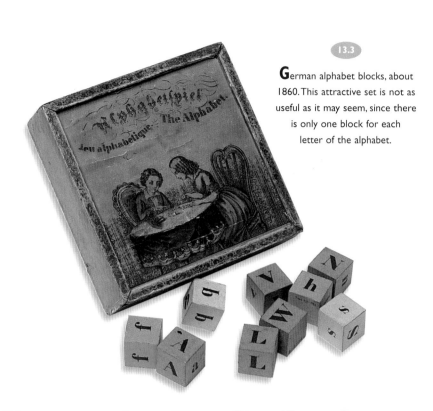

13.3

German alphabet blocks, about 1860. This attractive set is not as useful as it may seem, since there is only one block for each letter of the alphabet.

DR. RICHTER'S PUBLISHING OFFICE, LONDON E.C.
1 & 2, RAILWAY PLACE, FENCHURCH STREET.

13.4

Catalogue from Dr Richter's English branch. Richter exported Anchor blocks energetically. This catalogue contained testimonials from all over the world.

Anchor blocks, which can only be fitted into their boxes one way, are rather coercive, with their complex instructions and elaborate system of progressively supplementary sets.

13.5

Czechoslovakian blocks, 1990. The repertoire of simple block shapes pioneered by Richter has been constantly reproduced, in wood and plastic.

It is no surprise that blocks, abstract and mathematical, appealed to educators and psychologists when they needed toys for experiments with children's play. One of the first to use them was Erik Erikson, who discovered (to the gratification of all Freudians) that boys tended to build tall, phallic constructions while girls made low, rounded, hollow constructions. Educationists claim that blocks allow children to play creatively, but there is a lot of regulation hidden in blocks.

—14—

TOYS AS GIFTS

Toys offer children their first experience of owning something. Clothes might do too, but adults usually buy them for children, and control their use. Toys are more or less under children's control. They can readily feel they own them - especially if another child puts in a bid for ownership. Gradually children learn the economic facts of life, especially if they are made to save up their pocket money, week by week, for some longed-for toy, but to begin with their toys come as gifts, and seem to prove that the universe is benevolent.

Seasonal toys. The Father Christmas and the monster made from fir-cones are from Austria (1938 and 1950s). The prune figures, traditional in Germany, were bought in 1982.

Parents give to children all the time, but there are special occasions when gifts are expected. Christmas is the time when the universe seems most generous with gifts of toys. Seasonal gifts were given at the Roman Saturnalia in December, and the Wise Men brought gifts to Jesus, so there is no lack of precedents for Christmas presents. Perhaps, though, the custom of giving gifts to children on December 6, the day of St Nicholas, the children's saint, helped as well. This custom could be double-edged. In Jan Steen's painting of St Nicholas's Day in mid-17th century Holland, a good girl has received a doll, but a naughty boy has been given a birch - a symbolic punishment. It took some time before Christmas presents could be given for their own sake, without reference to a moral balance sheet.

For a long time, the Christmas gift-giver, who gradually turned into Santa Claus or Father Christmas, gave token presents: gingerbread, apples, nuts. But by the mid-19th century we find everywhere the now conventional representation of the old man with a

What ever happens - the children will have their Christmas Toys!

THERE ARE OVER 5000 SAMPLES IN OUR SHOW-ROOMS FROM WHICH TO MAKE YOUR SELECTION

BEDINGTON, LIDDIATT & CO. (1920) LIMITED,
16/18 BAYER STREET, GOLDEN LANE,
LONDON, E.C.1.

14.2

Advertisement of 1940. While Britain was at war with Germany, no German toys were imported. British toy dealers hastened to assure their customers that the supply of Christmas toys would not dry up.

basket or sack full of toys. Christmas became the time when the toy industry made most of its sales. Special Christmas markets, with stalls full of colourful toys, became customary in Germany, and still are, while in London the penny-toy sellers clustered on the pavements of Ludgate Hill. At some point over Christmas, there was a climactic point when children got all their presents together. In Germany, they found their toys round the Christmas tree on Christmas Eve; in England they woke on Christmas morning to find them in a stocking or, if they were lucky, a pillow-case.

Nowadays birthdays are also a high-spot for toy consumption, but this is a more recent development. In 1846, little Augustus Hare got a wreath of snowdrops and a special pudding for his birthday. In 1890 Gwen Raverat gave her cousin a penny stick of chocolate for his birthday. An 80 year-old middle-class woman, interviewed in 1974, recalled: 'Oh yes, we had Christmas and birthday presents but of course not toys like children have today. Not the endless toys.' More research is needed on the

place of gifts - and hence of conspicuous consumption - in the life of the child.

When children receive presents today, they are always gift-wrapped. Indeed, tearing off the fancy paper is half the fun, yet this is another topic little researched. There seems no evidence that presents were specially parcelled up in the 19th century - though in the 1820s Alexander Herzen received 'an expensive toy wrapped up in a napkin'. The origin of gift-wrapping may have been in the wrappings and boxes used for bon-bons and pastries: these were certainly used in the 19th, even the 18th, century, and bon-bons developed into the Christmas cracker. But when did the coloured paper and fancy ribbon now available in every little stationer's arrive?

From the start, very small toys, like toy soldiers, tended to come in boxes, but bigger toys were sold unpackaged. This was the chief charm of a toy shop: you saw what you were getting. Now most toys are packaged, and one significant moment in the rise of packaging must have been the 1950s when transparent acetate film came into use: a panel of this in a package still allowed a child to see the toy inside. Packaging is important to toy museums and collectors because it provides visual documentation.

14.4

French postcard of 1903. In France children often believed that Christmas presents were brought by the Christ Child or an angel. Like Santa Claus, he would come down the chimney, and children would leave their shoes by the fire to act as receptacles for the presents. This little girl is praying to 'O cher petit Noël' to forgive her naughtiness and for 'beaucoup de joujoux'.

14.3

Father Christmas, with a sizable load of toys, depicted in a late 19th-century scrap. Many images of this kind show Father Christmas armed with a birch, in case he has to deal with bad children. He has not brought it with him in this illustration, but he still has an admonitory air.

—15—

TOYSHOPS

Engraving (first published 1632) from Jacob Cats, *Alle de wercken*, 1736.

To visit a toyshop is one of childhood's most exquisite experiences. The sheer quantity of toys, covering the walls, hanging from the ceiling, stacked on the floor, seems to promise infinite enjoyment. Modern toy supermarkets, like those of Toys R Us, could threaten to overwhelm their customers with superfluity, but children are almost insatiable. The experience of conspicuous toy consumption, however, has only been available for about a century. Many country children had to buy toys from the small range carried by pedlars (see 18.1), and before the early 19th century it would have been hard to find even a tiny toyshop. But since then, toy retailing has grown to an ever larger scale.

What is probably the earliest picture of a toyseller shows not a shop but a stall (15.1). It illustrates a moralizing poem of 1632 by the Dutch poet Jacob Cats, in which he warns his readers, in verse and pictures, against the wicked pleasures of the world. Presumably his illustrator has tried to give an accurate picture of the pleasure of toys, which is so tempting to the little girl. Throughout Europe at this time most retailing was carried on at markets (see section 47). An illustration of a German market in J.B. Basedow's *Elementarwerk* (1774), shows a toyseller surrounded by stalls selling other products. For German children nothing could match the traditional Christmas markets, which were (and still are) full of toys, decorations and food. Toy stalls would, however, be found in all countries: illustrations of French and Danish examples are known.

Toyshops begin to be mentioned in the early 18th century, but at that time 'toy' meant 'a thing of little value' rather than a children's plaything. So such shops would be selling knick-knacks and trifles. Gradually, though, children's toys crept into their stock. There is a

convincing illustration of an English toyshop (15.2) in Lady Fenn's book *Cobwebs to catch flies* (1783). This contains improving dialogues for children about various subjects, and sets one in a toyshop. The boy is saying 'I will have a gun. No, I will have this dog. May I not have both?' A similar toyshop is shown in a book called *The Toy-Shop*, first published by John Newbery in 1787 (15.4). These early illustrations reveal what were the popular toys of the time: dolls, of course, musical instruments, hobby-horses, guns, bows and arrows, kites, and all sorts of toy animals. Towards the end of the 18th century, we begin to find trade cards (advertisements) for real toyshops, such as Au Singe Violet in the Rue St Honoré in Paris or the aptly named Coles Child shop on London Bridge.

It is tantalizing to see these toyshops only in black and white, but coloured pictures arrive in the 19th century. The picture of the London Toy Warehouse (15.3), with its affable proprietor, comes from a Dean's Toy Book (see section 20) of about 1852. From this time also come pictures of toyshops in scenery for toy theatres

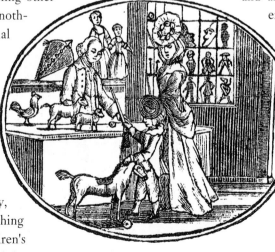

Wood-engraving from Lady Fenn's *Cobwebs to catch flies* (1783).

15.3

15.3

Hand-coloured wood-engraving from
Wonders of a toy-shop, published by Dean
of London in about 1852.

15.4

Wood-engraving illustrating
The Toy-Shop (first published 1787)
in an edition published by F. Skill
of Swaffham in 1830.

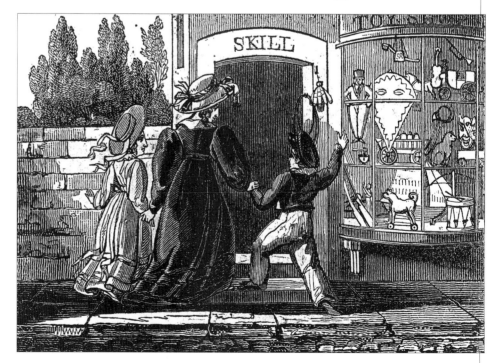

15.5

Illustration from *Games and Toys*,
December 1925.

(see section 48). Pantomimes (Harlequinades) usually included a chase through the London streets, and all sorts of shops were pictured in the scenery, including toyshops. Another piece of toy theatre scenery (15.6) shows the interior of such a shop. These shops had windows with small panes of glass, in the Georgian style, and it looks as if the shopkeepers (or at any rate the illustrators) went to some trouble to fit the toys neatly into the grid of glazing bars. This is the kind of window against which the young Charles Lamb, Charles Dickens or Benjamin Disraeli might have pressed his nose.

Shops got larger in the 19th century, and their window displays became more impressive as plate glass came in. In the later 19th century, London children would have made a beeline for W.& F. Hamley's Noah's Ark Toy Warehouse in High Holborn (Hamleys, founded in 1760, are still trading), or perhaps Cremer's of Regent Street, Morrell's of the Burlington Arcade, J.S.Theobald and Co. at the West End Conjuring and Model Manufactory in Kensington Church Street, or W. Stevens's Model Dockyard in Aldgate. In Paris they would visit Le Paradis des Enfants or Le Nain Bleu (which still exists) in the Rue de Rivoli. 15.7 shows an advertisement for the Nuremberg toyseller, C.F.Rau. These shops catered for the luxury end of the toy market, for prosperous families.

15.6
Toy theatre sheet, Scene 13, no.15,
for *Harlequin St George*, published
by J.Green in 1847.

15.7
Advertising broadside published
by C.F.Rau, Nuremberg,
mid-19th century.

Smaller toy traders might work through bazaars - these were full-time commercial bazaars rather than the charity bazaars set up on special occasions by aristocratic ladies. The Soho Bazaar, which ran from 1816-85 in Soho Square, the Crystal Palace Bazaar in Oxford Street (1858-89), and the German Fair (known also as the German Bazaar, or Portland Bazaar) in Langham Place are good examples. These were precursors of the department stores, like Gamages, which also had toy departments. The great department stores of Paris, from the Bon Marché (1852) to the Galeries Lafayette (1895) used to issue illustrated gift catalogues each Christmas and New Year (*Etrennes*), which are now important documents for toy historians. The Christmas issues of late 19th-century illustrated magazines in each country are also a good source of advertisements. The supreme toy bazaar in London was the Lowther Arcade: not really a bazaar, in

fact, but two rows of small lock-up shops facing each other across a covered passage. By the 1860s almost all were taken by toy dealers, whose wares overflowed into the passage, making a wonderland for children. The Arcade closed in 1902.

Right into the 20th century, streetsellers remained an important source of toys, just as they had been in the 17th century (see 35.1). In London at Christmas the pavements of Ludgate Hill were crowded with penny toy sellers, with trays slung from their necks. Many would have made their flimsy toys at home. But now there were also large import firms specializing in toys, which came mostly from Germany until the two world wars. The illustration of Kleiner's of Houndsditch (15.5) shows a scene of frenzied activity. Today, toy retailers tend to be at the mercy of huge international suppliers, and it is difficult to run a traditional toyshop.

—16—

PICTURES FOR CHILDREN

Small children understand pictures better than words. Today the world is saturated with images, infinitely multiplied by printing, photography, and by the media of film, television and video. Six hundred years ago there was no way of producing multiple copies of pictures, so neither child nor adult would have seen many pictures in their lifetime. They may perhaps have only seen stained-glass images and wall-paintings, in churches. Then, in the early 15th century, the printing of pictures from carved wooden blocks was invented. A half-century later, engraved metal plates began to be used.

16.1

Scene from a Munich Bilderbogen strip narrative, *Die Wunderbare Bärenjagd* (The Wonderful Bear-hunt) by the greatest artist to work on children's prints, Wilhelm Busch.

Thus printed pictures began to circulate, but it was a long time before they were produced specially for children. At first, many of the woodcuts or engravings were of religious subjects: no doubt children learned to recognize these. Artists naturally used the new techniques, so some prints were recognized as works of art while, alongside them, cheaper and cruder prints were published for popular consumption.

By the 17th century, there was a varied range of popular imagery. Some of it continued to be religious. Some represented news items, showing shooting stars, earthquakes, monsters, prodigious births. Other images were political: the Reformation in Germany, for example, let loose a shower of pictorial satire. Many themes constantly recurred: courtship, peasant festivals, variations on the battle-of-the-sexes theme (such as 'Who wears the trousers?'), and the paradoxical notion of 'the world upside down'. A picture-hungry child of the 17th and 18th centuries would be familiar with all of these.

Such imagery was not folk art in the sense of being made by ordinary people (on the contrary, it was made by shrewd printers in towns), but it was aimed at ordinary people. Certain printers specialized in it. In north-eastern France, for instance, the Pellerin family ran a print workshop in the town of Epinal. They supported Napoleon, and the Revolutionary and Napoleonic periods gave them plenty of opportunity to produce political prints. By the mid-19th century, however, after the

16.2

restoration of the French monarchy, new laws restricted trade in these prints so they turned to a new market: children. Other print makers followed.

Some of the old themes, such as depictions of saints (especially the children's saint, St Nicholas, who was also the local saint for the Epinal area) and that of 'the world upside down' were suitable for children. Many moralizing prints were produced too, showing in quite grisly terms what would happen to naughty children. But above all, the Pellerin firm turned out fairy tales and stories. Popular prints had varied in size and layout hitherto, but children's prints tended towards standardization. They were usually strip narratives with about 20 frames on an A3-size sheet. They had previously been printed from wood blocks, but lithography took over in the late 19th century. Colouring was still applied, through stencils, by hand - often by children.

French printmaking for children also flourished in Metz and Pont-à-Mousson, near Epinal, and later in Paris where the publisher Quantin recruited higher-quality illustrators. In Germany, the towns of Stuttgart, Neuruppin and Esslingen had many printmakers, but the best-known were Braun and Schneider of Munich, who produced a long series under the name 'Münchener Bilderbogen'. Some of the best German illustrators contributed to this series, and it also launched the career of a young artist who became an important caricaturist, Wilhelm Busch. This body of imagery for children was not matched in England, though Pellerin did produce English-language versions for export to America. By the 20th century, picture books and then comics superseded the prints, and they died out. Collectors and museums, however, have documented them very thoroughly.

There is no specifically childish artistic style to be found in children's prints, which use whatever styles came naturally to the artists. It could be argued, though, that in 20th-century graphics for children, particularly in comics and in Walt Disney animations, there is a distinct childish idiom. For here comic artists, in their depiction of human (or pseudo-human) figures, habitually resort to the proportions of babies: big heads, long fat bodies, stubby limbs and snub features.

The Munich Bilderbogen often adopted the strip layout, but sometimes a designer would fill a whole sheet with a more complex design. This Grimm fairy tale, *The Frog Prince*, was designed by Otto Speckter.

Children's print from Epinal. The strip narrative in frames is typical, as is the subject, *'The Consequences of Disobedience'*.

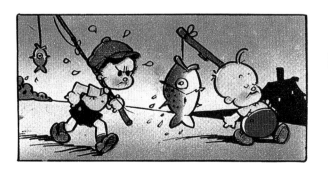

Baby-faced and baby-bodied comic figures, from the 'Bobby and Chip' strip in *Mickey Mouse's Weekly*, 2 November 1940.

— 17 —

PICTURES BY CHILDREN

Woodcut by a pupil of Franz Cizek, 1919, showing something of the prevailing Art Nouveau style.

For many centuries no-one regarded children's drawings as anything other than botched attempts at what adults did better. It is almost impossible to know for sure what children's drawings looked like before the 19th century, because it seems that nobody kept any. Occasionally an artist might depict a small child holding its own drawing: reassuringly, such drawings seem to show the stick-like figures familiar to us from modern children's drawings. One might expect that the youthful work of artists who later became famous might have been treasured. But there is not much of it (although there are examples by Millais, Rossetti and Toulouse-Lautrec), and one cannot help valuing it according to how nearly it approaches the artists' more mature accomplishment.

The idea that the marks made by a very young child are interesting emerged only towards the end of the 19th century, as a result of the 'Child Study' movement, in which psychologists, following the lead of Taine and Darwin, began to investigate how babies learned.

Corrado Ricci's *L'arte dei bambini* (1887) and Bernard Perez's *L'art et la poésie chez l'enfant* (1888) opened up the subject. When James Sully's classic *Studies of childhood* appeared in 1896, child art was seen to be firmly on his agenda (chapters ix, x), and was signalled on the front cover of the binding by a reproduction of an infant's crude drawing. In Hamburg, Alfred Lichtwark at the Kunsthalle was the first to put on an exhibition of child art, in 1898. Ever since, psychologists and educationists have observed and analyzed children's drawings as evidence of their mental development.

Some people, notably artists like Rodolphe Töpffer in Switzerland and writers like Baudelaire and Gautier in France, were ahead of the psychologists in their interest in child art. Even in the 1840s and '50s they were praising child art for its aesthetic qualities. Its simplicity and directness showed, they thought,

a purity of perception not yet staled by conventionality. In pursuit of such fresh insight, many artists throughout the 20th century have turned to 'primitivism', drawing inspiration from the art of peasants, 'savages', the mad - and from children.

The interest in children's art fed into art teaching, which now tried to encourage children's free expression rather than to give them a strict training in conventional drawing methods. The pioneer here was Franz Cizek, who conducted children's classes in Vienna from 1897 to 1934. He regarded 'the child as a being with laws of his own, eternal laws perhaps closer to nature than those innumerable compromises, if not illusions, which dominate the world of the adult'. Through exhibitions of his pupils' work he gained a worldwide reputation, and generations of English art teachers, from early figures like Marion Richardson onwards, took inspiration from him.

Everywhere today, children's art is encouraged - in schools and at workshops held in places like the Bethnal Green Museum of Childhood. It is salutary to remember that its value was only so recently recognized.

17.2

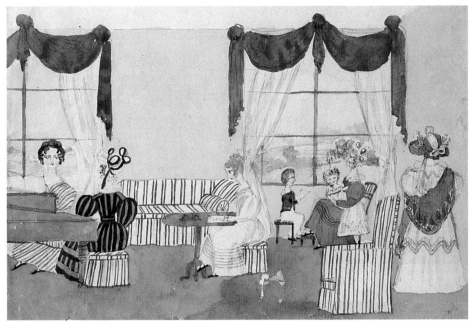

17.3

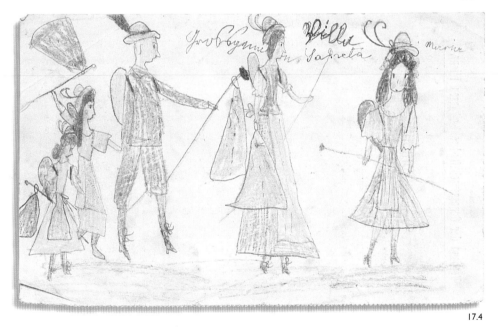

17.4

17.5

17.5

Drawing by Margarete Hamerschlag, made a few years later than 17.4. Margarete attended Franz Cizek's drawing classes, and became an artist and art teacher in later life.

17.2

How children drew in 1854: a true insight recorded in jest. Henry Cole (first director of the V&A) set up Britain's first system of art education. In 1854 he announced a method of teaching in the classroom, using blackboards and slates. The comic magazine *Punch* responded by showing what children might actually produce.

17.3

Watercolour drawing, dated 29 March 1828, from an album of drawings made by the children of the Drummond family. This one, showing the schoolroom, was done by Cecil-Elizabeth (Cecily) Drummond, aged 14. By this age, she had learned a fair degree of conventional accomplishment. Nonetheless, a child's drawing of this date is a rarity.

17.4

Child's drawing of a family going hiking. This is an early drawing by Margarete Hamerschlag, born in Vienna in 1902. Her father was a doctor, and this drawing is on the back of one of his prescription forms.

—18—
CHAPBOOKS

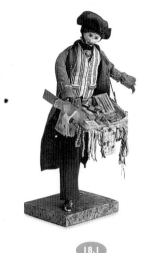

Early 19th-century toy. Toy pedlars of this kind were popular in England.

Children like both pictures and stories, and the most attractive children's literature offers both together. Until the 18th century, there was very little printed material which children could take pleasure in reading. The only book containing stories that they could easily get at was the Bible. If they wanted something more frivolous, they had to share in what was produced for adults: popular literature in the form of ballads or chapbooks.

Ballads were usually printed on a single sheet of paper as *broadsides,* that is on one side only. Buyers could pin them up on a wall, an attractive idea if they contained a picture as they often did. But instead a printer could arrange the text of a story so that single sheets of paper could be folded up to produce little pamphlets of 8 or 16 pages. These also usually included woodcut illustrations.

Both the broadsides and the pamphlets could be sold in bookshops in towns, but were cheap enough to be sold in the countryside at general stores and by the travelling salesmen who carried around boxes of small goods. This was the way of things in most European countries. In England, the hawkers or peddlers were called 'chapmen' so the little pamphlets they sold got the name of chap-books. 'Chap' comes from an old word meaning barter and is related to the word 'cheap'.

During the 17th century in England, the chapbooks which most pleased children were probably jestbooks (collections of riddles and jokes) and romances of chivalry. The romances were the old tales of King Arthur, and of other heroic knights such as Guy of Warwick, Bevis of Southampton, Tom of Lincoln. France, Spain, Germany and Italy all had their own knightly heroes. Such romances, usually very long and often in verse, were going out of fashion in the 16th and 17th centuries, but remained popular in shortened form as chapbooks.

Even when children's books began to be published in the 18th century, the chapbooks continued. There were now more printers to produce them, in the provinces as well as in London, and their range of subject matter grew wider. More material appeared specially for children, such as nursery rhymes, fairy tales and adaptations of books like *Robinson Crusoe*.

The chapbook publishers were chiefly interested in amusing their audience, using rude words when they felt like it. But in the mid-19th century, earnest bodies like the Religious Tract Society produced floods of chapbooks on moral and religious subjects, to try to drive out the more frivolous ones. Cheap newspapers and magazines eventually saw off the chapbooks.

Opposite page: English chapbooks. Top left and right: Two traditional tales, Thomas Hickathrift and Valentine and Orson, dating from the 18th century. Thomas Hickathrift was printed 'in Aldermary Church-yard', the centre of the London chapbook trade. The other chapbook says that it was 'Printed for the Company of Walking Stationers', a joke reference to the travelling chapmen. Both The Trial of an Ox (top centre), printed by Rusher of Banbury, and The Silver Penny (middle centre), by Kendrew of York, appeared in about 1820. These two were the best of English provincial chapbook publishers. The Silver Penny was specially aimed at children, as was Familiar Objects Described (middle left), published at about the same time by Lumsden of Glasgow. The best-known London publisher of chapbooks in the 19th century was James Catnach, who printed Cock Robin (bottom left) in about 1836. J. Marks, publisher of Bluebeard (middle right) in about 1850, was another London stationer, as was J. March. His late 19th-century House that Jack Built (bottom right) is unusual because it was printed in colours; chapbook illustrations were sometimes coloured by hand (such as Familiar Objects Described). Truth and Falsehood (bottom centre) was published by the Religious Tract Society in about 1840.

HISTORY
OF
Thomas Hickathrift

PART the FIRST.

Printed and Sold in ALDERMARY CHURCH-
YARD, LONDON.

THE TRIAL
OF
AN OX,
for Killing a
MAN.

BANBURY:
Printed and Sold by J. G. RUSHER,
BRIDGE-STREET.

Price One Penny.

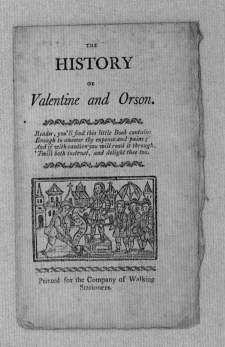

THE
HISTORY
OF
Valentine and Orson.

Reader, you'll find this little Book contains
Enough to answer thy expense and pains;
And if with caution you will read it through,
'Twill both instruct, and delight thee too.

Printed for the Company of Walking
Stationers.

FAMILIAR OBJECTS

GLASGOW:
JAMES LUMSDEN AND SON.

Price One Halfpenny.

4 Silver Penny.

A Apple, a

The Apple with its rosy cheek,
Doth first begin this pretty toy;
How sweet it tastes! and oft is made
The prize of each good natur'd boy.

Silver Penny. 5

B Bull, b

The crafty Bull with vicious haste,
Pursues the travler o'er the field;
Till caught and fasten'd to the stake,
The fiercer mastiffs make him yield.

BLUE
BEARD

London, J. L. Marks.

THE
Death & Burial
OF
COCK ROBIN.

PRINTED
BY J. CATNACH,
2, & 3, MONMOUTH-COURT, LONDON.

Sold by all Booksellers.

TRUTH
AND
FALSEHOOD,
OR THE HISTORY
OF
JANE AND LUCY.

LONDON:
Printed for
THE RELIGIOUS TRACT SOCIETY;
AND
SOLD BY F. DAVIS, AT THE DEPOSITORY,
56, PATERNOSTER ROW; AT THE DEPO-
SITORY, 19, PICCADILLY, MANCHESTER;
BY J. NISBET, 21, BERNERS STREET,
OXFORD STREET; AND OTHER
BOOKSELLERS.

Price One Penny.

THE HOUSE THAT
JACK BUILT

ONE FARTHING
J. MARCH WATERLOO RD

— 19 —

CHILDREN'S PUBLISHING BEGINS

In England, at the start of the 18th century, a child looking for something to read might have come across a book called *Youth's Recreation*. Its subtitle offered 'merry jests, witty sayings, and pleasant tales, bulls, blunders and puns ... strange and wonderful stories of giants, pigmies, fairies, witches and sorcerers ... also tales of specters, spirits, ghosts, apparitions, hobgoblins ... with many other stories of strange and amazing things of divers natures'. This came from a lowbrow publisher (G.Conyers, 1704), and was obviously a jumble of traditional lore, like that offered by chapbooks and ballads. Conscientious parents might have felt that their children deserved better than this.

Even traditional tales could be presented in a more polished way. This happened in France in 1697, when a collection of fairy tales, now known as *Contes de ma Mère L'Oye (Mother Goose Tales)* was published and quickly became popular in translation everywhere. This first significant fairy-tale book seems to have been written by a member of the Académie Française, Charles Perrault. He brought literary skill to it but, perhaps ashamed of its subject, published it under his son's name.

This type of writing, however, proved to be very rare for many years. Most authors who bothered to write for children (such as James Janeway or John Bunyan in Britain) aimed to save their souls rather than amuse them.

The first attempt to write for children on their own level was made in England in the 1740s. A publisher called Mary Cooper brought out a little book of nursery

19.1

One of Thomas Boreman's 'Gigantick Histories' (actual size). Publishers in the 18th century often secured themselves financially by taking subscriptions from buyers of a book in advance of printing it; they then included a list of subscribers in the text. Although he got very few words on a page Boreman liked to pretend that his miniature books had all the characteristics of real ones, so he included a list of juvenile subscribers, seen here on the left-hand page.

rhymes (see section 6), *Tommy Thumb's Pretty Song Book* and an ABC book, *The Child's New Play-Thing* (1742). The format of these tiny books was adopted by Thomas Boreman, in his series of seven 'Gigantick Histories' (1740-3), describing features of London for children in miniature format.

The jokey approach of these books was taken up by John Newbury, generally regarded as the first specialist publisher for children. He set up shop in London in 1743, and in 1744 published *A Little Pretty Pocket Book*, 'intended for the Instruction and Amusement of Little Master Tommy and pretty Miss Polly; with an agreeable Letter to each from Jack the Giant-Killer, as also a Ball and Pincushion, the Use of which will infallibly make Tommy a good Boy and Polly a good Girl'. He published a long run of books for children, including *Little Goody Two Shoes* (1746). As an

19.3

A 1792 edition of *The Looking-Glass for the Mind* (1787). In the last quarter of the 18th century concern for children reached a new height under the influence of Rousseau, and new writing for children in England, France and Germany was shared in translation. Berquin's part-work, *L'ami des enfants*, was published in England as it appeared in France in 1780-3. This selection was its most popular English version, and was illustrated with woodcuts by John Bewick.

19.2

Newbery's most famous book, *Little Goody Two Shoes*, is said to have been written by Oliver Goldsmith. This is the edition of 1770, which re-uses the wood engravings that first appeared in the edition of 1746.

astute businessman he tried to attract his new market – children – with sales gimmicks like the free ball and pincushion.

Newbury's familiar style was kept up by English and French writers in the later 18th century, though they tended to exert a stronger moral pressure on children than had Newbury's books.

The German contribution to children's literature was illustrated encyclopaedias. The Moravian teacher Comenius had set an example, with his illustrated vocabulary book *Orbis Pictus* in 1658. In the later 18th century, J.A.Basedow's *Elementarwerk* (1770-4) and F.J.Bertuch's *Bilderbuch* (from 1792) were much bigger and really elegant. Children had become significant as consumers.

19.4

Bookbinding styles for children's books around 1800. The book second from the right is bound in Dutch flowered paper. Newbery often used this for children's books because it was bright and cheerful.

—20—

SPLASHES OF COLOUR

20.1

At first, pictures could only be multiplied through printing in black-and-white. Colour, which attracts children, had to be added by hand. Every copy of an illustration would have watercolour paint applied with a brush to printed black-and-white outlines. Coloured book illustrations were often produced separately from the printed text and glued into place in the book.

At the top of the market for illustrated books, Rudolph Ackermann, publisher of luxury volumes on travel and costume, employed teams of trained, competent artists to add colour to illustrations subtly printed in tones of grey or brown by the aquatint process. Mrs E.M. Field, one of the first to write a history (1891) of children's books, tells us that around 1800 'colouring by hand ... rose to the dignity of a profession, and the streets about Soho Square and Clerkenwell especially were filled with diligent workers'. But another historian, Andrew Tuer (1898), looking at humbler books intended for children, relates that these were coloured

> by children in their teensThey sat round a table, each with a little pan of water-colour, a brush, a partly coloured copy as a guide, and a pile of printed sheets. One child would paint on the red, wherever it appeared in the copy; another followed, say with the yellow, and so on until the colouring was finished.

In effect, poor children were employed to produce pictures for rich children. Illustrations carefully coloured in this way can be charming-

An illustration from *The Peacock 'At Home'*, by Mrs Dorset, published by Harris. From an edition of the 1820s. Compare illustration 20.3.

The same illustration could be coloured differently in different editions. Here is the 22nd edition of *The Peacock 'At Home'*, 1844.

ly fresh and vivid. They can also be blotched very clumsily.

In the early 19th century, several publishers developed books for children which had bright illustrations, and entirely unfussy texts. These included John Harris, who took over Newbery's firm in 1801, Benjamin Tabart, John Marshall, and Darton and Harvey. While Boreman and Newbery had obviously believed that very small books appealed to children, these publishers found that coloured pictures worked better in larger sizes. So coloured books for children gradually increased in page-size. The number of pages was few, however, so that these picture books were no thicker than pamphlets.

It was Harris who first struck lucky, with an illustrated edition, in 1807, of a light-hearted poem, *The Butterfly's Ball* (by William Roscoe), quickly followed in the same year by the similar *The Peacock 'At Home'* (by Mrs Dorset). Harris produced many more such booklets, and other publishers followed suit. These first colour books had their illustrations, and often their brief text, engraved on copper-plates, and had a small squarish format (about 5x5 inches).

Soon the publishers found that it was easier to print the outlines of the illustrations from woodblocks and the text from type; and they enlarged the format to 7x4 inches.

Thin books with hand-coloured illustrations, and stories that were pure fun, soon established themselves as a genre and earned the name 'toy book'. This phrase was first used, it seems, casually in 1801, but took its special meaning from the books produced by the firm of Dean and Co. from the 1820s onwards. Dean's aimed to produce cheaper books than the other publishers, and promoted them as series under the names of supposed authors who were sometimes illustrated on the covers.

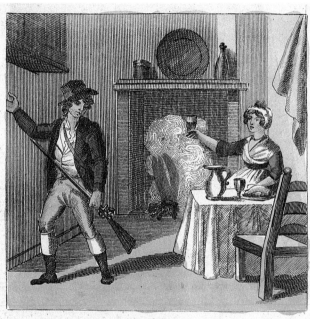

Then as soon as he had din'd,
It came into his mind,
To take his gun again to the lake;
For since he had such luck,
To shoot the little duck,
He'd go try to bring home the drake.

The final page from *Sam and his Gun,* one of the square-format books with copperplate illustrations and text. This was published by an imitator of Harris, the firm of Didier and Tebbett, 'at their Juvenile Repository, 75 St. James Street, London' in 1808.

Slapdash colouring, in a chapbook *Pictorial History of London,* published by Catnach probably in the 1850s.

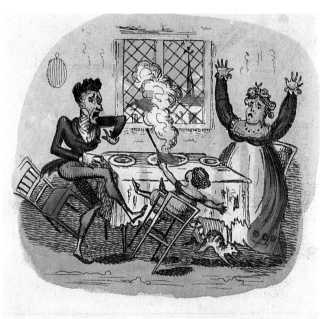

At dinner so pleas'd,

For his mind was quite eas'd,

As all his new clothes were just come,

Sat our dear Mr. Parrot,

Till, carving a carrot,

He unhappily put out his thumb.

From *The Dandies' Ball,* published by Marshall in 1819. The many colour-books inspired by *The Butterfly's Ball* obviously appealed to adults as well as to children. Some, imitating the style of contemporary caricaturists like Gillray and Rowlandson, were perhaps rather unsuitable for children. This one was denounced by a critic: 'its gaudy glaring prints ... vitiate the taste as much as the buffoonery of the letterpress corrupts the disposition of ... youthful readers'.

THE LITTLE OLD WOMAN

LONDON,
DEAN AND SON.
Lithographers, Printers, and Book and Print Publishers, 11, Ludgate Hill.

HERE was an old
woman,
And what do you
think!
She lived upon nothing
but
Victuals and drink;
And though victuals and
drink
Were the chief of her
diet,
This Little Old Woman could never be quiet.

20.6

20.6

Pages from *The Little Old Woman* (1855), one of
Dean's 'Uncle Heart's-Ease Series' of Toy Books.

20.7

Rare example of an instructive Toy Book.
Dating from the 1860s, this one is about
astronomy. The illustrations are still coloured
by hand, and quite skilfully.

Dean's published 'Grandmamma Easy's New Pictorial
Toy Books', alongside other series from Aunt Affable,
Uncle Buncle, Cousin Honeycomb, Uncle Heart's-Ease,
Aunt Busy Bee, Papa Please-Me-Well, Miss Merryheart,
Brother Sunshine and Mama Love-Child. The minor
publisher Park of Finsbury offered series presided over
by Cousin Rosebud, Aunty Jaunty, Frank Funny, Fairy
Fairstar and Humpty Dumpty. Subjects included nursery
rhymes, fairy tales, ABCs, amusing rhymes about funny
old ladies and merry millers, derivations from the origi-
nal Harris successes (e.g. *The Sunflower's Ball, The Donkey's
Party*), and even some instruction. As these books were
intended for young chidlren, their pages were sometimes
mounted on linen to make them 'indestructible'.

The firm of Routledge, Warne and Routledge came
on the scene in the 1850s with Aunt Mavor's Toy Books.

These were at first illustrated by hand-coloured wood-
cuts, but soon colour printing took over, as described in
the next section. Commentators have often described
changes in children's book publishing as revolutionary.
The toy book revolution, with its introduction of colour
and unashamed frivolity, must have been one of the most
spectacular of these revolutions.

PAPA'S TALES

ABOUT THE

SUN AND STARS.

YOU are to know, my dear children, that astronomy is that science which teaches us the names and nature of the heavenly bodies The sun is the centre of our planetary system; it turns round like a wheel on the axle-tree in the space of about twenty-five days. Its real diameter is 882,000 miles; that means right through the centre, as you would pierce a round ball. It is the source of all light and heat; and it appears to prosecute daily a stately course through the heavens, owing to the rotation of the earth upon its axis, ascending like an intensely brilliant ball from the eastern horizon, and declining towards the western, continually emitting pure light or fire. It is then said that the sun rises, and that the sun sets; the earth goes round the sun, and in the place where we live, when it first comes to sight, or turns toward the sun, then it is morning—the various cattle begin to graze, the larks spring high in the air, and the husbandman quits his cottage, and goes forth to make hay, and to reap, and to do all that the fields require. As the sun rises, the flower-garden looks beautiful, the dew-drops that have fallen in the night are dried up, and the sweet buds open to the light of the glowing sun. Oh, how very sweet it is then to rove among the roses and sweetbriar; the birds sing the young lambs bleat, the cattle low, and all nature seems to rejoice.

20.7

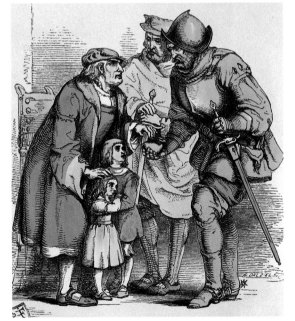

20.8

Good taste applied to hand-coloured illustration. Henry Cole, eventually to become the first Director of the V&A (then South Kensington) Museum, had a finger in many pies. This included children's books: 'my young children becoming numerous, their wants induced me to publish a ... series of books', called 'Summerly's Home Treasury'. In the 1840s he made several attempts to improve the design of consumer goods under the name 'Felix Summerly'. He enlisted well-known artists, the best London printer of the time, Charles Whittingham, and the publishers Joseph Cundall and Chapman and Hall. The books were at first hand-coloured, but soon colour printing came in. This illustration by John Franklin is for 'The Babes in the Wood' in *The Old Story Books of England* (1846).

— 21 —
COLOUR PRINTING

21.1

Detail from *Schöne alte Singspiele*, published in Munich in about 1910, with illustrations by J.Mauder. A songbook with charming folksy pictures.

Colour printing began to become a commercial proposition in the 1840s. Two black-and-white processes could be adapted to colour: lithography, and printing from wood blocks. Firms used either method, or sometimes both together, with their own special improvements. Both methods required each colour to be printed separately, from a series of wood blocks or lithographic stones.

Artistic skill was needed to prepare the blocks or stones: to sort out which parts of the picture should be on which printing surface, and to make allowances for the changing tints brought about by colours being printed on top of each other. Considerable technical skill was also needed to ensure the blocks or stones were 'in register': that they printed each colour exactly on top of the others so as to avoid a blurred effect. The kind of ink used also made a big difference to the effect of illustrations, which could be delicately pale like watercolour paintings or rich and glossy like oils.

While the finest handcoloured books had tended to be travel or topographical books, the early triumphs of colour printing were in books on the decorative arts, such as architecture, ornament and (oddly enough) manuscript illumination. But alongside such big, expensive books, printers tried to use the new processes in cheaper, more accessible publications, and children's books were one field in which the audience wanted colour. Henry Cole and his publisher friend Joseph Cundall, intervening in children's book production just as methods were changing, used both handcoloured and colour printed illustrations. Another place where many children would have encountered early colour printing was in the yearly volumes of *Peter Parley's Annual*, which began to sport colour frontispieces from the mid-1840s.

As we have seen, toy books had become the chief vehicle for coloured illustration for children, and here too colour printing soon replaced handcolouring. It appeared from the mid-1860s, in Routledge's 'Aunt Mavor's Toy Books', and in Warne's 'Aunt Louisa's' series, all of which had big, glossy pictures. The illustrators of these pleasing but bland books were of no particular distinction (and were often unnamed), until one outstanding artist emerged from the anonymous crowd: Walter Crane. Eventually to become a top figure in art education, Crane was an all-round designer, and his illustrations have a rich density of stylistic allusion and a well-packed overall pattern, which reward close looking. Crane was popular enough to have his own named series of toy books.

More relaxed and unfailingly genial was Randolph Caldecott, who also produced

21.2

Randolph Caldecott's *The Farmer's Boy*, first published in 1881. Notice that on this cover image the artist's initials are branded on the sheep.

21.3

From Walter Crane's Toy Book, *The Hind in the Wood*, first published in 1866.

his own series of Picture Books. Like Crane's, these were printed by the firm of Edmund Evans, who also printed the work of Kate Greenaway, the third of the trio of great late Victorian British illustrators. She had a narrower range than Crane and Caldecott, but perhaps for that reason established a stronger brand image (of tripping, mob-capped children), which still retains wide public recognition even today.

Plenty of children's books in France and Germany were illustrated with occasional colour-printed plates, and eventually more elaborate picture books appeared there too. Pierre Boutet de Monvel evoked a soft nostalgic world not unlike Kate Greenaway's, but he had a surer line and could rise to grand set-pieces. 'Job' (Jacques Onfroy de Bréville) moved adeptly from caricature to the swelling historical manner. In the first decades of the 20th century 'Uncle Hansi' (Jean-Jacques Waltz) created a vivid patriotic vision of folksy France, amidst the pressures of war. They all worked with wood block colour printing. In the German-speaking countries the best illustration was influenced by the Art Nouveau movement. The modest square books in the 'Jugendbücherei' series, by the Viennese publisher Gerlach, are some of the most exquisite children's books ever produced.

20th-century printers quickly took advantage of the arrival of three-colour half-tone photomechanical reproduction, the method of colour printing that is still used. Whereas an artist's work previously had to be prepared for printing by an engraver, from the 1880s photography could do this mechanically, producing metal

plates. At the same time a new method of reproduction (translating a picture into a pattern of minute dots) made it possible to print not just black on white but shades of grey. Adapting this 'half-tone' process for colour printing made it possible to get a full range of colours from four plates, printing in red, yellow, blue and black. At first, the new processes only worked successfully on glossy paper, so colour illustrations had to be pasted in books that were printed on ordinary, rougher paper.

The new methods introduced the world to the work of some of the greatest childrens' book illustrators: to Arthur Rackham's world of gnarled roots, tumbled skies and swooping elves, to Edmund Dulac's ice-and-fire

Vignette from *Tim to the rescue* (1949), by Edward Ardizzone.

designs that combine jewel-like colours with coldly menacing outlines, and to Henriette Willebeek le Mair's pale, formal compositions, like samplers made by fairies.

Nonetheless, the new techniques brought about something of a slump in picture books, since they often failed to reproduce an artist's work well. While artists could have protested to engravers, they could not very well argue with a process. So in the mid-20th century some illustrators returned to lithography, where they had more control. By now zinc plates (replacing stones) and the offset process made it much easier. In England, Kathleen Hale's 'Orlando' books, Edward Ardizzone's 'Little Tim' books, and the Puffin Picture Books were printed in this

way; in France, examples include Jean de Brunhoff's 'Babar' books and many publications from 'Père Castor'.

Half-tone colour printing was also made easier by the offset method, and by the 1970s techniques were fully adequate to support a new blossoming of children's picture books. The broad, floating watercolour washes of Michael Foreman are as well conveyed as the deft blobs and scribbles of Quentin Blake. In America, Maurice Sendak has developed a plump, rounded style which can effortlessly dissolve from caricature into myth, while in Austria Lizbeth Zwerger can evoke great atmosphere from an oblique viewpoint. Recently the airbrush has introduced a sort of hyper-realism into children's books.

21.5

Pages from *Le paradis tricolore: petites villes et villages de l'Alsace* (1918) by Hansi.

21.6

An illustration by Lizbeth Zwerger for *The Gift of the Magi* (1982), by O. Henry.

—22—

MOVABLE BOOKS

22.1

An early Dean's movable, *Merry Tales,* probably from the 1860s. If you pull the tab, the man's arm moves the wheelbarrow.

Although Victorian publishers used the term *toy book*, the books they so described were simply picture books and could not be played with in any practical way. Some books, however, do have physical, even three-dimensional qualities, which bring them nearer to being toys. For instance, there are shaped books. Instead of being rectangular, these are cut into the shape of a figure illustrated on the front cover - Robinson Crusoe, for example. Thus each page of the story is shaped like its hero. Some books have elaborate bindings that make them look like boxes. Other books appeal to more than just the eye: a well-known example of an early audible book is the *Speaking Picture-Book*, published in about 1893. It is rather bulky, to accommodate sound-producing devices; nowadays much smaller electronic devices can be neatly fitted in. 'Feely' books present the reader with interesting surfaces to touch, and 'scratch-and-smell' books offer tantalizing fragrances to the reader's nose. But there is one thing above all others that makes a book into a toy: movement.

In a sense there is movement in all books, because you have to turn the pages in order that the book can reveal its contents in a certain sequence. There are many ways in which this can be exploited, especially by illustrators, to heighten the experience of reading. But we are used to this, and like other kinds of movement to excite us. Movement can be in two dimensions or three. A book can present to us a flat picture with parts that move. Or, as we open the book, paper shapes can be made to rise up from the page towards us. Many modern movables combine both methods, and if we look back to the archaeology of movables both methods are to be found there. Even before the invention of printing, revolving discs were attached to pages of manuscripts; later they appeared in printed books. These *volvelles* had a practical purpose, usually to help the reader make arithmetical calculations or work out dates. Other early printed books contained flaps which could be lifted to reveal something concealed underneath, as in anatomy books where the outer skin of an illustrated body could

be raised to show the veins and organs inside. These movable features were intended to be useful, and had nothing to do with fun for children.

The first movables for children were little more than illustrated pamphlets, but they were not pages bound in the usual way. They were sheets ingeniously folded so that, to follow a story, the reader had to turn up numerous flaps in various directions. They were called *Harlequinades*, because they sometimes featured Harlequin (see section 48), and were produced by the publisher Robert Sayer in the 1760s. Oddly enough, they have never been repeated in exactly the same form since. The main point about them was that the flap system caused the pictures to split across the middle, so that the top half of one could fit with the bottom half of another, offering playful and incongruous combinations. This device has been much used since.

It was not for almost another century that movable books for children really took off. Then, as so often happens, two publishers seem to have alighted on the

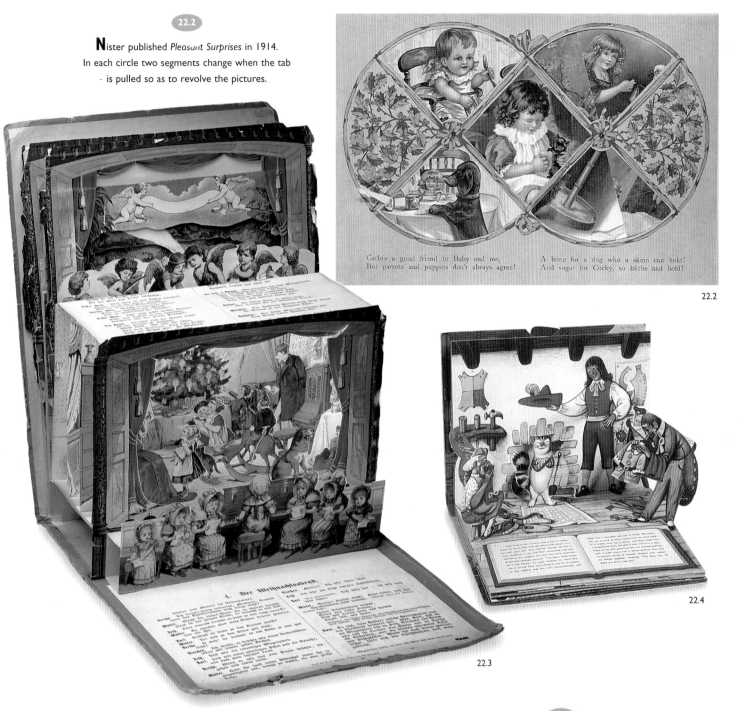

22.2

Nister published *Pleasant Surprises* in 1914. In each circle two segments change when the tab is pulled so as to revolve the pictures.

Carlo's a good friend to Baby and me, But parrots and puppies don't always agree! A bone for a dog who a skein can hold! And sugar for Cocky, so blithe and bold!

22.2

22.4

22.3

same idea at the same time. In 1856 Darton and Co. produced a 'moveable' *Book of Trades*, while Dean and Son are said to have produced *Cinderella*, the first of their 'New Scenic Books'. Perhaps further research will disclose earlier movables than these. The scenic books worked on the principle of peep-shows, dividing up a picture into layers and placing these one behind another, to give the appearance of recession to a picture. If the

22.4

Kubasta's *Puss in Boots* (1961). A version of the peepshow, or multiple layers, device.

22.3

This movable book is based on the peepshow principle. *Theater Bilderbuch,* published by Schreiber of Esslingen, probably in about 1885.

various layers were appropriately folded and stuck, they could be enclosed flat within the covers of a book. When the book was opened so that the covers were at right angles to each other, the various layers stood up. This was one of the two basic principles behind three-dimensional movables.

Many of the mid-Victorian movables worked in two dimensions, with paper levers concealed behind the illustrations. Thus the reader would pull a paper tab at the edge of the page which, for example, would cause a man in the illustration to wave his arm. This leverage device is still in constant use in movables. Some of the most ingenious lever effects were achieved in the books of Lothar Meggendorfer (1847-1925). Printed in Germany, these were popular worldwide in translation, because of Meggendorfer's humorous graphic style.

Germany fostered some of the best late 19th-century colour printing, and from Bavaria came the movable books of Ernest Nister. He specialized in another two-dimensional effect, the 'transformation' or 'dissolving scene'. As the reader viewed one of his pages, it would appear to be a single surface with a single illustration. But in fact it had two layers, ingeniously intercut so that when the reader moved a tab, the second layer would slide over and efface the first, presenting a new illustra-

22.5

One of many simple movables designed for very young children by Rod Campbell. *Lift-the-flap 1,2,3* (1987).

22.6

This magnificent paper construction looks equally good from any angle. *Noah's Ark,* by Kubasta, 1962.

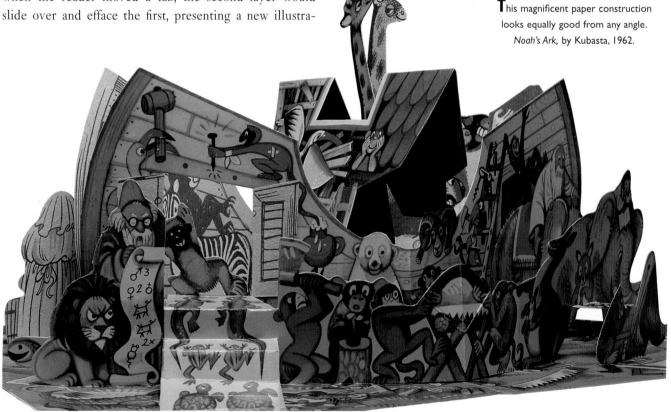

tion. The layers could be cut and interwoven in two ways, by slices or by segments. However, as all Nister's books tended to be anthologies of disconnected verses and pictures, his movable effects, while amusing, were rather pointless.

After Nister and Meggendorfer, movables became less popular, but in the 1930s in England, the *Daily Express* annuals and the 'Bookano' books exploited another device, the V-fold. To operate this, the reader had to open the covers of the book until they lay flat. This caused paper shapes, attached diagonally to the pages, to spring up. All kinds of shapes (such as animals, people and buildings) could be made to rear up.

The 1950s and '60s saw another high point in movables in the work of Vojtech Kubasta. He worked for the Czech firm Artia, and his work was published in England by Bancroft. Not only was he a master of technique, but he had a bold, colourful, racy style which has not dated.

In the 1970s and '80s came a craze for movables in England, in which brilliantly complex effects were achieved. The contribution of the 'paper engineer' was usually celebrated as prominently in these books as that of author or artist. Some of the virtuosi engineers were Ron van der Meer, Vic Duppa-Whyte and Tor Lokvig. Since then, production has declined. Perhaps it was simply impossible to go on excelling previous achievements, but there were also economic difficulties. Movable books have to be put together by hand, and cheap labour is required if they are not to be prohibitively expensive. Singapore and Columbia provided the labour for the British boom in movables, but it could not remain available for ever. All the same, experiment continues. Ron King at the private Circle Press has used paper engineering for artist's books. And all the old ingenuity is present in a recent French non-fiction series, published in England as 'Kingfisher Kaleidoscopes'.

22.7

Raymond Briggs's *The Snowman,* adapted as a pop-up book in 1986 with paper engineering by Ron van der Meer.

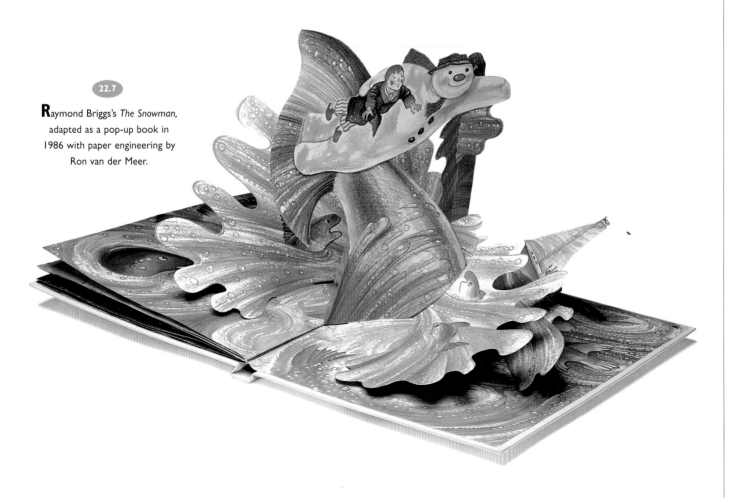

STORYBOOK HEROES OF EARLY CHILDHOOD

Alice approaching Wonderland. The plausibility of Carroll's fantasy is corroborated by the precise illustrations of Sir John Tenniel.

Left to themselves, children often invent imaginary companions. Towards the end of the 19th century, stories for young children began to present characters who were capable of living on in readers' imaginations, of keeping them company off the printed page as well as on it. For centuries, folk tales and ballads had been the only fictions available to children. They were certainly memorable. James Boswell always retained an affection for Jack the Giantkiller, and so did Wordsworth and Dickens; Dr Johnson liked to think about Tom Thumb. But while such heroes took part in stories of mythic power, they had not much personal character, being little more than stock types.

From the mid-18th century, alongside these stories composed by and for adults, children could read stories specially written for them. But these also were peopled by stereotypes: by children as adults thought they ought to be. Gradually, however, children's literature admitted heroes with distinct, often quirky, personalities. One such, who moved over from German folk literature, was Till Eulenspiegel (Till Owlglass). He was a trickster, who roamed at random, outwitting everyone who opposed him. Could such a character, who belongs to the genre of picaresque adventure, be replicated in child literature? A possible mate for Eulenspiegel might be Pinocchio.

He was a toy, a wooden puppet. Everyone knows how his nose got longer when he told a lie, and most people's memory of him is heavily influenced by the Disney film (1940), which tamed him somewhat. In the original story by Carlo Collodi (a journalist and politician of Florence) Pinocchio has wild, risky adventures, jerkily strung together, perhaps because Collodi wrote in fits and

Illustration from a comic-book abbreviation of *The Wizard of Oz*. The first illustrator of this American classic was W.W.Denslow, who provided images of the characters which other illustrators have followed.

starts for serial publication in a magazine in 1881-3. Pinocchio appeals to child readers because he is naughty.

Few childhood heroes have his panache, but many do have distinct, even assertive individuality. Lewis Carroll's Alice is one. No doubt it helped that she was based on a real person, 10 year-old Alice Liddell, for whom the Rev. C.L. Dodgson (Lewis Carroll) wrote *Alice's Adventures in Wonderland* (1865) and *Through the Looking Glass* (1871). Alice's individuality was also emphasized by the strong-minded way she coped with the odd world in which she found herself.

The Alice books appeared at just the same moment as the Countess de Ségur's *Les malheurs de Sophie* (1864). Her heroine lived in the real world, but resisted it stoutly. At a distance, following Alice and Sophie, come other little girls who do their own thing: Constance Heward's *Ameliaranne*, Joyce Lankester Brisley's *Milly-Molly-Mandy* and Dorothy Edwards's *My Naughty Little Sister* are all good examples.

It is sometimes said that the American equivalent of *Alice in Wonderland* is Frank L. Baum's *The Wonderful Wizard of Oz* (1900), in which a small girl, Dorothy, has a series of fantastic adventures with a Scarecrow, a Lion and a Tin Man. Although Baum intended that there should be no heartache in this fairy story, it presents an odd kind of world for a small girl to cope with. Americans also took Heidi to their hearts. Heroine of a book (1881) by the most famous Swiss children's author, Johanna Spyri, she became a naturalized American in a film version starring Shirley Temple (1937). Brought up remotely and eccentrically in the Alps, and unable to fit into middle-class town life, she too can be seen as an outsider, a free spirit.

If we have the makings of a theory that the heroines of children's fiction tend to assert themselves against the adult world, what about the heroes? We can find one who drops out of the world altogether: Peter Pan, the boy who wouldn't grow up. His creator, J.M. Barrie, though a successful playwright, seems

23.4

Detail from Attilio Mussino's binding design for a 1911 edition of *Pinocchio*. Attracting over 100 illlustrators, *Pinocchio* was first illustrated by Enrico Mazzanti (1883) and Carlo Chiostri (1901), who provided modest black-and-white vignettes suited to small-format editions. For the large format edition of 1911, Attilio Mussino provided a lively, brilliantly variegated pictorial commentary.

23.3

Dust-cover of a modern edition of *Heidi*.

23.7

Illustration from *The Squirrel, the Hare, and the Little Grey Rabbit* (1929). Margaret Tempest was the illustrator for all of Alison Uttley's tales.

From *Enid Blyton*

Dear Mr. Newfeld,

There are many Noddy models – but I really do think this is ideal – so soft – so human in its ability to take up any position – so gay – clean-looking – & WHAT a stroke of genius to put the bell inside the head! Whoever thought of that deserves a medal! (from Noddy!) Noddy isn't really Noddy without a jingle-jingle noise, & this Noddy really does jingle well. Nobody could ask more of any toy!

Yours with best wishes
Enid Blyton

Another Successful Bendy Toy

It looks good
It feels good
It SOUNDS good

Look out for Big Ears next

NEWFELD LTD., Ashford, Middlesex

23.5

Enid Blyton promoting Noddy toys, from a 1957 advertisement.

23.6

Movable toys of foam-rubber, made for the animated films of the Toytown stories shown on television. The Museum of Childhood now owns some of these.

23.6

23.8

Peter and Wendy was first illustrated by F.D. Bedford, while *Peter Pan in Kensington Gardens* had memorable illustrations by Arthur Rackham. Generations of children, however, knew Peter Pan from the illustrations of Mabel Lucie Attwell (such as the one shown here), first published in 1921 and often used with an abbreviated version of the text made by May Byron in 1935.

23.9

Bécassine, always recognizable by her Breton costume. The artist who created her was J.P. Pinchon, and most of the stories were written by 'Caumery' (Maurice Languereau).

23.9

23.10

23.12

also never quite to have grown up. Peter Pan, foreshadowed in Barrie's novel *The Little White Bird* (1902), started his independent life in a play first performed in 1904 (and popular ever since), and was then featured in the stories *Peter Pan in Kensington Gardens* (1906) and *Peter and Wendy* (1911). For Barrie, Peter was a wish-fulfilment, but for children he is a liberator who frees them from the confines of the nursery.

It is hard to find other males among these heroes of early childhood who offer the fantasy of independence and non-conformity. But we can trace the line in other directions. Little French girls still love Bécassine, who appeared as a strip cartoon figure in the children's magazine *La Semaine de Suzette* from 1905 to 1939, and whose adventures were gathered up into 25 picture books. As a servant, she does not belong to the world of parents and is thus an ally for children. As a provincial peasant, she

has her own scatty way of doing things which cuts across adult expectations. P.L. Travers's Mary Poppins is perhaps a relation of hers.

Animals also present themselves as children's allies against adults. The earliest on our roll of honour should be Brer Rabbit from the *Uncle Remus* stories (1880) of Joel Chandler Harris. This series of tales 'concerns a weak animal winning', says Margaret Blount, and 'celebrates the victory of a creature that has no natural weapons, only speed, concealment and cunning': plenty for a child to identify with here.

Animals who inhabit a more comfortable world but must still vanquish it are those in the Peter Rabbit tales of Beatrix Potter (from 1901 onwards), and Alison Uttley's Little Grey Rabbit series (1929 onwards). These animals do behave like humans, but they are by definition not part of the adult world and offer children

Australia's own indigenous childhood heroes: the gumnut babies (who grow on trees), Snugglepot, Cuddlepie and company, invented in 1918 by May Gibbs.

King Rollo, a character invented by David McKee in 1979.

"It's snowing," said King Rollo.

23.11

Title page of the 1950 Rupert Bear annual. The Rupert strip appeared in black and white in the *Daily Express*, but from 1940 the stories were printed in colour in annuals.

an alternative allegiance. Toys can perform the same function, so we can include here A.A. Milne's Winnie the Pooh.

One obvious factor in the appeal of these characters is that they have a strong visual identity. Sometimes, the author is also illustrator (Beatrix Potter; Jean de Brunhoff, creator of Babar the Elephant), while sometimes there are long-running partnerships between author and illustrator. Illustrations are important, and so is format. The Peter Rabbit and Little Grey Rabbit books, small and square, are instantly recognizable.

Some of the heroes achieve fame with an appearance in only one or two books, but it certainly helps to have a series. Bécassine appeared weekly. Rupert the Bear appeared every day in the *Daily Express* for 75 years, and is going strong. At first, in the stories of Mary Tourtel, he is an innocent caught up in fairy-tale adventures, but later, after Alfred Bestall takes over, he becomes a sort of special agent, putting the world's problems to rights from his placid base in Nutwood. Other memorable strip-cartoon characters, maintaining an incorrigibly sceptical attitude to the adult world, are the Peanuts group and the Perishers.

Exposure in other media than print helps. S.G. Hulme Beaman's Toytown stories, starting in the early 1920s, were adapted by the end of the decade for radio, and later for television; and Worzel Gummidge got similar treatment. Merchandizing helps: already in the 1920s, Bécassine toys and memorabilia were being produced. The popularity of cartoon films in the 1930s led to a great expansion of such 'character merchandizing'. In the 1950s Enid Blyton, never slow to exploit her market, was eager to endorse toys based on her characters.

In recent years, many fictional characters have secured a tight hold on their audience through a three-pronged approach: picture books, television programmes and spin-off merchandise: Noggin the Nog, Captain Pugwash, King Rollo, Postman Pat, the Mr Men squad. What is noticeable about these characters is that they are not children, nor are they strong candidates for the freedom-fighter role that has been proposed here. Admittedly, these fictional heroes are aimed at younger and younger children. But they may be evidence in support of the common argument that modern media personalities - not only in real life, but in fiction also - are increasingly bland, and famous only for being famous. In contrast, the earlier heroes and heroines seem like Titans. Rupert Bear, says critic Paul Vaughan, 'shaped the moral universe of an entire generation of middle-class children'. The Toytown plays, says historian Raphael Samuel, 'might turn out to the grand original of those imaginary Englands which did so much to sustain national morale in the years of the Second World War'.

—24—
HOW CLOTHES MARK US OUT

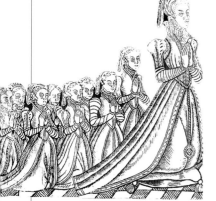

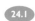

Miniature adults? Mother and daughters, dressed very similarly, on a church brass of 1550. From a rubbing, in the V&A's brass rubbing collection, of the memorial brass of Margaret Fitgeralds in the church of Clapham, Sussex.

One of the big ideas that constantly crops up in popular discussions of the history of childhood is that, until the Victorian age (or some such time), children were treated as small-scale adults. Almost everyone, including experts ranging from Iona and Peter Opie to Ivan Illich, has made use of the phrase 'miniature adults'. The notion is just sufficiently intriguing and paradoxical to have the sparkle of an insightful brainwave. But if you stop to think about what 'treated as miniature adults' might mean exactly, it loses some of its sparkle. Does it mean that children were equal with adults under the law? Economically independent at an early age? Politically empowered? Sexually active? Obviously not. What it comes down to, usually, is that children, as represented in portraits of the past, *looked like* miniature adults. It is to do with clothes.

Again, however, if you think about it, this idea loses some of its clarity. Firstly, you have to allow that all children, to a degree, look like miniature adults for that is what they are. The proportions of the human form alter interestingly at different ages but, after infancy, all humans are sufficiently similar to make it inevitable that their clothes will have similarities too. Then you must allow for changing historical styles in clothing. A child in Elizabethan clothes might well, at a quick glance, look similar to an adult in Elizabethan clothing. A child in jeans and T-shirt looks like an adult in jeans and T-shirt. Does this tell you anything about the relationship of children and adults in Elizabethan times and today? Or does it just tell you about changing styles in dress?

Thirdly, you must allow for class differences. Most of the pictures that are presented as evidence for the miniature adults theory are of rich children and their parents, posing in their best clothes. For such an occasion all parties are likely to be aiming at the same smart, expensive look. There is an often reproduced engraving after Holbein of Henry VIII's son Edward, aged two (1539). He does, amusingly, look quite like a miniature version of Henry VIII, who is forever remembered in the hulky image Holbein gave him. But you can set against this a woodcut by Hans Sebald Beham (1531) of a very similar little princeling being led along by a servant maid. Not surprisingly, the princeling does not look in the least like a miniature version of the servant. The miniature adults theory depends to a large extent on how you set up the comparisons.

Looking closely can reveal another factor that goes against the miniature adults theory. A group portrait, of about 1630, of Count Moritz von Hessen and his family, by August Erich, is in the art gallery at Kassel (reproduced in Weber-Kellerman's *Die Kindheit*). This is a wide, spectacular painting of man and wife, fourteen children and two dogs. All (except the dogs) are wearing elaborate starched lace collars and richly embroidered clothes. In the face of this mass of haberdashery, you can hardly avoid thinking that the children look like miniature adults. But notice the children in the front row: they are all wearing long skirts. You might assume that these are girls, who are miniature versions of their mother, but this is not so. At least three of them are boys. This we can tell because they are holding a hobby-horse and whip, a bow and arrow, and a drum. From the Middle Ages for

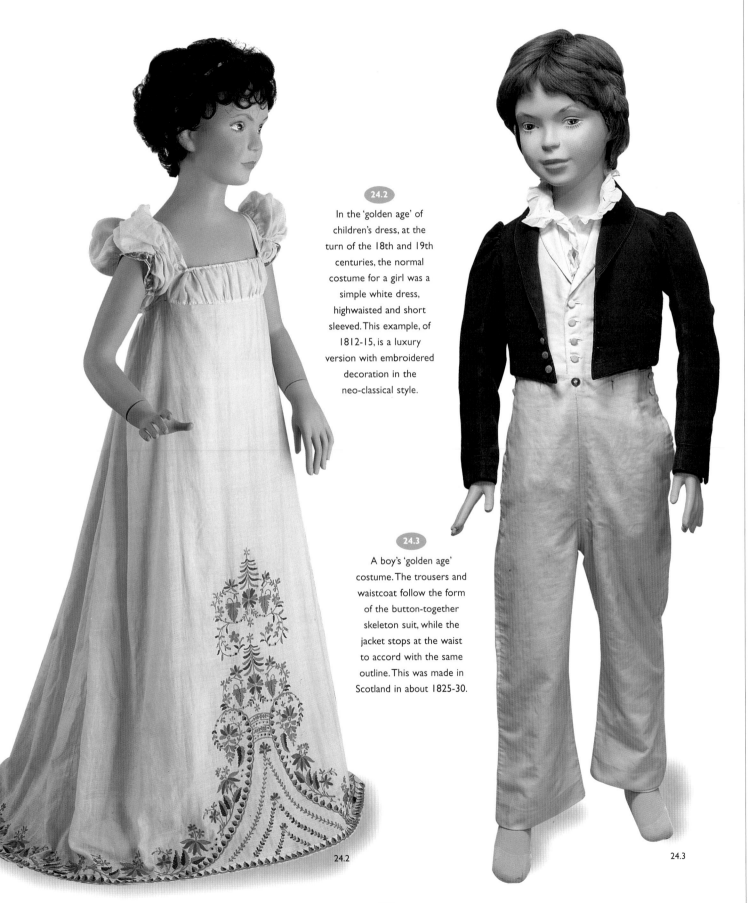

24.2

In the 'golden age' of children's dress, at the turn of the 18th and 19th centuries, the normal costume for a girl was a simple white dress, highwaisted and short sleeved. This example, of 1812-15, is a luxury version with embroidered decoration in the neo-classical style.

24.3

A boy's 'golden age' costume. The trousers and waistcoat follow the form of the button-together skeleton suit, while the jacket stops at the waist to accord with the same outline. This was made in Scotland in about 1825-30.

24.2

24.3

centuries onwards (right up to the early 20th century in places) it was customary for infants of both sexes to wear long dresses for their first few years.

Boys wearing skirts can hardly be regarded as miniature versions of their fathers. In the Wallace Collection is a portrait by Largillière of Louis XIV with his sons, including the infant Duc de Bretagne. This child, in skirts, does not look like a little man, let alone a little king, but is the spitting image of his governess billowing behind him. (So this time a prince does look like a servant!) The fact that boys were dressed in skirts undermines the miniature adults theory. Indeed, an apologist for the theory, Elizabeth Ewing, admits as much: 'to dress small boys like girls seems to contradict' her assertion 'that every effort was made to turn the child into an adult as soon as possible'. But she ingeniously goes on to argue that it was because little children were looked after by women that they had to look like little women. Perhaps it would be helpful to give the miniature adults theory a rest, and to analyze the resemblances and differences between adults' and children's costume individually.

One more case may be of interest here. When babies came out of swaddling clothes, but could not yet walk, they would be dressed in gowns long enough to keep their feet warm. (In earlier periods, they sometimes wore gowns over swaddling.) In the 19th century these gowns became longer and longer, sometimes more than 40 inches long. Costume historians have pointed out that they looked like ladies' ball gowns. Can we infer anything from this? Did the Victorians, usually credited with an increasingly sympathetic attitude to children, try to treat them as ball-going adults at the age of one year?

Obviously, clothes mark children out from adults in various ways, but we must be careful what conclusions we draw from this. Another initially convincing theory is that children's clothes are adult hand-me-downs. So far as their substance is concerned, this must often have been the case, especially among poor people. An essential skill for a mother was the ability to take up a needle and transform old clothes into children's clothes. But so far

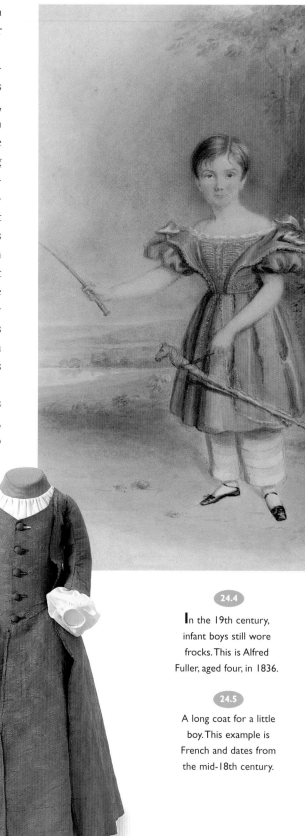

24.4

In the 19th century, infant boys still wore frocks. This is Alfred Fuller, aged four, in 1836.

24.5

A long coat for a little boy. This example is French and dates from the mid-18th century.

as style is concerned, the hand-me-down theory only works sometimes. Philippe Ariès, analyzing the infant's long robe in the early modern period, proposed that 'the first children's costume was the costume which everybody used to wear about a century before', i.e. children assumed out-of-date adults' styles. This might seem a plausible rule of thumb, but at the end of the 18th century the opposite case arose. Adult dress was anticipated by children's, notably by the appearance of full-length trousers for boys before these were adopted by adults.

Children's dress is both like and unlike adults', so the way in which it marks out age is ambiguous. How clearly does it mark out sex? 'Blue for a boy and pink for a girl' may seem a neat answer to this question. But the blue/pink code seems to be of recent invention, perhaps in the 1930s and, curiously, costume historians have been baffled in their efforts to track down its origins.

Apart from this recent colour-coding, there has been very little attempt, through history, to distinguish the sex of babies during their first months. Until they begin to move and to get involved with the world around, the priority for them must be warmth and comfort rather than individuation. So they were wrapped up well, at first in swaddling clothes and, from the mid-18th century, in less restrictive cloths and gowns. Once they were on their feet, all children, as we have seen, wore frocks for several years.

In the Middle Ages, almost everybody - men, women, and children - wore long gowns if they were in affluent circumstances, or shorter tunics if they needed more mobility. The waist was discovered in the 14th century and, ever since, western costume has used this part of the body as a sort of fulcrum, and has been hitched around it one way or another. Through the centuries women have tended to wear shaped bodices and spreading skirts. Men's costume, accommodating the legs individually, has been more complicated. Above the waist, doublets and jerkins in the 16th and 17th centuries developed into front-opening coats in the 18th. Below the waist, stockings, tights and various shapes of loose pants in the 16th and 17th centuries led to knee breeches and stockings in the 18th, trousers in the 19th. The most difficult parts to accommodate for both sexes were the private parts: hence many people had little in the way of underclothing.

Infants' frocks on the whole followed the construction of girls' frocks. Rich children got elaborate tailoring, and

most representations of costume available to historians show rich people's costume. In the paintings and prints of Brueghel (c.1520-69), however, you can see poor infants scuffling around in simple, bell-like long coats. If it was cold, they might wear an under-coat and stockings beneath but, if it was warm, nothing. This emphasizes one functional advantage of the infant's frocks: they allowed children not yet fully toilet-trained to relieve themselves without messing their clothes too much. You can also see from Brueghel's paintings that some gender differentia-

Poor infants often wore nothing under their short coats, as can be seen from this detail of Brueghel's engraving 'The donkey at school'.

What am I?

24.7

Images of naked children, posed on fur rugs or soft cushions, seem to have come into vogue in the early 20th century. Such images inevitably recall, for those with well-stocked visual memories, Boucher's *Miss Murphy*, a painting with erotic overtones. This postcard seems designed to titillate, with its caption 'What am I?'. This card was sent by 'Auntie Flo' to a small boy, with the message 'My dear little Arthur, This little boy made me think so much of you'. Images of naked children were also widely used in babyfood advertisements in the early 20th century.

tion was made. Aprons, though sometimes worn by boys, usually mark out girls, as do white kerchiefs round the head. Aprons remained a marker for girls through succeeding centuries, and on occasion (for example the 1760s and '70s) were fashion accessories for women. As we have seen, when rich infants in skirts were depicted in paintings, they often held symbolic objects to indicate their sex: a doll for a girl, a drum, a toy horse or a weapon for a boy. The transition from skirts to breeches, at the age of four to six years, was for centuries an important rite of passage for small boys, offering them a new sense of masculinity and freedom.

The dress of children from about six onwards generally follows that of adults. But, as we have seen, there were interesting developments in the late 18th century which led to what historians have called a 'golden age' of children's dress. Simple white muslin dresses for girls, and the 'skeleton suit' (a kind of boiler-suit, with long trousers buttoning on to a short, sleeved top) for boys, offered an ease of movement still denied to adults. In the 19th century, however, children's dress became more elaborate and upholstered. There was a greater variety of whimsical styles for boys, while girls' fashion imitated the fluctuating profiles of their mothers' dress. For infants, however, there was still a common look: a waisted dress, which in its more masculine versions might look like a tunic, with pantaloons (often frilly) peeping out beneath.

Dress marks children out as children, and distinguishes them as boys and girls. It can also be an indicator of class. At the present time, when there is a general taste for casual clothes, dress does not perform this function very powerfully, but in the past it did. Many poor children would have been dressed in little more than bundles of rags: drab fabrics, scruffy from much use, and ill-fitting because handed on. In contrast, children from well-off families would be dressed in well-tailored garments made from varied and expensive fabrics. It is difficult now to imagine the extreme visual difference between rich and poor that diminished only in the present century.

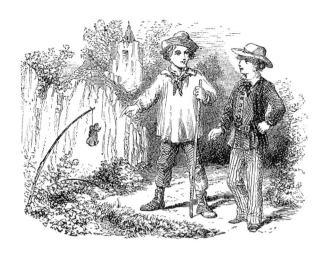

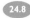

Class divisions overcome. This illustration, from *The Boy's Week-Day Book* (1865 edition, but first published some years before) shows a middle-class boy, in belted tunic and fitted trousers, with his rustic friend, the mole-catcher, who wears a smock, loose trousers and boots.

24.9

Class divisions upheld. This satirical illustration, of about 1900, by the German artist Thomas Heine juxtaposes a rich little boy, wearing a 'Fauntleroy' suit, and a ragged urchin. The father reproves his dog: 'Fie, César, aren't you ashamed of chewing such dirty trousers?'

— 25 —

DRESS FOR USE AND COMFORT

A 'pudding' - a padded headpiece for a child - from the 18th century.

Fashion often involves sacrificing comfort to appearance. Children's dress has not been immune to fashionable influence, but it is reasonable to assume that parents were probably more concerned to ensure comfort and healthiness in their children's dress than in their own. Nonetheless, such concern would vary from parent to parent and age to age, and there is no doubt that sometimes parents clothed their children for effect. 'Kindness, comfort, convenience, count[ed] as naught beside social ambition,' asserts Pearl Binder, commenting on Victorian parents' taste. And parents were often ill-informed or honestly mistaken: many must have genuinely believed that swaddling was good for babies, though no-one does now.

On the whole, children's dress has become more comfortable over the centuries. This seems undeniable, though we must remember that comfort is a mental as well as a physical condition. Also, it depends on environment: thick, heavy clothes are a comfort if you are cold; thin, light clothes if you are hot. It might be expected that children would prefer freedom of movement to constriction. That has not prevented the encasement of the human form in corsets through much of modern times. Both girls and boys wore stays as infants, even as babies, from the late 17th to the present centuries. Boys became free of them around the age of seven, but for girls, as they grew to womanhood, stays closed in tighter and tighter. Freedom began to beckon in the late 19th century, with the Rational Dress Movement. The arrival of the Liberty bodice in 1908 at last brought soft, simple underwear for children. Rompers also appeared around this time, signalling that crawling was no longer regarded as a lapse into beastly degeneracy by babies.

Safety in movement was always a concern. In the 17th and 18th centuries, infants' frocks were often equipped with leading strings. These strings or ribbons attached to the shoulders were (like the reins and harnesses of the present century) intended to help a parent support the tottering steps of an infant. They often, however, had little more than a decorative purpose, especially when attached to the dresses of older children. In the 17th century, many parents obviously feared lest their tottering infants might fall over and bang their heads, and equipped them with 'puddings' - a sort of skeletal, padded crash-helmet. Though these are always recorded in histories of children's dress, and plenty of specimens survive in museums, no-one seems to know why they came into vogue, and then went out, in quite a short space of time.

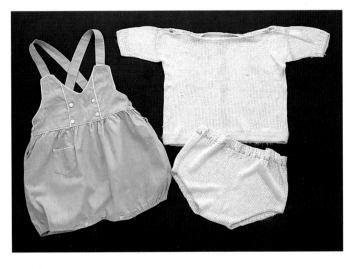

Comfort for children. A hand-knitted suit for a baby boy, from about 1933, and a blue sunsuit of the 1920s.

The relaxation in children's fashions which occurred in the late 18th century was part of a softening of attitudes to children which arose from complex causes. One powerful influence in the world of ideas was the French philosopher Jean-Jacques Rousseau. He exerted little influence through practical example, because he despatched his own children into an orphanage to avoid the bother of bringing them up. But he wrote at great length on children's upbringing in *Emile* (1762). The heart of his belief, a revolutionary notion at that time, was that Nature should be allowed to take its course. His application of this belief to children's clothes could be startling. Children should wear the lightest possible clothes, and never wear hats. They should not wrap up to keep warm, for 'great cold never does them any harm, if they are exposed to it soon enough'.

Some disciples followed him to the letter. R.L. Edgeworth recalled that 'I dressed my son without stockings, with his arms bare... He had all the virtues of a child bred in the hut of a savage'. The child, Richard, unfortunately turned out irresponsible. Many parents, not going as far as Edgeworth, would have been content to accept Rousseau's proposition that 'before the child is enslaved by our prejudices his first

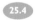

25.3

One way of exerting control over children is to make sure that they cannot get out of their clothes. In earlier times, much children's costume was so complicated that children could only dress with an adult's help. Older boys and men had the advantage, from the 18th century on, of dressing in shirts, coats and trousers that fastened up the front. Girls' and women's costume, however, often fastened at the back where children could not reach. This illustration, from a book of rhymes, *The Tender Nurse* (dating from about 1815), shows an infant reluctant to get into its frock and triumphant at escaping its nurse's control.

wish is always to be free and comfortable. The plainest and most comfortable clothes, those which leave him most liberty, are what he always likes best'.

At any rate, under the influence of Rousseau and others, children's dress did become simpler, as we have seen in section 24. This simplicity, however, was not without artifice. Girls' white muslin dresses were light and pretty, but tended to leave the shoulders and arms exposed, and easily got dirty. They were fine for well-off girls, but poor girls had to wear darker and stouter fabrics. The boy's skeleton suit fitted close to the limbs but was quite a complicated piece of tailoring with many buttons. Many working boys would have worn looser trousers under a tunic.

25.4

Today, children learn very early how to dress themselves. Jan Ormerod's illustration (from *Sunshine*, first published 1981) could only have been drawn in the later 20th century.

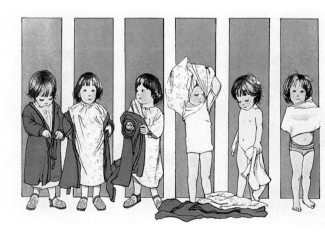

It can be argued, perhaps, that the need for dress to be functional was one of the strongest influences towards comfort and simplicity. People who did physical work had to dress simply. Trousers were worn by working men long before they became fashionable. The countryman's smock, developed in the 18th century, was an adaptable, practical garment. Working women had to wear fewer corsets and petticoats than fashionable women in order to obtain freedom of movement, and in the 18th century often adopted the 'bedgown', a wrap-around dress that was easy to get into.

Working dress for many children was school dress. In a sense this, even when practical, can be constricting because it imposes a uniform appearance upon individuals. Charity schools and orphanages everywhere in Europe tended to impose a common dress. In England, many 'blue coat' schools for boys carried on using Tudor costume for hundreds of years after everyone else had forgotten it. Schools for better-off children did not at first require uniform dress. J.T. Smith, in *A Book for a Rainy Day* (1845), recalls seeing a party of schoolboys in about 1800 dressed in pea green, sky blue and the brightest scarlet. But regimentation was imposed in the 19th-century public schools, and by the end of the century the Eton suit was the uniform of middle- and upper-class schoolboys everywhere in England. Of course, individuality was not entirely suppressed. There were little touches by which caste could be asserted 'in public schools where a boy may show his significance by leaving two buttons of his waistcoat undone, or using a coloured handkerchief, or having his hat tilted forwards or backwards instead of straight' (Doris Langley Moore). On the whole, though, boy's school uniform moved dress in the direction of functionalism.

Sports gear took boys' clothing further in this direction. Football jerseys and caps in team colours were established at Rugby by 1857. School caps and blazers developed from games wear; shorts, which became common for younger schoolboys in the 1920s, had also been pioneered on the sports field. Thomas Henry's illustrations for Richmal Crompton's William books record the transition from Eton suit to blazer and shorts.

Girls' education developed more slowly than boys', but by the 1920s it had brought into daily use the gym tunic, which hung from the shoulders over an uncorseted body (see illustration 43.3), and matching knickers with elastic to replace white, open drawers with tie-strings. In later times, sportswear has continued to influence children's dress, for example in making track suits and trainers desirable attire.

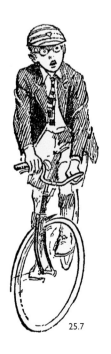

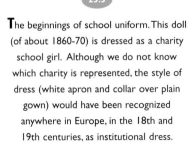

25.5

The beginnings of school uniform. This doll (of about 1860-70) is dressed as a charity school girl. Although we do not know which charity is represented, the style of dress (white apron and collar over plain gown) would have been recognized anywhere in Europe, in the 18th and 19th centuries, as institutional dress.

25.7

25.7

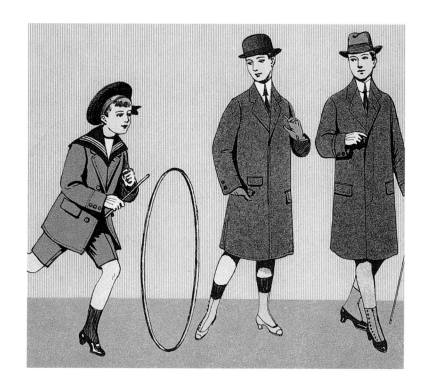

 25.6

Short trousers were common for boys by the early 20th century. As this illustration from the catalogue of West End (the Paris outfitters) shows, shorts went well enough with a sailor suit, but looked odd when teamed with the overcoats and adult-style hats which adolescent boys might also wear.

 25.8

The most relaxing clothes of all are beach wear. In the late 19th century, as the sailor suit and red-striped bathing dress show, it was necessary to cover up thoroughly. But the green rubber-backed cotton waders (1928) and the elasticated bathing suit (1956) worn by the children in the foreground are more comfortable.

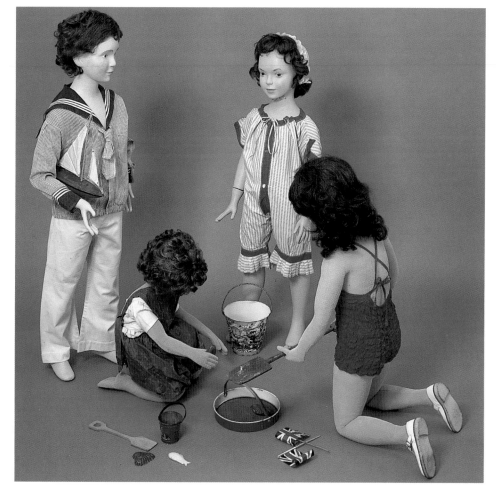

 25.7

Classic English schoolboys' uniform (cap, blazer, tie, grey shorts, knee-socks), worn here by Anthony Buckeridge's heroes, Jennings and Darbishire, in *Take Jennings for instance* (1958).

— 26 —
BEST AND FANCY DRESS

26.1

Sunday best in about 1910.

The idea of 'best' clothes both pleases and infuriates children. Some like to dress in their best clothes and show off. Others are agonizingly self-conscious when they have to turn out in unaccustomed finery. The very poorest people would have no best, perhaps possessing only what they stand up in, whereas the rich have wardrobes full of best clothes. But they do need something comfortable to slip into sometimes: George III's queen, Caroline, wore a 'nightgown' on informal occasions, which might later be called a dressing-gown. This was a handy garment from the 16th to 18th century for both sexes, and for children. People of the middling sort would have had several sets of clothes, some smart enough to be considered 'best'.

In our casual society, the possession of best clothes is not a very important matter, but in earlier times it was a social obligation. The point is well made by looking at examples from just above the poverty line. Girls in 1786 at the Blue Coat School, York, needed two of everything - petticoats, gowns, aprons, shifts, and so on. Perhaps this was simply what was needed for survival: one set of clothes to wear, while the other was in the wash. Significantly, though, a girl had to have '1 band or Sunday handkerchief'. For everybody had to dress up on Sunday to go to church.

This obligation emerges again when we look at the sort of clothes that charity school children were issued with when they were sent out as apprentices. They had to have two sets of clothes, 'the one fit and decent for weekdays and the other for Sundays'. Whenever working people's clothing is described, it is clear that they looked a good deal more clean and respectable on Sundays, in their best clothes, than they did during the week. The ethos and habits of the Christian Sunday (now almost extinct) would be a good research project. Most of the children's costume that survives in museums is 'Sunday best', as everyday dress got worn out.

26.2

The fashion magazine, *Gazette du Bon Ton*, in its Christmas 1913 number, illustrated some seasonal fancy dress for children: the Christmas tree shown here, a ball of mistletoe, a Christmas pudding, a cricket, and a roast goose.

If everyday dress for children has gradually tended towards simplicity and comfort, best clothes are where style and expense were given free rein. In periods where there was a degree of consistency in clothes styles, children's best dress would be distinguished more by quality than by cut. In the 19th century, however, styles in clothes, as in architecture, furniture and decoration, were hectically variable. The silhouette of the fashionable lady in the 19th century expanded and contracted almost every five years, and girls' dress tended to follow, though avoiding the wilder excesses of crinoline and bustle. Boys' dress followed a somewhat different stylistic development, dictated by allusion.

Boys were dressed in fantasy versions of adult military or naval uniform or the dress of earlier periods. An enthusiasm for military matters in the Napoleonic Wars led to many boys dressing in the hussar jacket in the 1820s and '30s. This amounted to little more than rows of horizontal braid across the chest between buttons, and such trimming was adopted on women's and even babies' dress also. The popularity in the 1850s and '60s of the zouave jacket, an open jacket with only a single button at the neck, was probably due to the Crimean War.

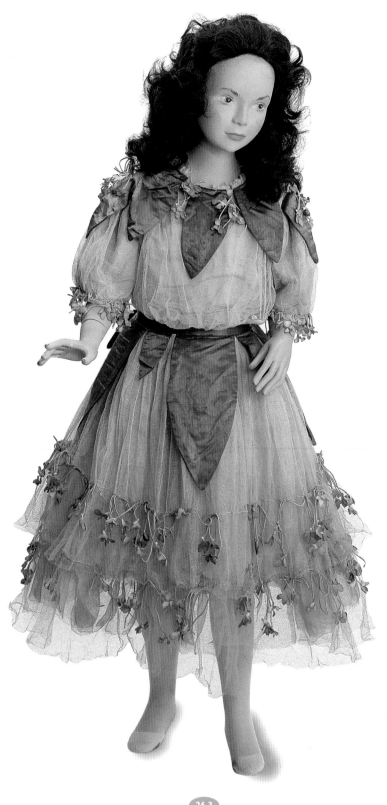

26.4

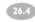

Sailor suits still going strong for both sexes, as this advertisement in the *Children's Magazine* of October 1912 shows.

The knickerbocker suit, which arrived in the early 1860s, took its name from a *nom de plume* used by Washington Irving, which became accepted as a generic name for the early Dutch settlers in East Coast America. The spacious knee breeches known as knickerbockers were thought to recall 17th-century costume. In the 1880s many boys were clothed in a more sentimental 17th-century style, a velvet suit with lace trimmings recalling the Cavalier costume in portraits by Van Dyke. This was inspired by Frances Hodgson Burnett's book *Little Lord Fauntleroy* (1886), where the hero wore such a suit.

26.3

Girl's fancy dress of 1915-20, 'Violet', following the shapes of the flower and trimmed with artificial violets.

The most popular of all these allusive styles was the sailor suit. This fashion seems to have been set by the Royal Family. The five-year-old Prince of Wales was painted by Winterhalter in 1846 in a sailor suit that closely followed the white bell-bottom trousers and loose blouse, with blue collar, worn as a uniform by sailors in the Navy from the 1840s. For almost a century sailor suits were popular for boys, and also for girls. They soon ceased to be accurate copies of naval uniform. All sorts of variations of colour and cut were introduced, the collar being the constant feature which identified the costume as a sailor suit. The sailor suit was by no means confined to England, but spread everywhere in Europe.

There is an element of fancy dress about these allusive garments. Fauntleroy suits were, indeed, sold not only as smart dress for children but also specifically as fancy dress. Fancy dress balls became a fashionable adult entertainment in the 19th century. They derived partly, no doubt, from a European tradition of dressing up for carnivals and masquerades. Carnival costume tended towards fantasy, but 19th-century fancy dress originally had a more earnest historical or geographical basis: period costume and foreign dress were favoured. Gradually the possibilities widened.

It was also in the 19th century that children's parties developed (see section 50), and

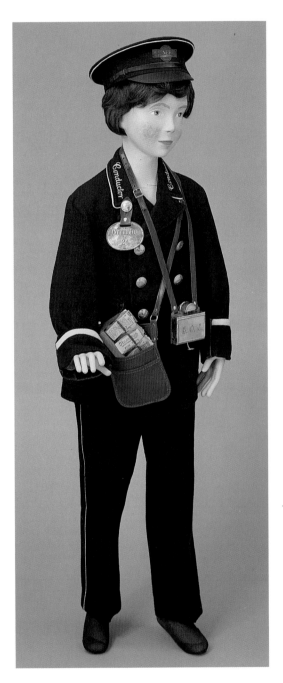

26.5

A bus conductor kit (uniform and cap, badge, cash-bag and ticket machine) dating from about 1935.

fancy dress was one of the ways to entertain children, especially after Queen Victoria held a Fancy Dress Children's Ball at Buckingham Palace in 1859. By the end of the century, as we can see from suppliers' catalogues, children's fancy dress included not only historic and national costume, but symbolic ('Summer', 'Liberty'), floral ('Rose', 'Poppy'), and fictional ('Bo-Peep', 'Dolly Varden') costume.

At some point around the turn of the century, a new spirit of invention led to fancy-dressers disguising themselves as things instead of people: an easy chair, a pack of cards, a gramophone record. Anything could now be evoked in fancy dress.

If you went to a fancy dress ball and found somebody else in the same costume, you would be mortified. Children like dressing up at any time, however, and toy manufacturers naturally looked for ways of mass-producing fancy dress for them. This often resulted in sets of partial fancy dress: bits of soldier, cowboy or nursing kit that children could wear with their ordinary clothes - enough to encourage them in role-play without requiring complete disrobing. 'Panoplies', boxed soldiers' kits, were a popular Christmas present in Paris early this century. A recent counterpart, from the Gulf War period (1991), is a 'Desert Shield Survival Kit. Includes nylon camouflage-color vest... rubber knife, compass, 2 grenades, and official documents. Ages 5 Years and up'.

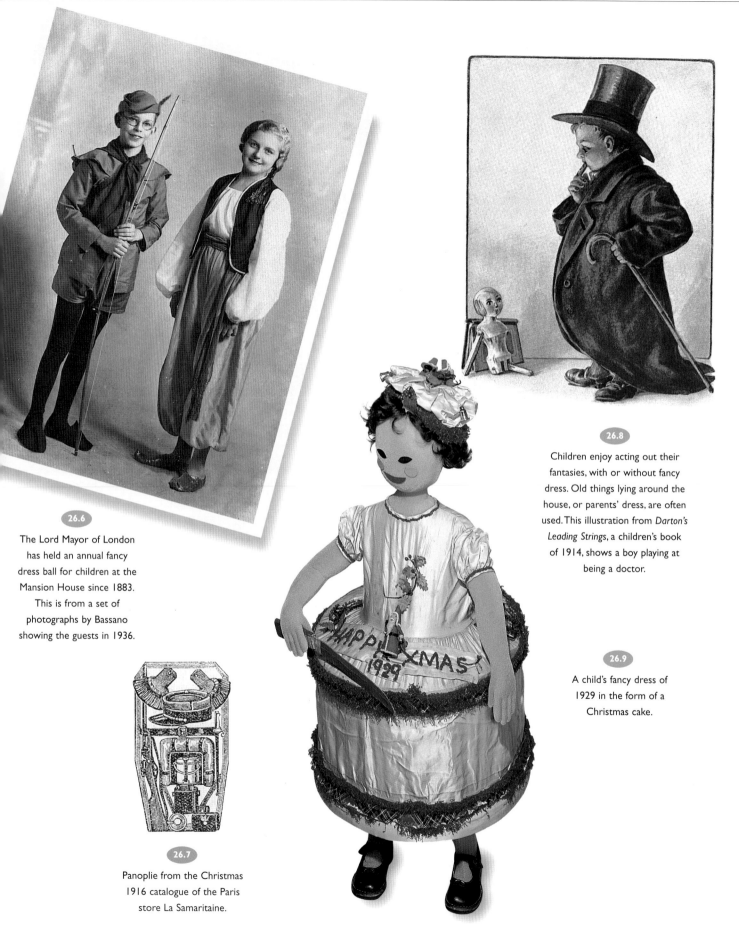

26.6

The Lord Mayor of London has held an annual fancy dress ball for children at the Mansion House since 1883. This is from a set of photographs by Bassano showing the guests in 1936.

26.8

Children enjoy acting out their fantasies, with or without fancy dress. Old things lying around the house, or parents' dress, are often used. This illustration from *Darton's Leading Strings*, a children's book of 1914, shows a boy playing at being a doctor.

26.9

A child's fancy dress of 1929 in the form of a Christmas cake.

26.7

Panoplie from the Christmas 1916 catalogue of the Paris store La Samaritaine.

LEARNING THROUGH PLAY

Educational theorists throughout the ages have almost always been sympathetic to children, as one would expect, since they wish to communicate what they know to children. The first-century Roman writer, Quintilian, suggested instruction in the form of play, using toys like ivory letters of the alphabet. The 16th-century humanist, Erasmus, liked the idea of using a bow and arrow to shoot at three-dimensional letters, with a cherry as a reward for a hit, and John Locke, the 17th-century philosopher, also believed in using toys to teach. But full-time teachers easily became stale and disillusioned, and for many children learning was a disagreeable experience of drill, rote and test. Gradually, however, learning through play became accepted through the efforts of a few reformers who, as well as being theorists, worked out their ideas in practice in schools. The first of them appeared in the late 18th century, and this was no accident, for all of them owed a debt to the revolutionary views of Rousseau. He inspired many with the belief that children were not naturally bad creatures who should be disciplined, but good creatures who should be allowed to develop as their natures prompted.

Johann Heinrich Pestalozzi (1746-1827), reacting against his own schooling in Zurich, tried repeatedly to find a better way. He taught orphans for five years at Neuhoff in the 1770s, and from 1799-1803 ran a school at Burgdorf, while producing many writings. It was his school at Yverdun, where he taught from 1804-25, that established his European reputation. He believed in teaching children by using objects and pictures, and by asking questions. His 'object-lesson' was copied by his followers.

Among those who visited Yverdun was Friedrich Froebel (1782-1852). He too was a theorist (the author of *The Education of Man*, published in 1826) and a practical experimenter. He taught in a series of schools in Switzerland and Germany, notably in Blankenburg, where he opened a school for very young children. Seeking a name that indicated his new approach, he called it a 'garden for children' (Kindergarten). His school here, and later at Marienthal, aroused international interest, but the Prussian Government disapproved and closed it in 1851.

Froebel believed that every human being was 'both a part and a whole'. Children should develop like plants in a garden, following their own natures, but they should realize that they harmonized with the totality of Nature, of the created universe. His educational methods were intended, therefore, to give the child a sense of a great systematic unity underlying the world. He invented a kit of geometrical toys (he called them 'gifts') and a series of related 'occupations' (modelling, sewing, stick-laying, paper-weaving). All this could be easily codified. Under the influence of the rich female patrons whom Froebel had attracted, his methods had become recognised throughout Europe by the end of the 19th century.

Both Pestalozzi and Froebel persevered through hard times in backwater schools. Maria Montessori (1870-1952) came on the scene when progressive education had gained greater momentum. Like Pestalozzi and Froebel, she saw the child as a developing organism following innate natural laws. As a feminist and a medical doctor, she was less interested than they in philosophy, being more empirical and behaviourist, and familiar with the newly developing study of child psychology. She too devised teaching methods which used a range of practical equipment.

A kindergarten class in England, from *The schools for the people* (1871) by George Bartley.

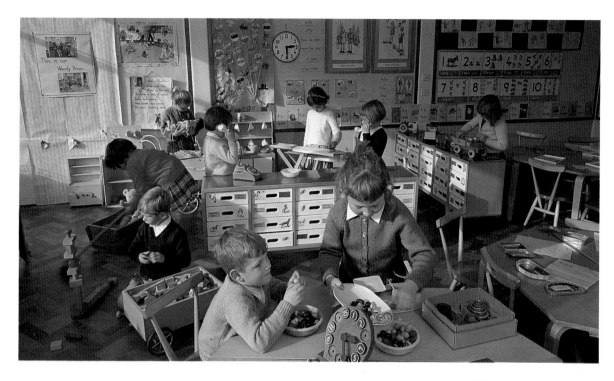

27.2

School scene, 1963: children playing with
Kiddicraft toys (see section 28).

Her methods swept across the globe after the First World War, and learning through play has never looked back.

Rousseau might not have approved. Disliking formal education of any kind, he might have felt that learning through play was a betrayal of play. If play is defined as free spontaneous activity for its own sake, with no external purpose, should it be shackled to learning? Rousseau believed that a child would find things out naturally: 'Instead of keeping [the child] mewed up in a stuffy room, take him out into a meadow every day; let him run about... Do you think this time of liberty is wasted? On the contrary.'

27.3

One of Montessori's learning toys: 1987 version of a
buttoning frame. Montessori devised a series of frames 'to
which are attached pieces of stuff, leather, etc. These can
be buttoned, hooked, tied together - in fact, joined in all
the different ways which our civilisation has
invented for fastening our clothing'.

DEVELOPMENTAL TOYS

In the early sections of this book, we have already noticed 'developmental toys' - toys which help babies and infants to gain control over their physical and mental skills. We return to them here because their invention and refinement is a further stage in the history of learning toys. It follows on from the work of Froebel, teaching infants in his kindergarten, and Montessori, interested in 'backward' children. Later educationists and psychologists moved the focus of their attention back to a child's earliest months and years. By experimental observation they established that most children become able to do certain things at certain times, and so child development can be charted through a series of stages.

28.1

Perhaps the best-known work on the stages of children's development - and the place of play in it - is that of Jean Piaget, but he did not begin to publish until 1937. For some years before that, Charlotte Bühler and Hildegard Hetzer in Vienna had been publishing the result of their researches into children's very early years, and in 1931 Hetzer published a short book entitled *Richtiges Spielzeug für jedes Alter* (The right toy for every age). Toy makers took heed.

In England, Paul and Marjorie Abbatt had started a toy business in 1931 and later opened a toyshop designed by Ernö Goldfinger. In the late 1930s they issued a catalogue, *25 best toys for each age,* which introduced the now familiar range of toys: pegs to fit into blocks; Russian pyramids (graduated rings that fit over a stick); building blocks; nesting boxes; hammerpeg toys; the posting box, in which certain shapes have to be put through matching holes; the 'abacus' (coloured balls that fit over graduated pegs); and the climbing frame. The Abbatts had all these made from wood.

These somewhat austere and expensive toys only became widely popular when the use of plastics permitted bright colours and mass-production. The entrepreneurial Hilary Page had been making what he called 'sensible toys' in wood in the '30s, but changed to plastic in 1937 when he found a suitable material which he called 'Bri-plax'. His Kiddicraft firm prospered, as did other entrants to this field, such as Galt Toys (originally founded in 1836) and Early Learning (1974).

Developmental toys tend to be abstract or symbolic. Since minutely detailed copies of things in real life appeal to older children but not to babies, developmental toys have been an especially attractive field for designers. And since these toys must have high standards of function and safety, why not have high aesthetic standards as well? The work of designers such as Antonio Vitali, Kurt Naef and Patrick Rylands stands out, and evidently inspires commercial firms making early learning toys.

28.1

Toys by Antonio Vitali. An Italian brought up in Switzerland, Vitali studied to be a sculptor, became a photographer, and took up toy making after the Second World War. He could be considered the Henry Moore of toy making, always seeking in his plain wooden toys a subtle simplicity of form and texture. An association with the American firm of Creative Playthings, in the 1950s, enabled him to find ways of reproducing his toys mechanically.

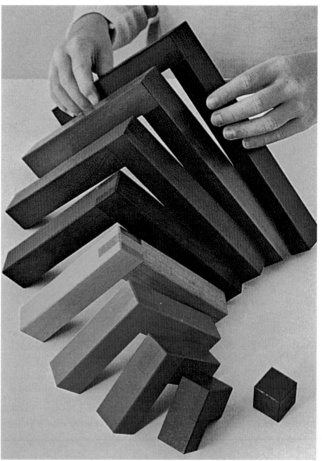

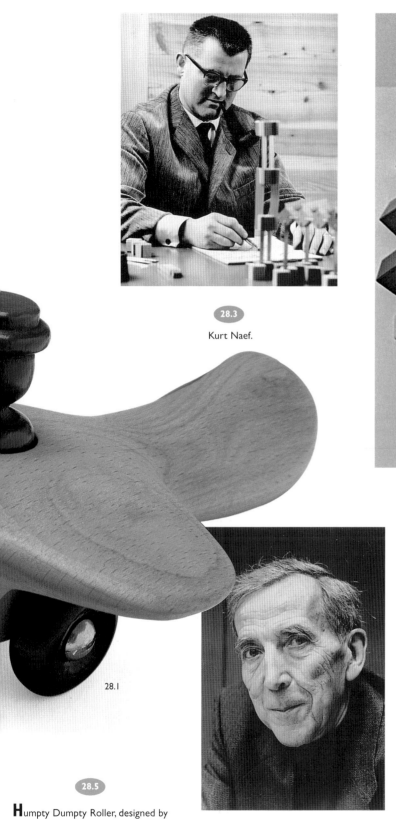

28.3

Kurt Naef.

28.1

28.4

Multi-coloured toy, 'Angular', designed by Peer Clahsen, one of the talented group of designers Kurt Naef gathered around him. A German designer, Naef collaborated for a time with Vitali, but his and his colleagues' toys are strongly geometrical and use bright colours.

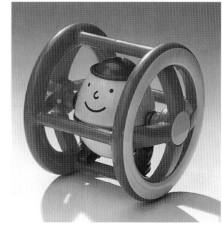

28.5

Humpty Dumpty Roller, designed by Patrick Rylands. Some of the most elegant plastic toys of today come from the Dutch firm Ambi Toys.

28.2

Antonio Vitali.

28.5

—29—
DOLL'S HOUSES

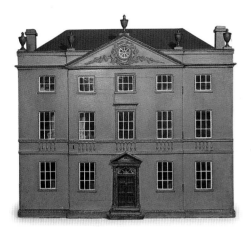

29.1

Make-believe, or 'role play', is practice for real life. Playing with a miniature house can reflect life in a child's real home, and foreshadow a future domestic life. But when one looks into the history of doll's houses, one finds that there is real doubt over whether the earliest examples were intended for children at all. Furthermore, adults still have a strong interest in doll's houses, and devote much money to them.

Four hundred years ago, perhaps, there were small, simple doll's houses that children played with and wore out. The ones that survive are, not unexpectedly, large and elaborate. The families who owned them treasured them carefully over the years, and they are almost all now in museums. Adult doll's house collectors today are lucky to get hold of anything older than about 1850.

There is a group of 17th-century doll's houses in the Germanic National Museum at Nuremberg. These are beautifully furnished with all the equipment necessary for life in a prosperous household. Full-size equipment of this kind from the 17th century has almost entirely disappeared. Perhaps a few metal vessels may survive, but pots will have been broken, linen will have perished. In the doll's houses, however, such equipment is still there and, with the help of documentary evidence, can be used to reconstruct the daily life of the past - as Leonie von Wilckens, a curator at the Germanic Museum, has shown in her books.

One doll's house of this period (now lost) was written about by its owner, Anna Köfferlein. She wanted people to pay to come to see it, and wrote verses to advertise how useful this would be. She claimed that it would help young girls to learn the art of household management. But it is significant that she stressed that the girls should only look at her doll's house; she did not offer to let them play with it. No doubt the houses did inspire young ladies to be house-proud. But perhaps family pride was what the houses were really about, rather than instruction.

Doll's house, c.1800. This is a doll's house that successfully imitates architecture, observing classical proportions. It was made for the sisters May and Isabella Foster, who belonged to a Liverpool family.

Doll's house, 1942. Although it is easy in the 20th century to buy complete doll's houses, many parents enjoy making them for their children. This one was made for Rita Flower in 1942 by her father. With its florid colours and rough finish, it is a true piece of folk art.

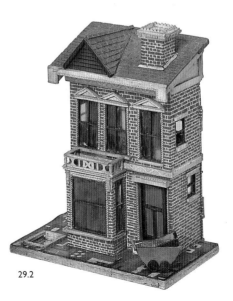

29.2

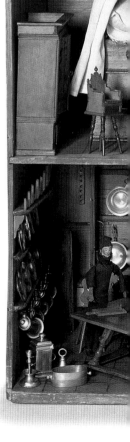

29.3

This room is one of four in a doll's house of about 1835 belonging to the family of a Manchester doctor, Egerton Killer. It is recorded that his children were not allowed to play with it (and so all its contents survive in pristine condition). Many of the fittings were ordered from London, 'and the children would watch the scarlet-liveried footman go to the mail-coach to see whether it had brought the drawing-room couch or the beautiful bedstead for their dolls'.

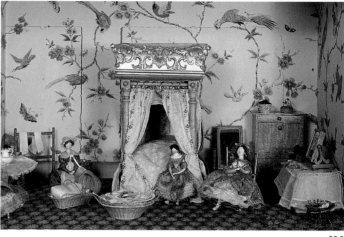

29.3

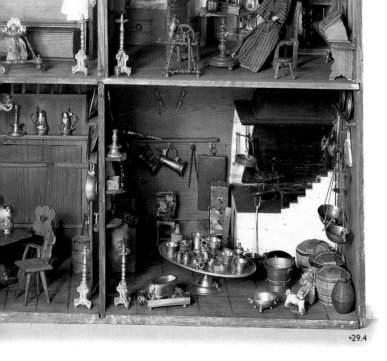

This seems even more likely with a group of yet more splendid houses in Holland, now in museums in Amsterdam, The Hague and Utrecht. From the outside, they do not look like houses. They are in cabinets, and therefore seem comparable with the 'Antwerp Cabinets' of the 17th century. These princely diversions presented a spectacle of minute craftsmanship, lavish intricacy and visual illusion through ingenious systems of drawers, cupboards, niches and mirrors. The pleasures offered by the doll's houses are not dissimilar. These houses are associated with named young ladies (Petronella Dunois, Petronella Oortman, Petronella de la Court, and Sara Ploos van Amstel), and this may suggest that they were made to celebrate the growing up of these girls, to mark a rite of passage.

England enters the story around 1700. Again, there are some half-dozen magnificent houses, two still in family possession but the others publicly accessible. The grandest, at Nostell Priory, Wakefield, is in a National Trust house, as is that at Uppark, Sussex. The Museum of London has the Blackett House, and the Tate House is in the Bethnal Green Museum of Childhood.

29.4

The only authentic Nuremberg house outside Germany is this one in the Bethnal Green Museum of Childhood. It is smaller than the examples in the Germanic Museum, with only four rooms, but has gables decorated with stars, common in Nuremberg until prohibited at the end of the 17th century (in high winds they fell down on people's heads). This house is inscribed with the date 1673, and is full of well-made household equipment.

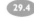

•29.4

It is likely that the miniature domestic equipment in doll's houses of this type was made by the same craftsmen who made full-size equipment. Each little item would be a one-off creation by an expert in copperware, wood-turning or another appropriate craft. But in the course of the 18th century, doll's houses and their fittings began to be made in quantity as toys. A 1762 advertisement for an English toy shop offers 'Fine ... Baby-Houses [as they were then called], with all Sorts of Furniture at the lowest Price'. In the 1790s the Nuremberg novelty merchant Bestelmeier advertised doll's houses in his catalogue, with the words 'children may arrange the furniture inside and play with it'. By the 19th century, doll's houses were certainly being aimed primarily at children.

Most early 19th century doll's houses are individual creations, but by the end of the century houses were mass-produced by firms such as Lines in England and Bliss in America. Bliss houses imitate the elaborate architectural styles of American wood houses. Reproducing the fiddly detail of this in miniature would have been very difficult, so it was printed lithographically on paper and this was stuck over the wooden carcase of a doll's house, to give an attractive effect. In Germany, dolls' rooms, open at the top - in effect, interiors without exteriors - were the norm rather than houses.

In the 20th century, educational designers have tried to simplify doll's houses to make them easier to play with by small children. At the same time adult enthusiasts, especially in America, support flourishing bands of craftsmen who take enormous pains to achieve minute accuracy. But part of the charm of doll's houses lies in their imperfections. Architecture is crudely paraphrased by carpenters, and furnishings can rarely be made to possess texture, shape and tension in a right relationship, corresponding to their full-scale counterparts. Nonetheless, total verisimilitude is what modern collectors want.

For children, perhaps the best sort of doll's house is the one made by a parent, with love. Fortunately for the parent, there are many assemble-it-yourself kits on the market today.

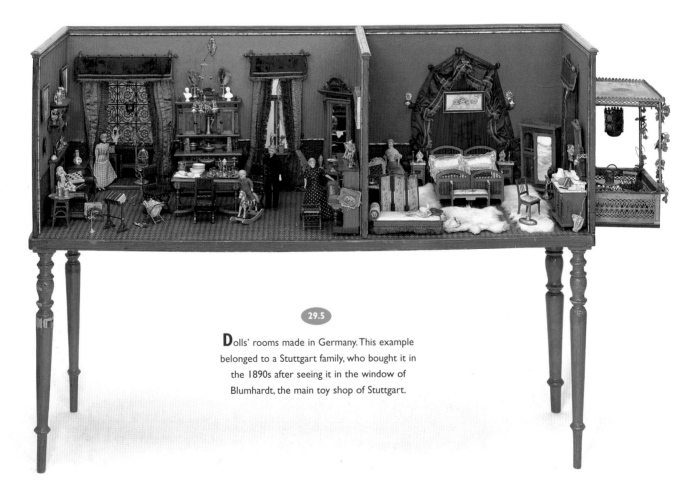

29.5

Dolls' rooms made in Germany. This example belonged to a Stuttgart family, who bought it in the 1890s after seeing it in the window of Blumhardt, the main toy shop of Stuttgart.

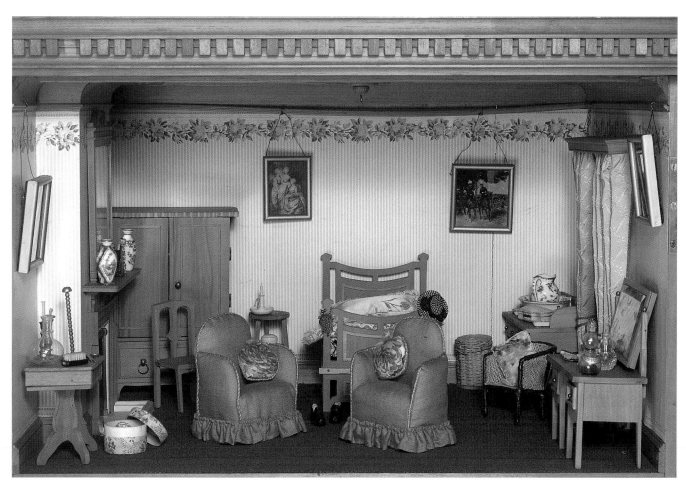

 29.6

Room from a two-room house by David Allen (the 'tapissier' at Buckingham Palace), furnished to Queen Mary's instructions. The best-known doll's house in the world is the one in Windsor Castle, given to Queen Mary in 1924 - it was her keen interest in miniatures that inspired this gift. Many other doll's houses passed through her hands, and she gave several to the Bethnal Green Museum of Childhood. She gave this one to the Museum in 1924.

29.7

Detail of a modern doll's house designed by Roger Limbrick in the 1960s for Galt Toys. It has no walls, so that several children can gather round it to play, and its furniture, by DOL-TOI, is simplified.

— 30 —
SHOPS

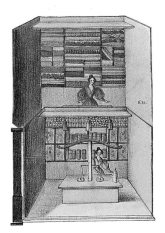

There is no doubt that children like playing at shop. Using their imaginations, they can do it quite satisfactorily without much in the way of wares to buy and sell, just a few oddments found in the home. Still, it is no surprise that miniature shops, made as toys, do survive from history. Examples can be found in museums all over Europe, owing their survival no doubt to the fact that they were finely and elaborately made. Sometimes – a sad sight – carcases of shops turn up at sales, bereft of most of the tiny produce which would have lent them fascination.

30.1

Miniature shops, of a rather rudimentary type, in the catalogue of Louis and Eduard Lindner of Sonneberg from about 1840.

Shops as toys could hardly have been made before shops became a well-established part of real life, and so we do not know of any dating from earlier than the end of the 18th century. Examples, covering various trades, are found in the illustrated catalogues (1794-1807) of the Nuremberg dealer Georg Hieronymus Bestelmeier. This gets the history of miniature shops off to a good start. (The miniature town, 'Mon Plaisir', belonging to the Princess Augusta Dorothea von Schwarzburg-Arnstadt and dating from the first decade of the 18th century, is still at Arnstadt and contains a number of shops, but these hardly count as children's toys.)

After this, it is difficult to map any landmarks. In Germany miniature shops, like the kitchens and rooms (Puppenstuben) which have a longer history, had as their basic form an open box, with base and three sides but no top or front. This was obviously practical, as it enabled children to get at the produce and play with it, even if it did not closely mimic the shape of real shops. German examples of the late 19th century, of which there are many, often have this basic shape trimmed with mouldings and fretwork, and filled with complicated shelves and drawers. The shops sometimes seem to be approaching the form of Victorian sideboards or dressers, in all their elaboration.

Almost any kind of shop that could take a child's fancy was made in miniature. There are some fine early 19th-century milliners' shops in the museums of Nuremberg, Stuttgart and Copenhagen. In the Paris stores before the First World War the épicerie seemed to be the most favoured type of shop, but there are no clear trends to be detected.

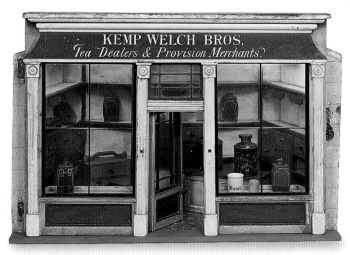

30.2

English shop, thought to date from about 1875, which actually looks like the outside of a real shop.

You can still get toy shops in the old style. But, reflecting changes in retail trade, you can also buy, in brightly coloured plastic, toy supermarket trolleys full of produce as well as miniature electronic tills.

Toy shops can have a serious purpose, teaching children how to buy and sell. But perhaps it is their small-scale intricacy and profusion that chiefly appeals to children.

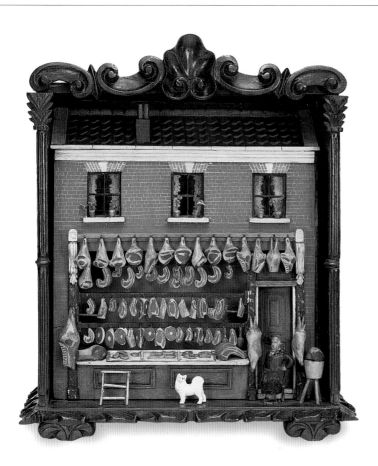

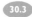

English butcher's shop, dating from about 1880. Made by a Mr Pells, a woodcarver in Hackney, it is supposed to have been modelled on the shop of a local butcher named Tichbourne.

Butcher's shops of this kind, showing the front of a building hung about with carcases (as butcher's shops used to be), seem to be a peculiarly English type of folk art. Many survive in museums, and further examples turn up in sales from time to time. They do not seem to be children's toys, since many are in glass-fronted boxes so could not be played with. It is thought - but hard evidence seems to be unavailable - that they were used by butchers as a form of window display at times when they could not display meat itself: after closing hours, perhaps, or in hot weather. They are striking pieces of popular sculpture.

30.4

Home-made shop, constructed for Ivy Davies by her father in about 1910.

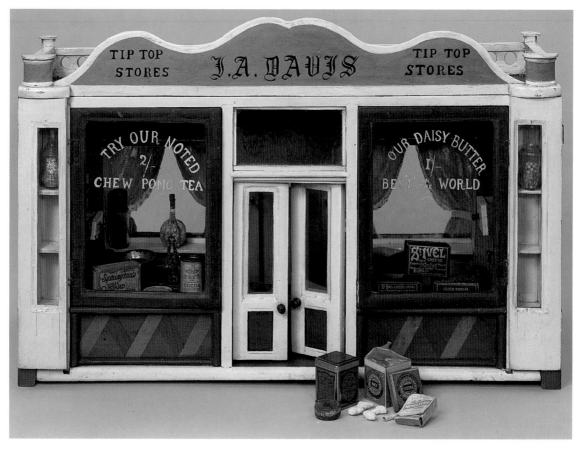

— 31 —
DOLLS AS ADULTS

An English wooden doll
of about 1700-20.

In the auction houses some types of doll fetch big prices, such as 18th-century English wooden dolls and the best of French 19th-century bisque-headed dolls, with their rich and elaborate costumes. These are dolls that appeal to adult collectors. Like other collectors, doll collectors are concerned first with identification, so they learn to check out a range of features: what a head is made of and how the details are applied, how a body is constructed, how a costume is made. Dolls often carry trade marks, so interpreting these is an important skill. As they learn their subject, doll collectors proceed to acquire a sense of the rarity, historical significance and cash value of the dolls they see. But collectors always focus first on physical qualities, so the history of dolls has usually been written in terms of the materials from which they - or, at least, their heads - are made: wood, wax, composition (a papier-mâché or wood-pulp mixture), china, bisque, cloth, celluloid, plastics. A history based on materials turns out to be more or less a chronological history, since the various materials were used in succession, though of course makers did not cease to use an old method when a new one came along.

On the whole, in the past dolls were not produced to be sold to adult collectors (though there is a very active collectors' market today, especially in the USA). Since they were playthings for children, an alternative history of dolls might look at how they were used. This has only been done patchily because it is difficult to find evidence from periods beyond the memory of living people. But certainly developmental psychologists and educationists have been interested in what children do with dolls. A pioneer student of child development, James Sully, remarked in 1899: 'If dolls could tell us what they are supposed, as confidantes and confessors, to hear from the lips of their small devotees, they might throw more light on the nature of "the child's mind" than all the psychologists'.

A third way of looking at the history of dolls is to concentrate on what they represent. Do dolls take the form of females more often than males? Do dolls take the form of adults, children and babies and, if so, why and when? There is enough evidence to show that children played with dolls in the Middle Ages, but virtually no specimens survive to show us what these dolls were like. Some must have been improvised and almost abstract. The early 15th-century Scottish poem *Ratis Raving* speaks of a girl making 'a cumly lady of a clout' (cloth). Other dolls would have been more sturdily made of wood. One of the earliest representations of a girl with a doll is in Cranach's painting of Charity in London's National Gallery. Allowing for the fact that the human characters are naked (though the doll is clothed) because this is a classical allegory, we can hardly fail to see that the little girl is clutching her doll in a sort of parody of the woman holding the baby in a maternal embrace. Another glimpse of a girl 'mothering' a doll comes in a rather saucy folk tale of a doll which excretes gold coins, published in 1550 in Straparola's *Le*

31.4

32.2

An early English wooden doll, of about 1680 and made, no doubt, as a fashion doll. It is said to have belonged to someone in the household of James II and of his son, the Old Pretender.

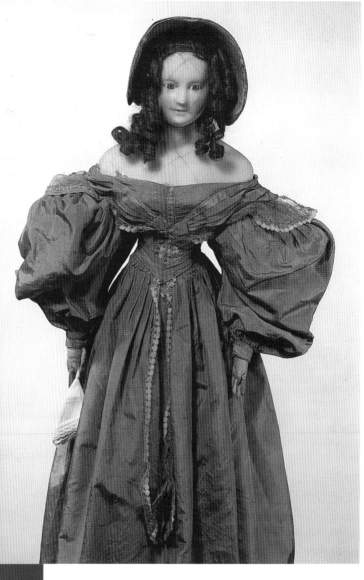

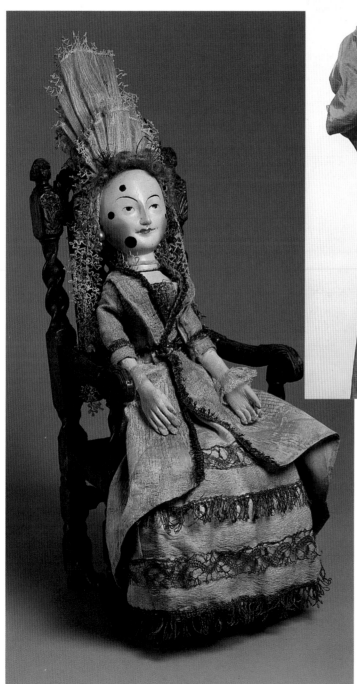

31.3

A fashion doll made in Germany in 1835.
Its head is of wax over composition.

31.4

This is one of the set of dolls kept by the Powell family (their famous collection is at the Bethnal Green Museum of Childood and records fashions between 1754 and 1913). This doll, dressed by Laetitia Clark, shows a Long Robe Coat Dress for a Lady of Sixteen, from 1758.

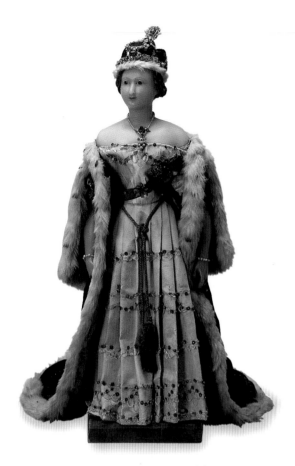

Queen Victoria in her
Coronation robes.
A wax-headed doll,
perhaps made by the
Pierotti family, in 1840.

A wax-headed portrait
doll of Field Marshall
Lord Roberts, probably
made by the Pierotti
family about 1900.

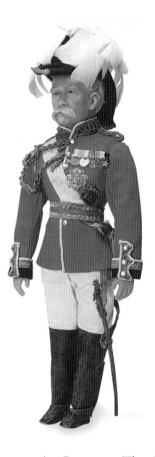

piecavole noti and in 1636 in Basile's *Pentamerone*, two of the earliest printed sources of fairy tales.

On the basis of such evidence it could be argued that, in early modern times, girls played with dolls as if they were children, but the dolls usually took the form of adults. This has to be largely speculation, but as our historical enquiry moves on through time into the periods from which actual dolls survive, it seems to be corroborated. In the 17th and 18th centuries most dolls (of wood and composition) were in the form of adults. In the 19th century, however, wax dolls quite often took the form of children, as did bisque-headed dolls. Convincing baby dolls were produced in composition in the early 20th century, and became widely popular when plastics were adopted for doll making. If this progression in the form taken by dolls occurred, it would relate to the widening awareness and enfranchisement of children which seems to have developed over recorded history. We will follow the fortunes of child and baby dolls in the next two sections.

Here we will look at dolls in adult form. The earliest cheap wooden dolls came, along with other wooden toys,

from the toymaking centres in Germany. The Gröden valley in the Alps, now in Italy, was the home of the 'peg wooden' or 'Dutch' doll. Although these are not known to have been produced before the 17th century, they have followed an accepted shape ever since, until the present. With turned head and body, and stick-like jointed limbs, they have a form that was no doubt largely dictated by ease and speed of making. But they do have adult proportions. Their faces are stylized (hardly more than a few dots and dashes), so they could play the role of adults or children.

The wooden dolls produced in England in the 17th and 18th centuries are similar but usually better finished. (They are often called Queen Anne dolls, but since they were produced through a period of over a hundred years, the inclusive American term 'Mary Anne Georgians' seems more apt.) They too have stylized faces, slightly more human than those of the peg woodens. Instead of being a turned sphere, they have subtle planes; and large almond-shaped eyes give them a quizzical air. Although such a doll might occasionally be dressed in a girl's clothes, its body would have adult proportions. The parts

of the bodies that were hidden under costume were finished with varying degrees of care, but the Bethnal Green Museum of Childhood has an example with shaped bosom and painted nipples who is clearly adult (31.1).

While most were made as playthings, dolls have been used from time to time for transmitting fashion design. Fashion prints, first widely used towards the end of the 18th century, put paid to this use for dolls, but before then it was convenient to inform customers about the latest modes by circulating miniature versions on doll mannequins about 2 feet high. These were called pandoras, and were often just a framework without legs, since it was the dress that mattered, not the doll.

Porcelain was used for dolls' heads from the 1830s and, in its unglazed, more realistic form, bisque, from the 1850s. Dolls made in Paris were the market leaders, largely because of their exquisite fashionable costumes. Often called 'fashion dolls' these were not pandoras, but were intended as toys, albeit for fashion-conscious adolescent girls. Part of the fun of playing with them was to dress and undress them. They often came with trunks full of alternative costume. Part of the fun for modern collectors of these 'parisiennes' is to study the bodies under the costume. Most of these (apart from some made entirely of wood or com-

position) look odd because they are made of stuffed kid to which bisque heads, arms and sometimes feet are attached. Compared to the real female frame, they seem like women who have suffered ghastly mutilations and have been strapped up with bandages, surgical corsets and prosthetic appliances.

The early 20th century saw the rise in Germany of the 'Art doll', made by Marion Kaulitz, Lotte Pritzel and others. Ever since, this art (or craft) has flourished, and there is an annual International Prize for the Art of the Doll, held at various venues in Germany. These dolls, emphatically for adults, have usually depicted adults in many fantastic guises. But some have offered a sentimental view of what might seem charming about childhood - innocence, dreaminess, cheekiness. And some have had a mild erotic charge, depicting danseuses, nymphs, and sometimes nymphets.

The 1960s were startled by the appearance of Barbie dolls in America (from 1959), closely followed by Sindy dolls in England. These were the parisiennes of their day: aimed at adolescent girls and with a huge range of alternative costumes to be slipped on and off their streamlined plastic bodies. Like Action Man toys for boys, these dolls undoubtedly pander to gender stereotyping.

31.7

The Barbie concept applied to the whole family. This is the Heart Family, made by Mattel of America in vinyl in 1985.

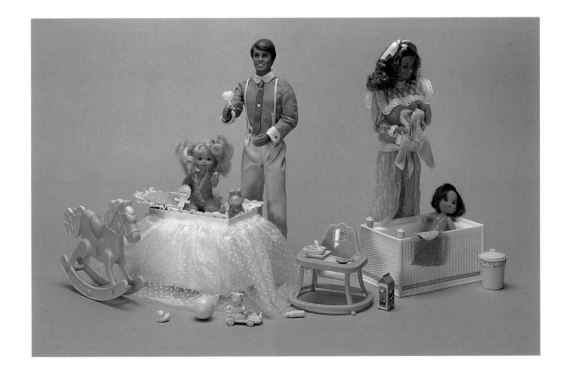

—32—
DOLLS AS CHILDREN

32.1

A wax-headed doll representing Queen Victoria's second child (and heir) Albert Edward, in 1844.

Since dolls began, many have taken the form of adults, and probably there have always been some dolls in the form of children. However, there were more dolls in child form in the 19th century than there had been before. Various ideas can be advanced to account for this. Children were, from the mid-18th century onwards, much more often and more sympathetically portrayed in other visual media such as paintings, sculpture, prints. As we have seen in section 19, there was much more literature for and about children. If stories dealt with children, then dolls - the focus for a child's own experiments in fiction and fantasy - might also appropriately take the form of children. The doll-dressing books that suddenly popped up around 1810 are a symptom of this. Adults use fiction to point morals for children, and can use toys for the same purpose. If you want to use your child's doll to teach how a child should behave, the ploy will work better if the doll looks like a child (rather than like a lady of fashion). In England, another influence that worked on dolls was popular interest in royal children: Queen Victoria provided a regular supply of these between 1840 and 1857.

Wax modelling for artistic and medical purposes was a well-developed craft from the 15th century onwards. The exhibition of wax models in travelling shows was a popular entertainment in the 18th century. Madame Tussaud's show, set up in London in 1802, was the most famous and long-lasting of many. Since there were plenty of wax modellers in London, it is no wonder that some turned to dollmaking. What is odd is that wax dollmaking did not develop abroad to the extent that it did in England. The principal dollmakers were the families of Pierotti and Montanari. The latter were a big hit at the Great Exhibition of 1851, while the former were in business longer, from 1793 into the present century.

Wax dolls were certainly made in the form of adults. Sometimes these were used as fashion dolls: the Bethnal Green Museum of Childhood has the famous Powell family collection which records ladies' fashions from 1754 to 1913, and several of these are wax dolls. Because wax modellers were used to sculpting portraits in wax, some wax dolls represent real people: the Museum has a Queen Victoria doll dating from early in her reign. But many wax dolls were unmistakeably children, as demonstrated by their faces and their dresses. The faces, made by pouring hot wax into a mould, are often rather stylized (as were those of the wooden Mary Anne Georgians before, and the bisque dolls later on) but the stylization is more childish than adult. Dress makes it clear that many wax dolls were meant to be little girls.

32.2

A wax-headed doll in the form of a child. Made by the Pierotti family in about 1870.

32.3

A 'bébé', with bisque head and
limbs and kid body, made by
Bru of Paris in 1890.

32.4

Bisque-headed doll, 'Cedric',
by Simon & Halbig of Germany
from about 1903.

not signify a baby but meant 'small child'. Henceforth the parisiennes lost favour, and the French producers concentrated on the bébés. These eventually became the dolls most sought after by early collectors.

It has been claimed that the appearance of these dolls indicates a change of mood among children: they now preferred dolls which were a reflection of themselves in the present, rather than a symbol of what they would become in the future. But you might wonder whether children really had any say in the matter, which must have been decided between the buyers and the sellers - parents on the one side, manufacturers on the other. At any rate, bébés became the rage. Underneath their clothes they had the same strange construction as the parisiennes, and the faces were not very different, with their huge, widely-spaced eyes, and tiny rosebud lips constricted between heavy cheeks (which, in a real woman, would soon turn to jowls).

A move towards realism came in Germany, after the trade had been unsettled by the success of the new Art Dolls at an exhibition in Munich in 1908. Now makers such as the Heubach Brothers and Kämmer & Reinhardt commissioned heads with realistic expressions - laughing, frowning, crying, whistling. These were used for dolls representing both babies and small children. Significantly, many more dolls were made in the form of small boys than had previously been the case. These newly individualized bisque-headed dolls are known as 'character dolls'.

We have already noticed that the production of bisque-headed dolls was in full swing by the mid-19th century in France and Germany, and that some of these, the 'parisiennes', though intended as toys, were depictions in miniature of adult fashions. The best-known makers in later 19th-century Paris were Jumeau, Bru, and Steiner; in 1899 a group of makers, including Bru and Jumeau, joined together under the trade mark SFBJ (Société Française de la Fabrication de Bébés et Jouets). German dollmakers, it was thought, outdid the French in quantity but not in quality. Their big names were Armand Marseille, Kämmer & Reinhardt, and Simon & Halbig. In 1878, at the Paris International Exhibition, a new trend emerged among bisque dollmakers: the 'bébé', which confusingly did

Perhaps we can detect here an attempt to make dolls more child-friendly. We might regard in the same light the renewed popularity of cloth dolls in the late 19th and early 20th century. If a girl in the 15th century could make 'a cumly lady of a clout', there seems every reason to suppose that mothers and children went on making cuddly

32.4

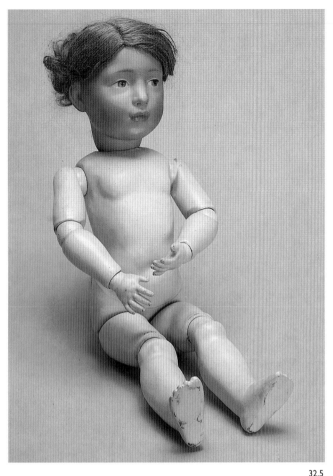

32.5

32.6

dolls of cloth. These home-made dolls were so easily worn out that none have survived. Cloth dolls became noticeable again at the point when it became worthwhile for somebody to mass-produce them. Of course, some dolls with wooden, wax or bisque heads had stuffed cloth bodies. Before all-cloth dolls could become successful, someone had to find a way of making a convincing cloth head. This was achieved in the 1890s by Martha Chase of Pawtucket, Rhode Island, who used a modelled face-mask under the stockinette outer skin of her dolls, to quite realistic effect.

In Germany Margarete Steiff, famous for her soft toy animals (see section 11), also made soft dolls with moulded heads. These were of felt, stiffened to hold the shape of the face, though the realism was usually slightly spoiled by a seam which ran right down the middle. More artistic versions of this sort of doll were made by Käthe Kruse in Germany (from 1911) and the Lenci firm in Turin (from 1918). Both these firms are still in business. These shaped rag dolls were of a superior standard to

printed rag dolls, popular from the mid-19th century, though these were perhaps more cuddly. Although the dolls of Steiff, Kruse and Lenci included many novelty figures, it is noticeable that they often took as their subjects small children, including boys.

Royal children inspired imitation by dollmakers in the 19th century. In the 20th, child film stars excited a similar response. The most popular child star ever was Shirley Temple, 'The World's Darling', and as soon as she shot to fame in the 1930s the Ideal Toy Co. was churning out dolls in her image in sixteen different sizes, Her popularity rose again in the late 1950s and inspired new ranges of dolls in vinyl. Other child stars immortalised as dolls were Jane Withers, 'Baby Jane' (Juanita Quigley), Sonja Henie, and Margaret O'Brien.

By this time most dolls looked like children, and to market a doll to children in the form of an adult would have seemed misguided. It was clear, after the success of the film star dolls, that the associations of a doll could be a significant part of its appeal. A doll designer who

32..7

32.5

A doll made by Kämmer & Reinhardt of Germany in about 1914. Its expressive character head is of bisque. Its composition body has ball-and-socket joints.

32.6

Anne Shirley, an all-composition doll made by EffanBee of America in 1936.

32.7

A Shirley Temple doll, of composition, from the 1930s.

32.8

Sasha dolls, 1970-73.

32..8

approached this in a high-minded way was Sasha Morgenthaler of Zurich. A lonely childhood, and a later personal association with Paul Klee and the Blaue Reiter group of artists, influenced her when she made dolls for her three children. Her dolls were later mass-produced in vinyl in Stockport, Cheshire. Representing, with tactful stylization, young children of many nations they embodied an ideal of international harmony.

A contemporary example of dolls which promote ideology is the American Girl series. This includes 'Felicity, 1774, A spunky, spritely colonial girl', 'Kirsten, 1854, A pioneer girl of strength and spirit', Addy, a Civil War girl, Samantha, a Victorian beauty, and Molly of 1944. They come with background books and accessories, craft kits, dress patterns, and a teen magazine *American Girl*. These dolls aim to 'give girls an understanding of their past and a sense of pride in the traditions they share' - a worthy motive, but perhaps not quite so worthy as Morgenthaler's internationalism.

— 33 —

DOLLS AS BABIES

A German painted poupard doll, of traditional type, dating from 1926.

33.2

A modern (1990) version of the poupard doll, by German doll maker Elisabeth Pongratz.

The baby doll is said to have been invented in the 1850s. There are several twists to this odd little tale of technical innovation, and before telling the tale it is worth pausing to consider why baby dolls were not common before the 19th century. As we have seen, there are quotations and illustrations which indicate that girls always treated their dolls as children, in imitation of their mothers' behaviour to themselves - but the dolls seemed to take the form of adults nonetheless. It may be that the woodcarvers of Germany who produced the traditional 'peg wooden' or 'Dutch' dolls for centuries also produced, in the early days, 'poupards' or dolls representing swaddled babies. Certainly, they produced these in later times. It is logical, perhaps, that dolls representing babies should take this form because, for most of the time, a baby looked like a parcel. Its body, extracted from the swaddling wrappings, would have been an uncommon sight, and the idea of dandling a naked baby might not have struck mothers as a good thing for their daughters to copy in play.

We cannot assume, however, that naked babies were a censored sight during the swaddling centuries. In section 5 *putti* (cherubs) were seen to be gambolling around in paintings, prints and drawings, as well as being represented three-dimensionally in sculpture and ceramics. The expertise was there to produce a modelled baby. One particular baby was, of course, constantly represented: the Baby Jesus. Sometimes images of Jesus came very close to being dolls when made, along with other Nativity figures, for Christmas cribs (these might well be naked), or as souvenirs from shrines, or as the focus of devotion by nuns sublimating their maternal feelings.

However, the first secular baby dolls seem to have been those illustrated in the catalogues of German

33.3

A devotional doll representing the Christ Child, probably made in a convent in Italy or Austria between 1830 and 1850.

dollmakers in Thuringia - figures with large round heads, wearing only a shift from which their hands and feel protruded. These had the name Täufling or Barfussler (baptism or bare-foot doll). They were made of composition (a papier-mâché or wood-pulp mixture), to which other substances might be added to make it stronger or cheaper. The toymakers of the region around Sonneberg took to this material in a big way from the 1820s, and used it for a wide range of toys, as well as dolls. It was not used on a large scale elsewhere.

We have already noticed that under their fine clothes early dolls often had a bizarre appearance. This is true of the baby dolls, which look as though they have been made up in slices. They have composition heads, chests and shoulders, lower arms,

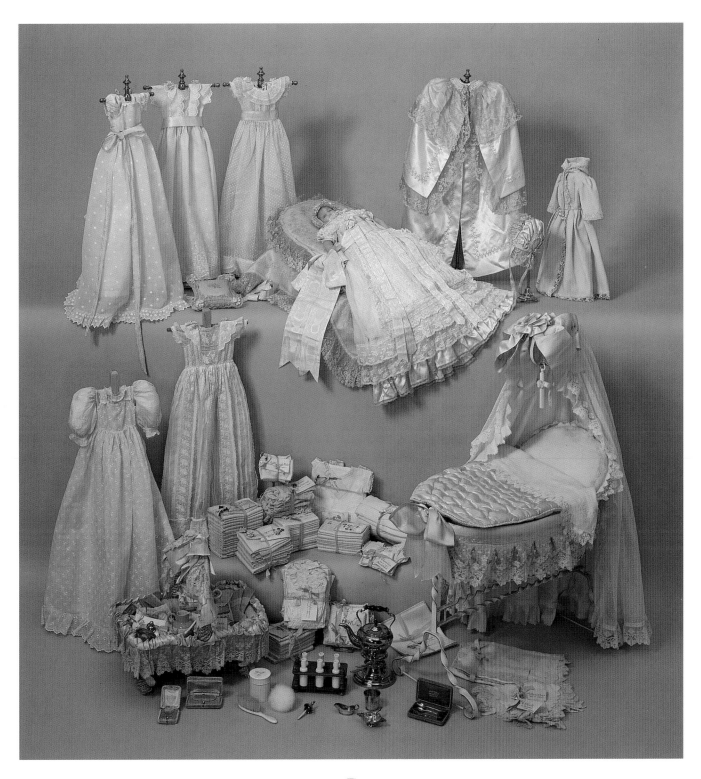

33.4

The most celebrated baby doll in the Bethnal Green Museum of Childhood's collection is 'Princess Daisy'. An English wax-headed doll, she was equipped abundantly with clothes and other accompaniments by a Dutch lady, and exhibited at the Amsterdam International Exhibition of 1895. She was eventually given to Queen Mary, and by her to the Museum.

pelvis and lower legs. The other parts are of cloth: the upper legs, the upper arms, and - most important - the stomach area. Inside this cloth section is a squeaker which makes baby noises when pressed. This way of constructing the baby dolls is directly copied from Japanese dolls. One account claims that the Sonneberg toy trader Edmund Lindner saw such dolls in Cologne on his way to the Great Exhibition in London, and decided to copy them. Another suggests that Charles Motschmann, also of Sonneberg, saw Japanese dolls at the Paris exhibition in 1855. Certainly in 1857 he took out a patent for this kind of doll, which is therefore usually known as 'Motschmann-type'. It seems odd that Europe needed the influence of Japan before it could produce a baby doll.

One of the sources of these dolls' appeal was that they made a noise. The first patent for a speaking mechanism was taken out in 1823, and there have been many later attempts, especially after Edison invented his phonograph in 1877. Equally desirable for a baby doll were eyes that could close. These had been provided in some of the early 19th-century English wax dolls, but they usually had to be operated by pulling a wire. Counterweighted eyes, which close when a doll is laid on its back, came later in the 1870s.

A convincing version in doll form of a baby, with its chubby body and slightly bent limbs, had to wait not only until the dollmakers wanted to make such dolls, but also until they had the technology. It is not possible to make a really convincing stuffed doll, from cloth or kid, in the form of an adult, child or baby. You can make a realistically shaped baby from ceramic, and tiny unjointed porcelain dolls (known as 'Frozen Charlottes') were made, along with some slightly larger jointed dolls, but on the whole porcelain was too heavy and fragile to make big dolls. Some of the bisque dolls, from the 1870s on, had carved wooden bodies but more often composition bodies, with childish or babyish contours, though their limbs often had ball-and-socket joints which looked unnatural. It was the adoption of celluloid, in the early

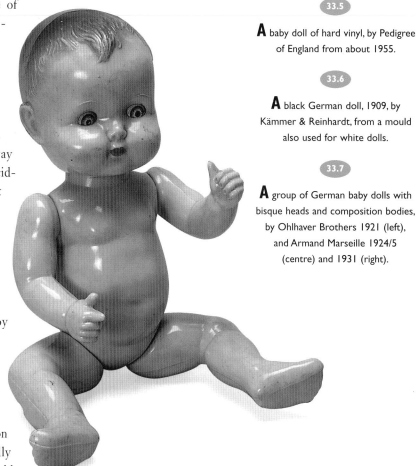

33.5

A baby doll of hard vinyl, by Pedigree of England from about 1955.

33.6

A black German doll, 1909, by Kämmer & Reinhardt, from a mould also used for white dolls.

33.7

A group of German baby dolls with bisque heads and composition bodies, by Ohlhaver Brothers 1921 (left), and Armand Marseille 1924/5 (centre) and 1931 (right).

20th century, as a material for dollmaking which allowed the first really convincing babies. These had one-piece arms and legs, which fitted neatly against a shaped torso and were held in place, along with the head, by elastic.

Celluloid dolls were made in places as far apart as Germany and Japan. But celluloid, not a sturdy substance, was easily squashable, so this material did not catch on universally. Until the Second World War baby dolls continued to be made in various materials - composition, cloth, rubber and china. But they all now had babyish or childish proportions, and undoubtedly they were accompanied by a new sentiment. The trade names of dolls produced by the American EffanBee company from 1910 onwards tell their own story: Baby Dainty, Baby Bright Eyes, Baby Huggins, Lamkin, Lovums, Baby Bubbles, Sugar Baby, Patsy Baby-kin, Baby Tinyette, Sweetie Pie, Beautee-Skin Baby, L'il Darlin', Honeykins.

From the beginning of the popularity of baby dolls at the turn of the century, black dolls have been made as well as white/pink ones, presumably for the American

markets. Quite often these were made from the same moulds as the pink dolls, and differed from them only in colour, not in cast of feature. Even when they looked right, they were often marketed (under names like Topsy, Sambo, Nigger) with the European racial prejudice that seems so blatantly offensive now but was allowed then to pass with a complacent chuckle.

Once hard and soft vinyl came into use in the 1940s, the versatile realism of these dolls was stressed by their manufacturers. The Mormit doll announced in 1949: 'You cannot tear me. You can't break me. I'm non-flam. I sleep and have a voice. You can bath and wash me. I can be fed and my nappies need changing. I float in water. My eyes are nearly human. My limbs are detachable and easily replaced. I'm irresistible'.

These functions are still what sells baby dolls, with the advantage today that many are battery-operated. Since the 1980s it has been possible to get startlingly accurate facsimiles of new-born babies, with hospital identity tags, navel bindings and modelled genitals. Most remarkable of all is the Danish 'Judith' Mother & Baby doll, from whose Barbie-like plastic body a little foetus can be extracted.

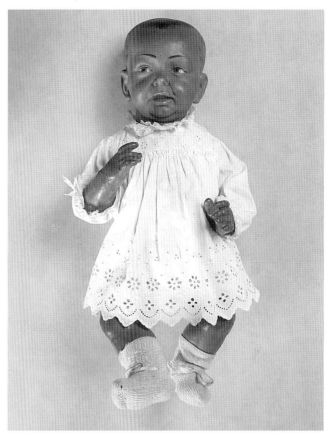

33.6

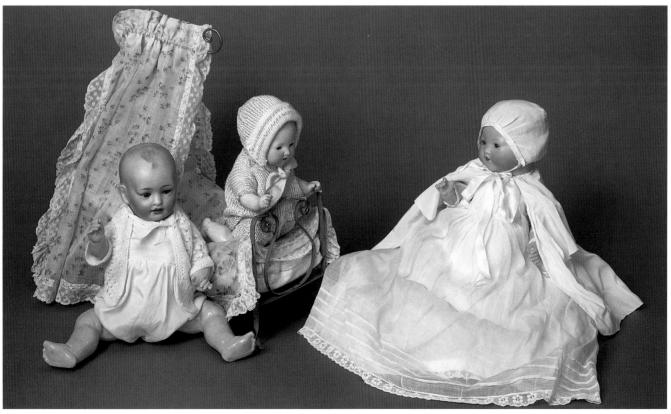

33.7

—34—

HOUSEHOLD TOYS

In poor homes, in any period, there is little household equipment and children have to help with the housework from an early age. In stately homes (in the days when they functioned) this was the business of servants, and stately children might never learn to boil an egg. Amongst the toys that crowd a museum of childhood, however, are many that must have been intended to accustom children, especially girls, to housework. There has to be a connection between the creation of the 'middle classes' and the provision of household toys.

As we have seen, the early doll's houses of Germany and Holland seem to reflect the lifestyles of prosperous merchants rather than the stately classes. A doll's house was bound to be expensive, however, and more modest household toys would have circulated more widely.

34.1

Sheet-metal enamelled stove, dating from about 1900. Made in Germany.

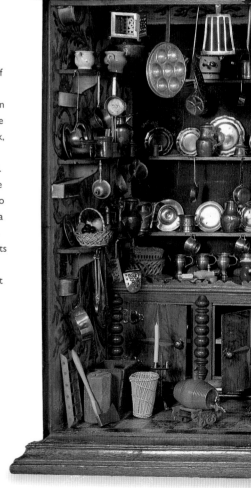

The most comprehensive of children's household kits was a kitchen - in effect, a part of a doll's house. Kitchens existed as separate items in Germany from the 18th century, but seem to have become widely available in the early 19th. Like shops, they are advertised in Bestelmeier's catalogue, and they have the same shape: an open box, without top or front. In the early standard layout, the cooking place was in the middle of the back wall. It was modelled on what was customary in real kitchens: an open fire, on a masonry base built up to a convenient height, with an overhanging canopy to catch the smoke and channel it up a flue. The second basic feature of a kitchen was lots of shelves to hold the many pots and pans. The storage of food, important in real life, did not matter much in a toy. But some kitchens (like the Nuremberg kitchen in the Bethnal Green Museum of Childhood) had a hen-coop, where chickens were fattened for the pot. Later toy kitchens sometimes had adjoining pantries.

In Germany toy kitchens can provide a complete miniature history of kitchen styles over the last 200 years. As well as equipment, they show changes in decor, from dark - kitchens with open fires painted in dark colours to hide smoke stains, with visual relief provided by the

34.2

A superb Dutch kitchen of the 17th/18th century. It represents a kitchen with an open fire: flames and smoke are painted on the fire-back, which is represented as blue-and-white Dutch tiles. The arched openings in the front of the fire-place are to contain firewood. There is a wide range of equipment. Note the kettle, which has its own little fire-basket so that it can be used apart from the main fire.

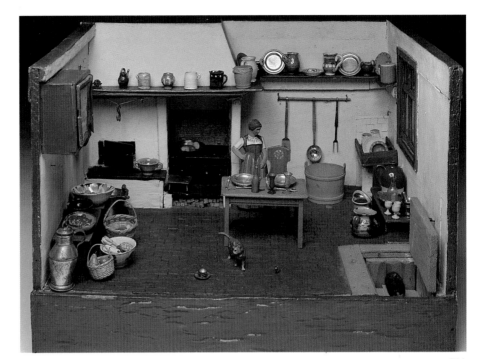

34.4

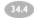
34.4

Swiss kitchen of about 1900. Though following the traditional German pattern, it looks as if it could be homemade. The stove is meant to be of iron. Equipment is sparse; no doubt this is a peasant kitchen.

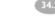

Kettle from the Dutch kitchen.

34.2

many gleaming vessels of brass and copper - to light, to the antiseptic white kitchens of the 20th century. Other countries do not seem to have produced toy kitchens so conscientiously as the Germans, but an English children's book of around 1835 shows one with a traditional English kitchen range.

As stoves changed in real life, so did toy stoves. They became operational. In Louisa M. Alcott's *Little men* (1871), Mrs Jo sets up a miniature kitchen for her niece Daisy. The centrepiece is the stove, 'not a tin one, that was of no use, but a real iron stove ... a real fire burned in it, real steam came out of the nose of the little tea-kettle, and the lid of the little boiler actually danced a jig, the water inside bubbled so hard'. Daisy was lucky, for most girls had to make do with sheet-metal stoves, produced from the mid-19th century, and in quantity around the turn of the century. You could not light a fire in these, but they often had a spirit lamp to provide heat. Fires and spirit lamps were undeniably dangerous. Only older girls would be allowed to play with them.

Mrs Jo admits to being bad at cooking, and has a black cook, Asia, downstairs. It is Mrs Jo, however, who teaches Daisy to cook, with only an incidental contribution from Asia: 'I know Asia wouldn't let you mess in her kitchen very often'. Daisy is bidden to assume the part of a servant cook: 'I'll call you

Sally, and say you are a new girl just come,' Mrs Jo pronounces. There are complicated class boundaries to be negotiated here, but of course children are adept at picking up unspoken domestic rules. Occasionally, however, a hint of class unease surfaces in the presentation of household toys, as on the box containing a toy dustpan and brush made by 'The "British Maid" Co.'. Mundane articles such as dustpans were presumably below the dignity of a decent middle-class girl, who must wear a servant's cap and pinny while playing with them. Education in housework was nonetheless necessary for middle-class girls even when servants were in ready supply, in order to equip mistresses to supervise their households.

To identify the equipment in a toy kitchen, one must compare it with the real thing. Since the beginning of this century, enthusiasts for old English life have collected domestic equipment. J.S.Lindsay's *Iron and brass implements of the English home* (1964) exemplifies the object-based approach, which, in the 1970s, gave way to the more searching scrutiny of feminists who found housework ripe for analysis, from an economic and political point of view. Ann Oakley's *The sociology of housework* (1974) is perhaps the best known of many books, which the historian of household toys must now be aware of.

It may be that today, in a servantless age, real children are drawn into real housework at so early an age that they do not need toys to practise with. Certainly, household toys seem now to be aimed at toddlers rather than teenagers. There must always have been a certain disjunction between toy kitchens and real

ones, but this seems specially acute nowadays when in a real kitchen the equipment is concealed behind cupboard doors, while the typical toy kitchen is a 'kitchen centre' or 'combination kitchen', in which a bright plastic kit is amalgamated into a sort of symbolic trophy of domestic wares, that is not in the least like a real kitchen.

Household toys, we must acknowledge, are mostly for girls. The acceptable household toy for a boy was, and is, the tool set. Plastic toy tools of today cannot do much harm, but in more literal-minded days toy tools were only too realistic. A *Punch* cartoon of 1859 shows the dire damage that results when 'a discreet (!) friend having presented Master Tom with a tool-box as a New Year's gift - the furniture is put into thorough repair'.

Printing presses and sets might be regarded as domestic toys, or perhaps as 'vocational training toys', but since they have given physical expression to many a young literary temperament, they deserve a mention.

34.5

Enamelled toy implements, made by Bing of Nuremberg. Copper and brass cooking equipment gave way to enamelled metal in the 1880s.

34.6

Miniature cleaning equipment, from a collection of 18th-century English implements given to the Bethnal Green Museum of Childhood in 1877.

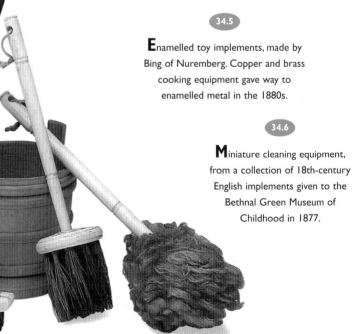

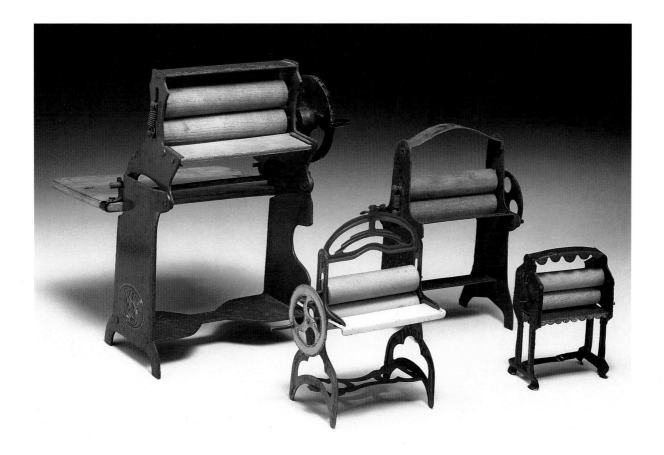

34.7

Toy mangles. Almost as important as cooking in a household was the laundry. Before washing machines, the only domestic laundry equipment for toys to reproduce was the mangle.

34.8

Tool kits for boys: about 1978 (left), 1867 (centre), 1986 (right).

—35—
HORSES

Before the invention of steam power, and then of the internal combustion engine, horses were a vital part of life. In the country they provided muscle for farming, in the towns they powered transport. No wonder that children had toy horses. Some of these - the smaller ones - were miniature copies of life, and were a way of celebrating the existence of horsepower in all its interesting variety. This type of horse, harnessed to coach, wagon or cart, is described in section 36. Other horses were usable in active play, and helped children to get used to riding while they were still too young to mount a real horse.

35.1

One of a series of prints depicting London street cries, by Marcellus Laroon, first published in 1687-8. Hobby horses, being small and light, were easily sold by travelling pedlars.

The oldest kind of active horse was the hobby horse - a stick, which a child could straddle, with a horse's head at the front end. Almost any stick would do. You could cut out a profile head and attach it to the stick, or the head might be little more than a joint in the branch from which the stick had been cut, as in the hobby horse belonging to Alfred Fuller, a rare survival, now in the Bethnal Green Museum of Childhood (see illustration 24.4). Hobby horses are so simple and breakable that most would be thrown away. However, we know from paintings on vases that they existed in Ancient Greece, and there are numerous illustrations of children playing with them in medieval illuminated manuscripts and Renaissance engravings. Such illustrations suggest that the point of these toys was to awaken an enthusiasm in children for warlike sports like the tournament, and so instill a spirit of chivalry. Even as late as 1614, in Ben Jonson's play *Bartholomew Fair*, we find a toyseller crying 'Buy a fine hobby-horse to make your

son a tilter'. There is not much that can be done to vary the design of hobby horses, but in the 19th century one or two wheels were sometimes added to the trailing back end, to make it more easily movable.

The most attractive kind of toy horse, because it looks realistic and is nearer to life size than most toy horses, is the rocking horse. There are one or two 17th-century examples in museums: the rocking horse does not seem traceable earlier than this. These early examples are more rocker than horse, for they consist of two flat sides, usually described as 'boat-shaped', joined at the top by a seat. From the front of the seat rise the horse's neck and head, the only part that need be naturalistically carved; and a tail may be attached at the back. The legs can be carved and attached to the boat-shaped sides, or can just be painted on. Folksy patterns, or background views can also be painted on. This type of horse seems to have been the norm in Europe.

English rocking-horses followed a different pattern. The

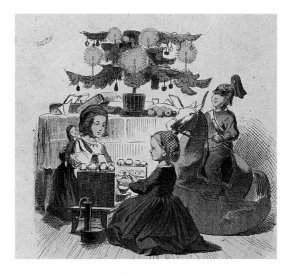

35.2

European rocking horse with boat-shaped sides, from a German children's book, *Das ganze Einmaleins*, published in the 1860s.

horses themselves were more elegant and sculptural, realistically carved and painted, often with mane and tail of real horsehair. They had a galloping posture with outstretched legs. These were attached at the hooves to curving struts that formed the rockers. The exciting effect of the taut balance of the shape was intensified by the expressions of the horses. Flared nostrils, staring eyes, and bared teeth can make these horses look positively ferocious. The English rocking horse seems to have achieved perfection of design almost immediately, and later makers have not been able to improve on the classic proportions.

They have nonetheless tried. Metal was sometimes used for parts instead of wood. Smallish horses on a light iron rocking frame seem to have been a French development. With rather roughly shaped wooden bodies, these often had cast iron heads. In 1880 a new way of supporting a rocking horse was patented in the USA. The horse's legs were attached to parallel bars, slung by iron brackets from a sturdy frame. These horses were safer than the earlier model, because they could not rock out of control and overturn. They offered the rider a more complex movement, but lacked the elegance of the gallopers.

Horses which stood on a wheeled platform, and could be pushed or pulled along by a toddler, were also popular in the 19th century. Sometimes they were clumsily distorted to make it easy for a child to sit on them. Sometimes they were realistic to the point of being covered with real skin - and these were probably

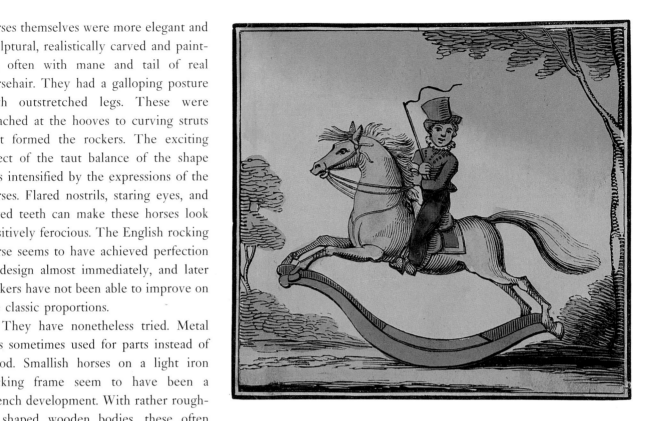

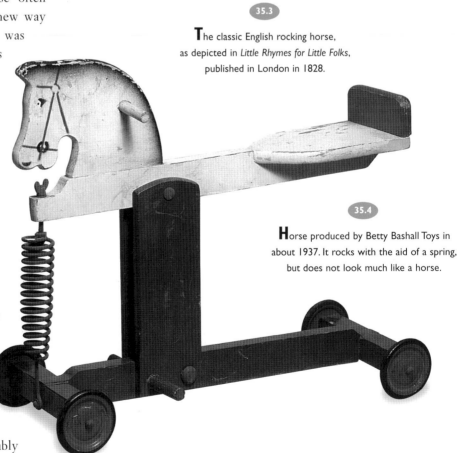

35.3

The classic English rocking horse, as depicted in *Little Rhymes for Little Folks*, published in London in 1828.

35.4

Horse produced by Betty Bashall Toys in about 1937. It rocks with the aid of a spring, but does not look much like a horse.

not easy to ride. In the late 19th century a popular pull-along version was the beech horse, an almost diagrammatic sketch in wood: barrel-shaped body, stick legs, profile head. The concept is very simple, but such a toy can be a real test of design ability: a fraction of an inch here or there can make all the difference between elegance and clumsiness.

Sometimes horses were designed to be both pull-alongs and rockers. One version of this type was basically a standing horse on a wheeled base which, when desired, could be bolted into a set of rockers. A more complicated variation of the idea was made in metal. The wheeled frame had optional metal rockers. In addition, the horse's body was supported on an expandable metal lattice which, working like scissors, could raise or lower the body to suit the stature of the rider. A technical *tour de force* which was also a quite attractive piece of design was a horse produced in the 1920s by Zoo-Kunst of Munich, makers of stylish wooden toys. This could move forward, by means of ratcheted wooden rollers built into the rockers, and thus could be raced. A feature in *Games and Toys* in November 1926 shows photographs of men in bowlers and ladies in cloche hats lurching about on these horses under the eyes of laughing policemen.

Modern designers have adapted the rocking horse in various ways, most of them inelegant. One or two versions, pared down almost to abstraction, have a stylish austerity which certainly appeals to sophisticated adults. But would children know they were horses? Another hybrid form of horse is the velocipede: a horse combined with a tricycle. In theory, this should be as nasty as a mixture of custard and gravy - but it looks good. The combination of horse and wheels does, after all, go together like a horse and carriage.

Rocking horses were playthings for well-off children, and they are even more of an expensive luxury today. Several English makers continue to make the classic models. Occasionally other rocking animals are produced, but somehow they do not catch on. As long ago as 1848 a writer in *Punch*, proposing that toy design should move with the times, said that rocking horses were out of date: soon, 'the Nimrods of the nursery will ride nothing but a Megatherium, or at least a monster steam-engine, worked with real steam'. The latter prediction came true, but the former, even while it eerily foreshadows the present-day popularity of dinosaurs, did not.

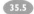

35.5

English velocipede, or tricycle horse, from about 1915.

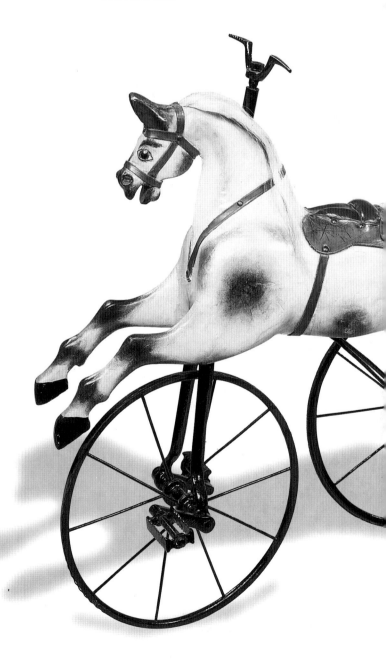

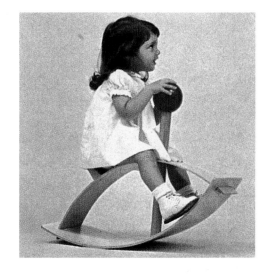

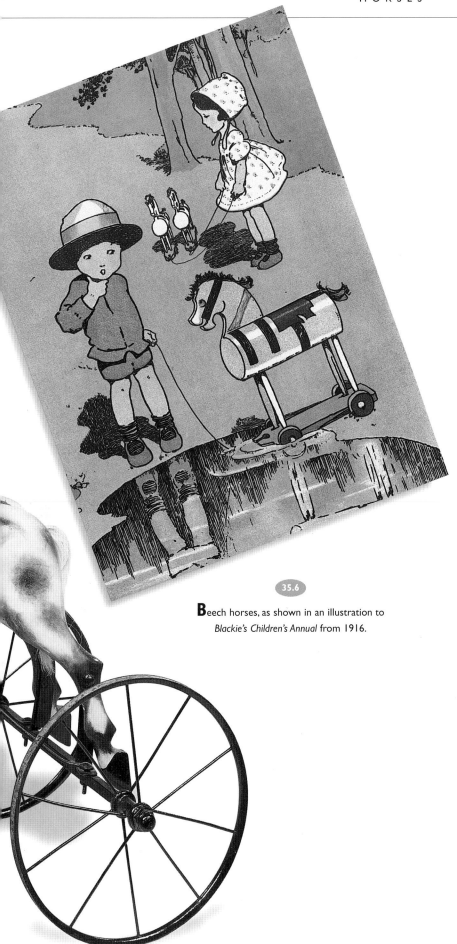

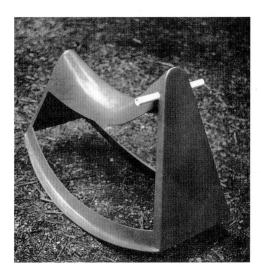

35.6

Beech horses, as shown in an illustration to
Blackie's Children's Annual from 1916.

35.7

Abstraction: wooden horse, on geometrical lines,
designed in about 1970, from the catalogue of
Creative Playthings, Princeton, USA.

35.8

Abstraction: moulded plastic horse
designed by Walter Pabst in about 1960,
as illustrated in *Esthétique industrielle*,
no. 61, 1963.

—36—
TRANSPORT TOYS

36.1

A toy stage coach dating from the 1830s, about 2 ft long, complete with passengers and luggage. Among the Bethnal Green Museum of Childhood's other vehicles are a water cart (1880s) and a coal cart (1913).

Children enjoy transport toys because the toys mimic transport in real life, and real life transport often gives pleasure to children. To some extent collectors of toy trains, cars or aircraft may be motivated by an enthusiasm for the real thing as well as for the toy. They may be motivated too by nostalgia for the forms of transport that they remember using in their own childhood. But once they are well into the business of collecting they find that it has its own values and routines, which have little to do with child's play (though collecting is no doubt a form of play for adults). Of course, collecting pleases children too, and is exploited as a marketing device by toy firms. For adults, early tinplate transport toys are 'blue chip' collectables.

It is obvious that if transport toys mimic real transport, they must have been invented in a certain order. First came toys representing animal-drawn vehicles, which can be traced as far back as the Ancient World. Toy horses and carts were fairly common playthings throughout the 18th and 19th centuries. They came at various scales. If they were table-top toys, only a few inches high, they might be made crudely of wood (along with many other traditional German toys), or could be made, with much more elegant precision, of cast metal. Bigger horses and carts (say, two feet in length), intended for a child to pull along, were almost always made of wood.

Horses and carts for both passenger and goods transport were copied. Gigs, phaetons, curricles, cabriolets and other passenger conveyances tended to be made delicately in metal, which could easily capture their curvaceous forms. Quite large examples went on being produced into the 1900s by the tinplate manufacturers who made trains. Wood was better for vehicles like farm wagons, haywains, water carts, brewers' drays, coal trucks, and milk floats. No-one seems to have made a systematic collection of toy horses and carts, though this would be almost as interesting as the various museum collections of full-size horse-drawn vehicles.

Horse transport gradually gave way to trains and cars. While wagons that ran along lines were not a new idea, steam-powered locomotives were. They came into use in Europe in the 1830s, and almost at once toy trains were made in wood, and in painted sheet metal. Metal trains started small, but got bigger and more accurate. Important German makers were Märklin (founded 1859), Bing (1865), Lehmann (1881) and Carette (1886); and Favre (1860), Rossignol (1868) and Radiguet (1872) were established in France. Often these trains were powered by clockwork.

36.2

Very early toy train (7 inches long), of soldered tin plate and hand coloured. Probably made in Germany in the 1840s.

English makers tended to prefer miniature steam engines, known as 'dribblers' because their water leaked out. Cast iron trains were a speciality in America.

By the 1890s complete miniature train systems were being devised, with rails, stations and accessories. A range of different track gauges was established in 1891 by Märklin, whose expensive, hand-painted trains are the heart's desire of today's collectors. But in America, Lionel were seizing the market for cheaper trains already. The

German hold on the market was weakened by the First World War, and in the 1920s Hornby in England set out to captivate boy enthusiasts with its chunky, clockwork Gauge O trains, undercutting the superior Bassett-Lowke productions. From the 1930s onwards, the smaller gauge OO scale model trains superseded gauge O.

The German makers mentioned above also made toy cars and boats. Children must have used sticks as boats from time immemorial, and paper boats must also have a

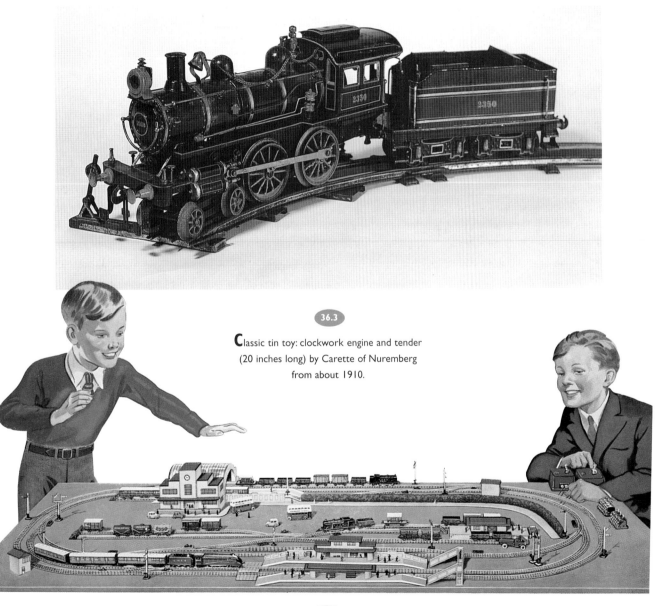

36.3

Classic tin toy: clockwork engine and tender (20 inches long) by Carette of Nuremberg from about 1910.

36.4

Electrically-powered Hornby Dublo system (gauge 00), introduced in 1938. From the *Hornby Book of Trains 1939-40*.

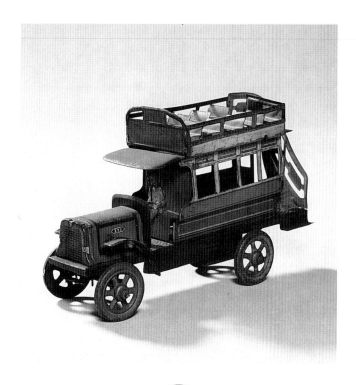

36.5

Omnibus of tin plate, with painted decoration, made in Germany in about 1920. 7¼ inches long.

long history which is almost beyond reconstruction now. Surely the kind of boat which gives most fun, because it obeys the wind rather than its owner, is the sailing boat. A completely unspoilt 19th century pleasure still available in Paris is to hire a toy boat from a barrow, and to sail it on the pond in the Tuileries Gardens or the Jardin de Luxembourg. But besides the simple sailing boats there were elaborate tin models of warships and liners. When played with these often sank, or at least got badly rusted, so surviving examples in good condition are collectors' items.

Motor cars began to replace horse-drawn carriages for personal transport in the early decades of this century, and the various types of saloon, tourer, coupé and tonneau were promptly reproduced in tin. These might be 8-12 inches long, and exquisitely hand-painted. Less expensively, decoration could be applied by lithographic printing. Clockwork motors equipped them to go for a leisurely spin across the carpet. Just as full-size vintage cars have great nostalgic appeal in their mix of jaunty and stately styling, so do the toy versions.

Miniature cars that fit into the palm of the hand were also made, but their time came after the Second World War when die-casting became common. This technique had been pioneered in the 1920s and '30s, but pre-war die-cast cars are now considered irreplaceable period pieces. Dinky and Corgi cars, and the Lesney Matchbox series, were the best known British makes. Though carefully designed as scale models, these had a pleasing solidity which enhanced their play value. Collectors seek them 'mint and boxed', i.e. not played with and in their original packaging. The producers of both early 20th-century tin toys and later die-cast models were well aware that it helped sales if their toys were part of a set or series, listed in catalogues. This encouraged children to collect, and the catalogues have served as bibles for later adult collectors.

A century of aeronautical theorizing and experiment resulted in the earliest successful flights in the first years of the 20th century. Both world wars gave boosts to aircraft design, and civil airlines were set up between the wars. The tin toy makers produced toy planes right from the start of aircraft production.

But there is a special problem with the play value of toy planes. If you want them to fly, you have to use very light materials like paper and balsa wood, and aerodynamics requires that you shape them, not in imitation of full-size planes, but so that they work. On the other hand, if you make an accurate miniature reproduction of a full-size plane, it will very likely not fly. So children had to choose between using practical kits for flyable planes (which usually got smashed) and scale-modelling kits for replica planes (which were cherished, and became adult collectors' items). The great age of the kit followed the arrival of injection-moulded plastics after the second world war, and the best-known English make was Airfix.

Space-ships have never caught on as transport toys, presumably because hardly any children have first-hand experience of them. Their time may yet come, if interplanetary travel becomes available to all.

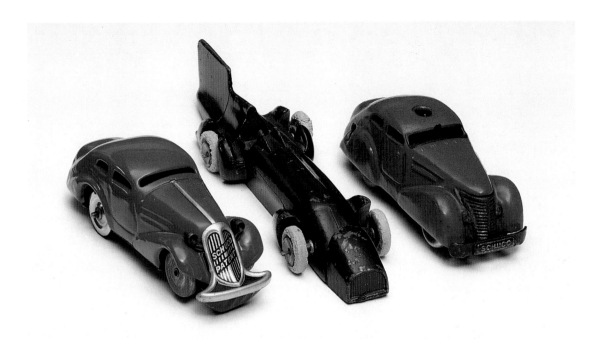

36.6

Fist-sized toy cars from the 1930s. The two red cars were made by Schuco from tin plate. Both have clockwork mechanisms. The one on the right can be steered by remote control through a wire that plugs into the roof. In the middle, a die-cast lead car represents Malcolm Campbell's record-breaking racing car, Bluebird II.

36.7

Fighter plane with an airgunner, of tin plate, with clockwork mechanism and made in Germany in about 1938. 4½ inches long.

36.8

Plastic space-ship made in Hong-Kong, in the 1960s.

— 37 —

CONSTRUCTIONAL TOYS

A pioneering constructional toy of 1875: Crandall's Treasure Box, which describes itself as 'Not one toy alone, but a dozen in one, supplying the wants of as many children'. Several members of the Crandall family made toys in America. Probably Charles Crandall was the maker of this toy, for some of the pieces have the dovetailed edges which are found also on his better known building blocks.

Building with bricks - or 'blocks' - is a pastime which children enjoy from a very early age. As they pile one thing on another, and then knock the pile down, they begin to understand some basic principles of construction. At this stage, however, they make structures that stay together simply through the force of gravity. Soon they are ready to explore ways of connecting parts of a structure, so that tension and balance, as well as sheer mass and weight, can be brought into play. From here on, they can follow a learning curve that leads to the Sydney Opera House and beyond. Constructional toys first became popular in the early 1900s and boomed between the wars. Returning in the 1950s, they held steady in the toy market and are flourishing again today.

Richter's Anchor blocks (see section 13) were produced in a range of shapes which, while staying together only by gravity, could be built up into reasonable facsimiles of real architecture. During the First World War, Britain hit back with Lott's Bricks, also made of artificial stone, which claimed 'to totally eclipse anything hitherto manufactured by German firms'. The buildings made with these looked more up-to-date ('in accordance with modern ideas, and very different from the monstrosities which children previously were given to construct'), and were actually designed by an architect, Arnold Mitchell, in a vaguely sub-Lutyens idiom.

The next logical step was to devise blocks which locked together. The Irish Toy Industry of Belfast in 1915 offered Dometo, interlocking wooden blocks which made up into constructions that could be 'lifted about without any fear of collapse', and Kubeto, in 1917, which was made of wood and cardboard. In the 1920s and '30s Thornton Pickard of Altrincham were producing Picabrix: drilled wooden blocks held together with pegs or dowels. The 1930s saw various types of interlocking wooden blocks, such as Berbis by Reuters of Germany, Erectiko by Wm. Bailey of Birmingham (who also made Weenibrix, metal pieces which interlocked by a tongue and groove system); and Cresco ('Once put – stays put!') which was purchased by the Queen.

A more momentous development was Minibrix, produced by the Premo Rubber Co. of Petersfield in 1935. Early publicity stressed that the material was 'hygienic and non-inflammable', and 'the bricks ... neither break nor chip, also - and this should prove a big selling point with mothers - they cannot damage furniture'. But it was the stud-and-cavity locking device that was really important. Later, in the 1940s, it appeared on plastic bricks by Hilary Page of Kiddicraft, and in Germany by Josef Dehm (Idema). Then, in the 1950s, it was adopted with some refinements by the Danish firm Lego, which soon achieved supremacy in this corner of the market. Its rivals

Pinit, an attempt by Percy Samuel Fowler, launched in 1920, to produce a cheaper variant on Meccano by using wood strips: 'Cotter pins are inserted into or withdrawn from scientifically bored holes in the wood by one tool only'. The Bethnal Green Museum of Childhood has Fowler's working papers.

Constructional toys can be made of paper or card as well as wood or metal. Samlo was made in the mid-1930s by John Waddington, who specialized in cards, board games and paper packaging. The shapes that can be made from the pre-cut cards are box-like or tube-like, but (warns the instructions) 'the very simplicity of the straight lines and curves accentuates any faulty balance' in design.

Structator, Kit no.3. Inspired by Meccano, various German firms tried in the 1920s to produce something similar, but original. Structator was devised by the famous firm of Bing in Nuremberg.

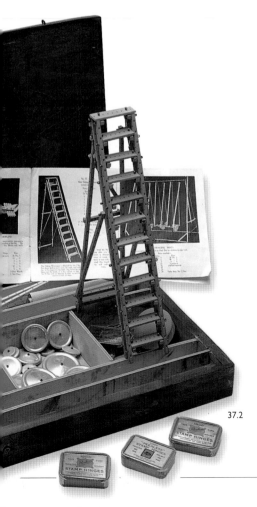

37.2

37.4

included, in the 1960s and 1970s, Bric à Bric from France, Bilofix, and Airfix's Betta Bilda; today Mega-Bloks and Mottik are mounting a challenge.

Although interlocking blocks are fun to play with, they do not resemble real life building techniques. They tend to be aimed at younger children or, as some would have it, the weaker sex (Weenibrix was advertised as 'the simplest building toy for girls'). Something a little more complicated was provided by construction sets that were based not on bricks but on panels, thus mimicking the methods of prefabricated building. In Unibrik (1915), the 'sections are all standardized, and fit together by a simple slot method'. Other such toys were (in the late 1920s) Mobaco from Holland and Mettabuild, and (in the 1930s) Briklo, Stanlo from the Stanley Tool Company in America, and Edifix, with which you could build a half-timbered Tudor House.

After the Second World War, Bayko (originated by The Plimpton Engineering Co. of Liverpool, and taken over by Meccano) used a system of panels slotted between rods. So did Tri-ang's Arkitex, and Chad Valley's Girder and Panel building sets, which presented themselves as 'the realistic construction sets that duplicate up-to-the-minute building methods, including "cantilever" extended upper stories and overhanging walls'.

Some constructional toys mimic scaffolding, using rods and connecting joints. Early examples were Stella-Baukasten from Hannover (1902), Happynak (1914), Klipit from Hobbies of Dereham (1914), Anchor Engineer (1914) from Richter of Rudolstadt, trying to extend their range beyond the well-known blocks, Pinit (1921), Tinkertoy (1924), Kliptico (1925) by Wm. Bailey of Birmingham, and Tuba (1935). A post-war variant was Bygge Flet from Denmark. In the late 1980s, Pipeworks, Tactic and Quaddro used the same principle, which is also an important element in the contemporary K'nex.

The best-known of all constructional toys is the metal-strip toy, Meccano, invented by Frank Hornby in 1901, made by his original firm until it wound up in 1979, and now made by a private company. Hornby's first title for this was, significantly, 'Mechanics Made Easy'. Although not himself a trained engineer, Hornby was an enthusiast and really wanted to teach the principles of engineering to children. Like so many adult inventors of constructional toys, he was in love with his own ingenuity. Inventing the toy probably seemed as thrilling as building real bridges. Certainly, the production of the standardized parts of such toys was a noteworthy step in the development of mass-production factory methods.

Meccano took its inspiration from metal girders, which could be joined together and strengthened by criss-cross braces. Iron frames were used in countless industrial buildings and bridges in the 19th century, and this method of construction reached its apotheosis in the Eiffel Tower. Hornby started a *Meccano Magazine* in 1916 which, in its heyday, featured many such real-life constructions in its articles and illustrations. It also inspired a clubby atmosphere, backing this up through the Meccano Guild, which was intended not only to interest boys in engineering, but 'to make every boy's life brighter and happier' and 'to foster clean-mindedness, truthfulness, ambition and initiative in boys'. Meccano was a really serious pursuit.

Many other toys used the system of pierced metal strips and nuts and bolts: Erector from America; Primus, Kinco, Ulox, Mex from England; Stabil, Dux, Trix from Germany, as well as Märklin. After the Second World War came Masterbuilder, Lynx, Tec. Simply to list the names gives an impression of the irrepressible enthusiasm that propelled hopeful inventors to devise and launch constructional toys. Some succeeded, while many did not.

Perhaps the most extraordinary toys were those which invited boys to do the whole thing themselves, such as Juneero and Manufax in England in the 1930s, and Meweka in Germany in the 1950s. These provided tools with which boys could cut up sheet metal, bend it, punch holes, and cut threads on bolts and ratchets on cogs. It might seem that these tools threatened to inflict personal injury too, but engineering boys are a tough breed: the latest Meccano comes with a toy power drill.

INSTRUCTIONS for OUTFIT

A Matador set (Austrian, 1985) and a Baufix set (German, 1990). These kits enable small children safely to get the hang of construction methods like nailing and screwing, through using much enlarged equipment made of colourful wood and plastic.

Minibrix interlocking rubber blocks first appeared in 1935.

Early Meccano manuals tended to illustrate on their covers awesomely complex models, such as the Giant Block-setting Crane. In 1948 a new cover design, while still using the crane, set it in an atmosphere of contentment at the family fireside.

38

WAR TOYS

The United Nations Children's Fund (UNICEF), in its 1996 report, recorded that in the previous ten years 2 million children had been killed in war, 12 million made homeless. In 1988 alone 200,000 children were actually fighting as soldiers. Would any of these want to play with war toys?

The answer might be yes. The first English toy historian, W.H. Cremer (in his *Toys of the Little Folks*, 1873) recalled that in 1871 in Sedan in France, after the Franco-Prussian War, 'an excursionist found two small boys sitting on the floor of a ruined cottage in the middle of the battle-field playing at soldiers with little tin men; a hundred yards off the bodies of the real men who had fallen were being burned in heaps'.

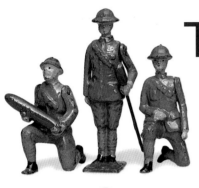

38.1

Royal Artillery gunners, made by Britains in about 1935. When military uniforms lost their bright colours, some of the charm went out of model soldiers.

On a more positive note, most of us find the pageantry of peacetime military ceremonies stirring. The Victorian artist Richard Doyle noted in his diary, at the age of 15, that 'there is scarcely anything so delicious to me' as a military parade. He enjoyed the 'sound of trumpets...the glittering cuirasses of the Life Guards sparkling in the sun'. The insistent rhythm of marching, the music and the bright colours were perhaps as near as a Victorian child could come to a rock concert. Doyle became famous for painting fairies, so teenage militarism evidently had no lasting effect on him.

For some children war toys were meant to inspire warlike virtues. The German emperor Maximilian I commissioned a picture book about his own upbringing, *Der Weiss Kunig*. One of the wood engravings by Hans Burgkmair (c.1515) shows noble youths playing at table-top jousting with toy knights on horseback. Such toys survive in museums in Munich and Vienna. Over several generations, from the 17th to the 19th century, the French royal princes were given various kinds of precious toy soldiers. Ordinary children would have had to make do with cheap wooden soldiers.

In the late 18th century, however, the Hilpert family of Nuremberg started to turn out litle moulded metal figures. The technique was not new. A few little metal soldiers survive from the Middle Ages, but they may just be by-products of the process which generated pilgrimage badges in great quantity. The Hilperts mass-produced their figures intentionally as toys. As well as soldiers they (and the other firms who followed them) produced model figures of great charm, showing all kinds of occupations and events in ordinary life, often copying these from engravings.

They used various combinations of lead (which could be moulded with fine detail but was soft) and tin (which was stronger). Firms like Heinrichsen of Nuremberg and Allgeyer of Furth followed the example of the Hilperts, and soon toy soldiers spread throughout Europe.

38.2

Wooden fort, c.1910. For children who probably do not want to create entire battlefields, as adult collectors often do, a fort provides an enjoyable setting for deploying toy soldiers. This one is of wood covered with printed paper and was probably made in Germany about 1910.

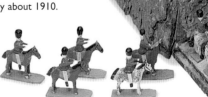

38.3

Illustration entitled 'Boys' Wars' from *Das erste Bilderbuch für Knaben und Mädchen* (First Picturebook for Boys and Girls), published in Germany in 1832. Similar illustrations appear in other 19th-century German children's books: they show boys, but not girls, playing at soldiers, though sometimes the group may include very small boys still in their skirts. The boys in this picture are improbably well-equipped with military toys. Other illustrations show boy-warriors with saucepans for helmets and brooms for lances, or with paper hats and rolled-up papers as weapons.

38.3

38.4

Early 20th-century hollow-cast soldiers, made by William Britain's firm in London.

38.4

Most of the German figures were almost two-dimensional, and are known as *flats*. Fully rounded figures (solids) were produced, but used up more metal and cost more. In 1898 William Britain of England found a way of casting rounded figures that were hollow, and thus more economical. Most metal toy soldiers since have been made in this way. Papier-mâché (called 'Elastolin' by the German firm Hausser) was sometimes used, and plastic is generally used today. Printed paper soldiers (to be cut out and stuck to stable bases) have been a cheap alternative to metal ones since the late 18th century.

Soldiers are popular with adults as well as children. The author H.G. Wells wrote an entire book, *Little Wars* of 1913, about complicated toy soldier games for men. It is adults rather than children who collect soldiers systematically, and often make them with careful attention to uniform. As the pageantry of war declines, will toy soldiers lose their appeal to children altogether?

TABLE GAMES

Children's games that involve running about were dealt with in section 7. This section looks at games that can be played sitting still. These games offer mental rather than physical exercise, and some of them have an almost mathematical, or anyway, geometrical abstraction. Draughts (or checkers) is a good example. The kit needed for the game could hardly be simpler: black-and-white circles on black-and-white squares. Some games of this sort do not need any specially designed kit at all. The ancient game of Wari can be played with pebbles and holes in the ground. These are games where, within a framework of rules, one player has to make moves which are related to what opposing players are doing. Forethought and imagination bring success.

39.1

A home-made English board, dating from about 1800, for the Game of the Goose. In format, it follows the rectangular spiral usual in earlier Italian and English engraved versions.

Strategy games of this kind include (besides draughts and Wari) Pachisi, Alquerque, the Royal Game of Ur, Nine Men's Morris, Fox and Geese, Solitaire, Shogi, and Go, which all use counters on geometrically laid out boards. What you see on the boards as the games progress is a changing abstract pattern, which can be of great complexity, as in Go. Some similar games like backgammon admit an element of chance, through using dice, but are still basically about strategy. Some, like chess, are not entirely abstract but have pieces with symbolic identity. Nonetheless, all these games are matters of almost pure logic, the fruits of a games impulse which is universal, transcending cultural or linguistic boundaries.

While most games have at their heart an abstract programme, this can be (so to speak) packaged in trappings that relate to a particular culture, language, time or subject. This happens with games based on the 'race' principle. The first race game seems to have been the Game of Goose. As 'Il Giuco dell'Oca', this was first known in Florence in Italy in the late 16th century, and had reached England by 1597. Using a board about twenty inches square, the players take turns to move counters along a marked path with numbered spaces, in accordance with the scores they have thrown with a dice. Every now and then they come upon a space with a goose in it, and if they land there, they get an extra turn. (Why a goose? Who knows? Why snakes and ladders?) The path of the game was plotted on the board in the shape of a rectangular spiral, starting at the outside and ending in the middle.

Everything depended on luck in this game, so it was less testing, and thus in a sense less educational, than the games of strategy. In about 1750, however, it occurred to someone that the race-game format could be put to educational use. The race at the heart of the game could be packaged within the

31.2

The rectangular spiral format used in a French game of about 1835, which leads the player through the famous buildings of Paris.

A HUMOROUS GAME.

THE COTTAGE of CONTENT, OR, RIGHT ROADS AND WRONG WAYS.

The idea of a wandering journey was adopted as the basis of several games by the publisher William Spooner. This one, *The Cottage of Content, or, Right Roads and Wrong Ways* (1848), leads its players along various moral and immoral paths in search of contentment.

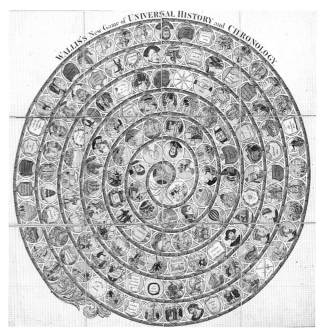

A historical game: Wallis's *New Game of Universal History and Chronology*. This starts with Adam and Eve and ends with the current English monarchy. When it was first issued in 1814 it ended with the Prince Regent. This version must date from about 1840, since the centre section has been re-engraved to include Queen Victoria. The format here is a circular spiral.

context of history, geography, science, morals - or almost any subject whatever. A few titles give the flavour of English games produced in the late 18th and early 19th centuries: *Royal Game of English Sovereigns*, *Tour of Europe*, *A New Geographical Pastime*, *Pleasures of Astronomy*, *The Reward of Merit*, *A Moral and Entertaining Game*.

As children progressed through these games they could absorb a commentary, supplied on the boards or, more conveniently, in the accompanying rule-books. The comments could be evocative: 'Hark at the horrid sounds which proceed from the forest! It is the death roar of a Jaguar which an immense Boa-Constrictor is in the act of crushing to a jelly'. Or, more likely, they would impart useful information: 'Birmingham, a large town, celebrated

for its hardwares, the variety of which is beyond description; also, for all kinds of trinkets and jewellery, and the most highly wrought fire arms. It has many fine buildings.- Stop one draw, and visit its factories'. Almost invariably, these games commended themselves as 'both amusing and instructive', sometimes with eloquent amplification: 'tends to incite a zealous, but generous emulation, actuates the ingenuity of invention, encourages perseverance, and at the same time gives birth to sportive flights of fancy'. To publishers dwelling on such

an elevated plane, the use of dice presented a moral problem, since dice were normally used in gambling. Often a teetotum (a numbered spinning top) was recommended instead.

Many of the games had the rectangular spiral layout of the Game of Goose. This may have suggested the form of a coiled snake, used as an overall motif on one game board. Others took the shape of an elephant, fishes and a basket of flowers. Geographical games naturally took the form of maps, which may have suggested the later use of maze-like layouts. Most game layouts were essentially made up of small pictures, and these could, in the end, take any configuration provided the sequence was clearly numbered. The boards were usually printed from engraved plates on to paper, painted by hand, mounted in sections on a linen base, and folded up into slipcases.

Quite a small group of English publishers specialized in these games: John Harris, the Wallis family, the Dartons, and later (from 1836) William Spooner. The early printers produced games as a sideline to their main business, book publishing, and tended to produce other

sidelines, such as jigsaw puzzles. The inventor of the 'dissected map', forerunner of the jigsaw puzzle, around 1760, is generally reckoned to be the London print-seller John Spilsbury. To begin with these puzzles, mounted on wood, were cut into pieces by hand. Owing to the difficulty of manoeuvring a saw, the pieces were usually shaped in gentle curves. It was only after the adoption of mechanical fretsaws in the mid-19th century that interlocking pieces could easily be made. By the end of the century, puzzles were being mounted on cardboard and cut by a die. But the characteristic interlocked shape of the pieces has remained.

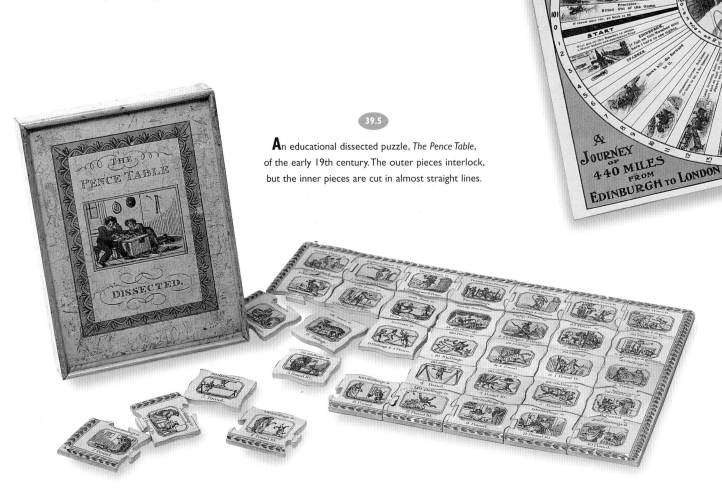

39.5

An educational dissected puzzle, *The Pence Table*, of the early 19th century. The outer pieces interlock, but the inner pieces are cut in almost straight lines.

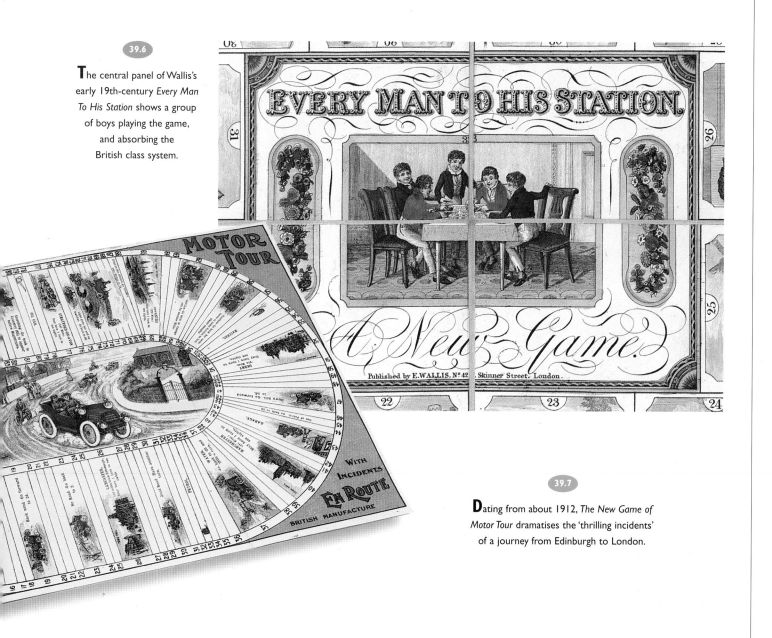

39.6 The central panel of Wallis's early 19th-century *Every Man To His Station* shows a group of boys playing the game, and absorbing the British class system.

EVERY MAN TO HIS STATION.

A New Game.

Published by E. WALLIS, Nº 42 Skinner Street, London.

39.7 Dating from about 1912, *The New Game of Motor Tour* dramatises the 'thrilling incidents' of a journey from Edinburgh to London.

MOTOR TOUR

WITH INCIDENTS EN ROUTE

BRITISH MANUFACTURE

In the course of the 19th century, specialist games firms came along: Jaques, Spears, Chad Valley, Waddingtons in England; Parker Brothers and Milton Bradley in America. France, Germany (see 54.2) and other countries also had their games publishers, who loaded their games with educational freight in their own languages. In the later 19th and 20th centuries the subject matter of board games embraced many new developments in the world around: motor transport, cycling, air travel, warfare in many forms. Games borrowed subjects from other pastimes: scouting, mountaineering, football, tennis. Children's book heroes like Beatrix Potter's Peter Rabbit and G.E. Studdy's Bonzo got their own games. Perhaps the most famous of all games is Monopoly, which introduces children to money and property dealing. Invented by Charles Darrow, an unemployed heating engineer in the Great Depression of the 1930s, and later exploited by Parker Brothers, this excursion into high financial fantasy seems to have an inexhaustible allure.

ARTISTIC TOYS

Some toys cling to the fringes of the world of art, because they show the kind of skill and sensitivity that are the marks of mainstream artforms, even though they cannot be regarded as 'serious'. An example is the Christmas crib, which has long been accepted as a sort of sub-department of sculpture. In Italy, especially in Naples, 18th-century craftsmen produced clothed dolls representing not just Biblical characters associated with the Nativity, but all of human life. Full of realism, sharpened by the humorous insight and theatrical expressiveness of the sculptors, these were placed in a conventional setting that owed much to the neo-classical, ideal landscape paintings of the time, and became a poignant mixture of the sublime and the trivial. A slightly different south German tradition also belonged to this sub-department of sculpture. Similarly, the decorative art of silversmithing included the miniature objects that were often produced in the 17th and 18th centuries. Of course, age

40.1

Two painted, turned box toys, dated 1937, by Ferdinand Andri, of the Wiener Werkstätte.

sanctifies such objects. Modern crib figures, or silver table-lighters in the form of miniature cars, would not yet easily be accepted as art.

Some toys have to be accepted as art because they are made by artists. There are dolls or puppets by Kokoschka, Hans Bellmer, Paul Klee, Oskar Schlemmer and Picasso. Calder's mobiles, the machines of Jean Tinguely, and some other examples of kinetic art have a near relationship to toys. It is possible, though not very frequent, for creators who think of themselves as toy-makers to be acknowledged eventually as artists. The prime example in England is Sam Smith, who started off making simple playthings, but elaborated them with such fantasy and symbolism that the results could only be regarded as sculpture. Smith was a highly sophisticated creator, but it is perhaps easier to make the leap to artistic status if you can be regarded as a 'primitive' or 'naive' artist, like the Englishman Bryan Illsley, the French couple Raymonde and Pierre Petit (whose toys are in the museum at Bourges), or the American John Vivolo.

Accepting that art is a shifting and sometimes mysterious entity, we could look at artistic toys from a contrary perspective. Instead of asking whether toys can make a contribution to art, we could ask whether art can contribute something special to toys. The answer might be

that there is a special visual elegance that enhances the artistic toy. The toy may have just the same 'playability' as an ordinary toy, but it possesses added value in its better appearance. The artistic toy may be the same as the well-designed toy.

There was a time when a concerted effort was made to raise the design standards of toys. This was during the early years of the 20th century, when the Child Study Movement and the Art in the Life of the Child Movement inspired parents and educators to present the best possible models to the growing minds of the young. With the foundation of design associations, decorative arts museums, and design magazines throughout Europe in the later 19th century, there was plenty of pressure to improve all the crafts, but toys came on the agenda only around the turn of the century. The new artistic approach is seen in the toys of the Kleinhempels of Dresden, August Geigenberger of Bavaria, Karl Grüber and Conrad Sutter of Karlsruhe, a group associated with the Wiener Werkstätte, and some twenty others. All these can be said to owe something to the idiom of 'Art Nouveau'. Some of their work, but seemingly not much,

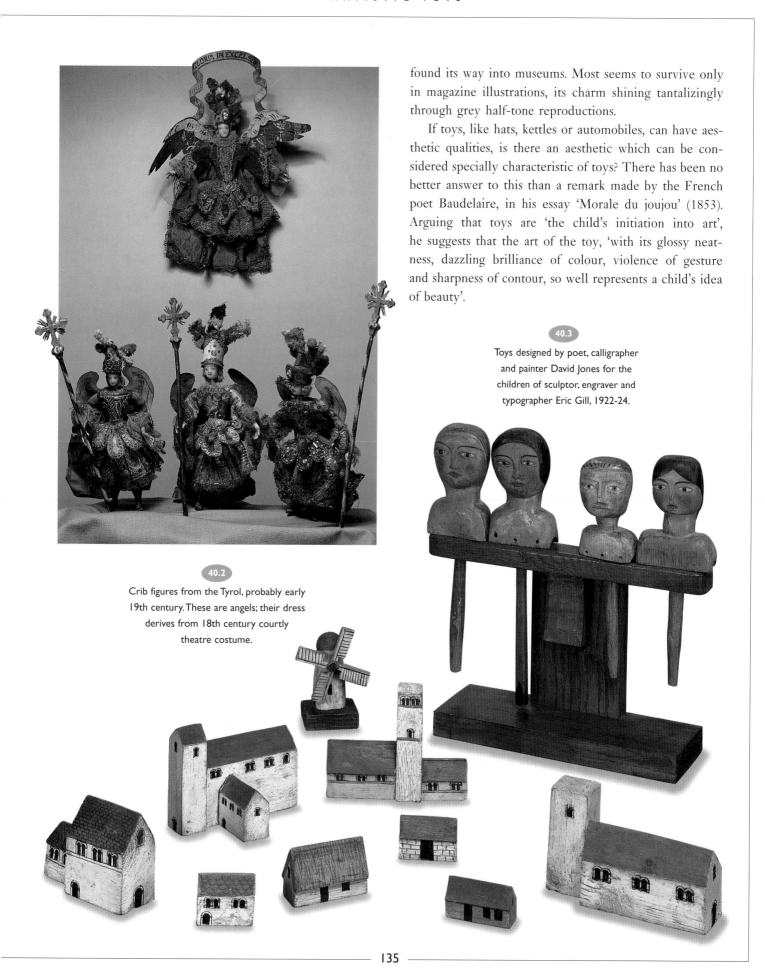

found its way into museums. Most seems to survive only in magazine illustrations, its charm shining tantalizingly through grey half-tone reproductions.

If toys, like hats, kettles or automobiles, can have aesthetic qualities, is there an aesthetic which can be considered specially characteristic of toys? There has been no better answer to this than a remark made by the French poet Baudelaire, in his essay 'Morale du joujou' (1853). Arguing that toys are 'the child's initiation into art', he suggests that the art of the toy, 'with its glossy neatness, dazzling brilliance of colour, violence of gesture and sharpness of contour, so well represents a child's idea of beauty'.

40.3

Toys designed by poet, calligrapher and painter David Jones for the children of sculptor, engraver and typographer Eric Gill, 1922-24.

40.2

Crib figures from the Tyrol, probably early 19th century. These are angels; their dress derives from 18th century courtly theatre costume.

—41—
FAIRY STORIES

In the late 18th century, popular culture was discovered by those who had hitherto cherished high culture: the intellectuals discovered the peasants. Or, as Andrew Lang put it, the 'progressive classes' turned back to the 'rural people' whom they had left behind. Over the next century, poetry, stories and music, which had been passed on orally for generations, were now recorded on paper by antiquarians throughout Europe, from Spain to Russia, from Norway to Sicily. In the middle of Europe, in Kassel in Germany, two experts on the German language, the brothers Jakob and Wilhelm Grimm, collected and published two volumes (1812, 1815) of folk tales. Because they were distinguished scholars, their story collection was received with respect and had a great effect on German writers of the Romantic movement. It was soon translated into other languages and its influence spread.

41.1

German edition of the Grimms' stories, published in Stuttgart around 1880, showing Snow White and the Seven Dwarfs.

The Grimm brothers might have called their book 'Folk Tales', for this term had come into use, but they chose to give it the title *Kinder- und Hausmärchen* (Children's and Household Tales). And so the book was regarded as being not only for scholars but for children too. It contained, among many others, the stories of Hansel and Gretel, Rapunzel, Snow White and the Seven Dwarfs, Rumpelstiltskin and the Frog Prince. These have remained as children's favourites. The brothers approached their work scientifically, and tried to take down the stories just as they heard them from ordinary

41.2

Illustration by Sébastien Leroy, in a theatrically poised neo-classical style, from an early 19th-century French edition of Perrault's tales (it lacks publication details).

41.3

people - the maid next door, a retired soldier, an old lady who sold them eggs. It is now thought that they did polish up the stories somewhat, but at that time the stories seemed so genuine that they gave a great boost to the scientific study of folklore.

In English these stories were called fairy-tales. Often there were no fairies in them, but they were usually about strange, magic themes. England had its own folk tales, such as Jack the Giantkiller, Jack and the Beanstalk and Tom Thumb. Children would have heard these at the fireside, and could have found them in print in chapbooks (section 18). The fairy-tales of France became quite respectable long before the Grimms' work started.

We have already noticed (section 19) the book of 'Mother Goose' tales published by Charles Perrault in 1697. This contained Cinderella, Puss in Boots, Sleeping Beauty, Little Red Riding Hood, Bluebeard and Hop o'my Thumb. In the early 18th century there was a craze for fairy-tales among French literary women, who competed to write them, not for children, but as a sophisticated entertainment for themselves, as some feminist writers do today. In 1785 a publisher made a collected edition of these tales which filled 41 volumes. Almost all of them, however, have been forgotten because they are too contrived. Perrault's survived, as did one by Madame de Beaumont: Beauty and the Beast (1756).

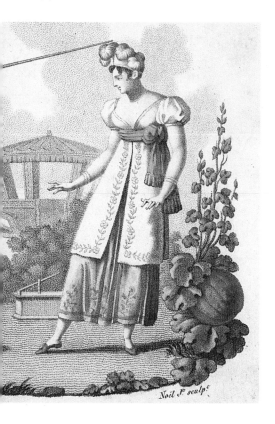

Some of the 41 volumes of literary fairy-tales - 'highly provocative, extraordinary, bizarre, and implausible' - published in 1785 by Charles Mayer.

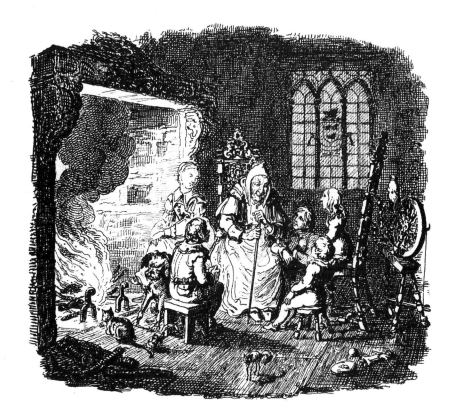

Title vignette to the second volume (1826) of the Grimms' fairy-tales, as they were first published in England in a translation by Edgar Taylor, with illustrations by the great, freakish artist, George Cruikshank. His title vignette to the first volume (1823) depicts a fireside group, mostly adults, chortling wildly as a waggish fellow narrates to them. This gives the impression that the Grimms' work is a sort of joke book. The above illustration is more appropriate: a woman narrator who might be Mother Goose or, indeed, Dorothea Viehmann, one of the Grimms' chief sources.

41.5

An edition of Perrault's tales, published in Paris in about 1850. The 'Mother Goose' narrator is shown on the title-page, while the other pictures illustrate Bluebeard and Red Riding Hood.

The vast *Motif-Index of Folk Literature* (1932-6, revised 1955) by Stith Thompson now underpins all study of fairy-tales, and scholars tend to trace the development of one at a time, rather than devising grand theories about them all.

While scholars were dissecting fairy-tales, children were obviously getting enjoyment out of reading or hearing them. What do these stories mean to children? The most compelling answer to this question came in *The Uses of Enchantment* (1978) by the developmental psychologist Bruno Bettelheim. For him, fairy-tales, although on the surface about kings, giants, princesses and witches, were really offering children a way of understanding how they could relate to the world and other people. They were psychological myths. Fairy-tales are generally thought to be timeless and elemental, but they did pick up traces of local colour as they were told and retold by successive

The more scholars collected fairy-tales, the more they found that the same tales were turning up over and over again in widely different places. (Some of Perrault's stories occur also in the Grimms' collection.) They could not avoid asking: how did fairy-tales get around, and where did they come from in the first place? Early folklore scholars developed very fanciful explanations. They believed that popular tales were watered-down versions of ancient myths which humankind, in its primitive state, had invented to explain the phenomena of nature - day, night, summer, winter, dawn, dew, sun, moon, wind. Red Riding Hood was the Dawn, the Frog Prince was the Sun. This sort of explanation was unprovable, and seemed increasingly unlikely in the light of modern anthropologists' investigations into how contemporary 'savage' peoples actually thought. So in the 20th century folklore scholars turned to close analysis and classification of the tales themselves.

41.6

Panorama card, telling the Aladdin story, published by Raphael Tuck in the 1880s. English children have long been familiar not only with English, French and German fairy-tales, but with some from the East. The Arabian Nights was published in French in the 18th century and in English in the early 19th. Aladdin, Ali Baba and Sindbad the Sailor soon joined the classic fairy-tales.

41.7

Illustration to Aschenpüttel, the Grimm version of Cinderella, by Adolf Münzer in about 1904. This is from a series of illustrated children's books published by Scholz of Mainz.

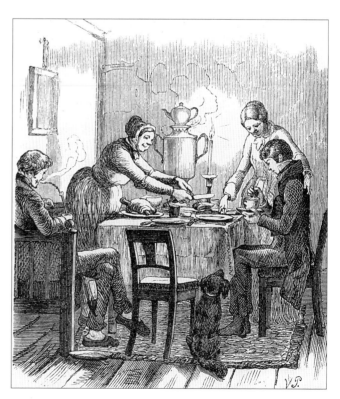

41.8

Illustration for 'Under the Willow Tree' from Hans Andersen's *Historier* (1855). The first illustrator of his stories was the Danish artist Vilhelm Pedersen. His gentle designs, reproduced by wood-engraving, evoke the atmosphere of 19th-century Denmark.

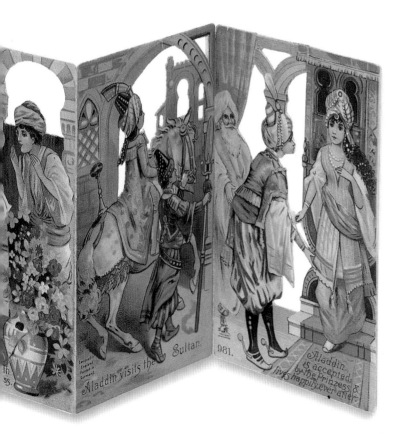

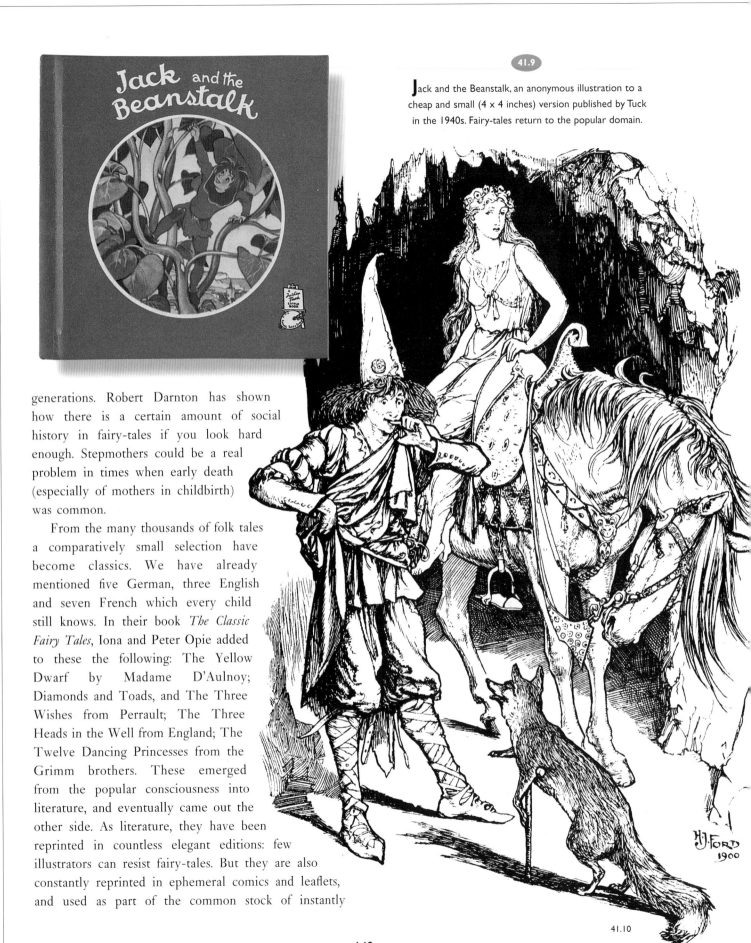

41.9

Jack and the Beanstalk, an anonymous illustration to a cheap and small (4 x 4 inches) version published by Tuck in the 1940s. Fairy-tales return to the popular domain.

generations. Robert Darnton has shown how there is a certain amount of social history in fairy-tales if you look hard enough. Stepmothers could be a real problem in times when early death (especially of mothers in childbirth) was common.

From the many thousands of folk tales a comparatively small selection have become classics. We have already mentioned five German, three English and seven French which every child still knows. In their book *The Classic Fairy Tales*, Iona and Peter Opie added to these the following: The Yellow Dwarf by Madame D'Aulnoy; Diamonds and Toads, and The Three Wishes from Perrault; The Three Heads in the Well from England; The Twelve Dancing Princesses from the Grimm brothers. These emerged from the popular consciousness into literature, and eventually came out the other side. As literature, they have been reprinted in countless elegant editions: few illustrators can resist fairy-tales. But they are also constantly reprinted in ephemeral comics and leaflets, and used as part of the common stock of instantly

41.10

recognizable imagery. However, children need find no difficulty in exploring the by-ways as well as the high roads of fairy-tale literature. Still in print are the collections of tales from all over the world made by the great folklorist Andrew Lang, beginning with *The Blue Fairy Book,* in 1889, and continuing through the colours for another 11 volumes. And there have been many other collections.

Writers who admire the way fairy-tales can contain themes of great strength and resonance in a few simple paragraphs have tried to write modern versions. Perhaps the only author who really succeeded was Hans Andersen. As a Dane, he was nearer to the sources of folk literature than he would have been in a more cosmopolitan part of Europe. A fitful upbringing, often on the fringes of the theatre, left him with intense and restless emotions. Like Dickens he had swift access to heartbreak and joy, and a capacity to make everyday things come alive like people. Among his 150 fairy stories, many have become classics: The Little Tin Soldier, The Ugly Duckling, The Little Mermaid, Thumbelina. Though these have moments of piercing feeling that come close to sentimentality, they still have the compact directness of folk tales.

In the very early days of folklore study, Sir Walter Scott wrote that 'the mythology of one period would ... appear to pass into the romance of the next, and that into the nursery tales of subsequent ages'. The idea that children's literature is adult literature which has been 'cast-off' or 'handed down' is an insistent one. The same notion can be applied to other aspects of children's culture: their clothes, for instance, often are handed down. Related to this is the idea that children, as they grow, recapitulate the development of humankind. Such thoughts raise questions to which there are no simple answers.

As children and their parents read fairy stories, they find that such stories do not reflect life as they know it but open windows to other dimensions.

H.J. Ford's *Laughing Eye and Weeping Eye*. Ford illustrated nearly all of Andrew Lang's Fairy Books. His intricate pen drawings were reproduced photomechanically. A student of Burne-Jones, he seems also to show influences from several other late Victorian artists like Arthur Hughes and Fred Walker, and moved easily from pre-Raphaelite languor to caricature. Lang's stories were gathered worldwide (this one is from Serbia), but they were all illustrated in the same style by Ford. He was evidently taken as a model by other early 20th-century fairy-tale illustrators, and many a child must have consequently imagined that Fairyland was a grey, wiry place.

English fairy-tale, in a 19th-century chapbook version.

41.11

OLDER HEROES & HEROINES

Book jacket by Thomas Henry. Richmal Crompton's William books were, like many books of their time, rather badly printed, so the illustrations by Thomas Henry (succeeded almost imperceptibly by Henry Ford) were often smudgy.

Just as fiction provides young children with role-models (see section 23), so it does for older children. In the 19th century, when the role of girls was expected to be a domestic one, several American authors provided examples. The mere titles of Louisa M. Alcott's *Little Women* (1868), *Good Wives* (1869), and *Jo's Boys* (1886) indicate the trajectory of a woman's life as wife and mother. Susan Coolidge's *What Katy Did* (1872) and its sequels, and *Rebecca of Sunnybrook Farm* (1903) by Kate Douglas Wiggin also paint a picture of young womanhood which, underneath its American liveliness, is fundamentally earnest and high-minded.

The classic stories of American boyhood had more spice and zest. Mark Twain's *Tom Sawyer* (1876) and *Huckleberry Finn* (1884) introduce mischievous drop-outs, who are often at odds with conventional morality. Other ne'er-do-wells feature in Thomas Bailey Aldrich's *Story of a Bad Boy* (1869, anticipating Tom Sawyer), George Wilbur Peck's *Bad Boy* books (from 1883), and Booth Tarkington's *Penrod* series (from 1914). Penrod is sometimes cited as a fore-runner of Richmal Crompton's *William* books, but somehow William seems to need no precedent. In his unflagging vitality (through 40 books between 1922 and 1970) and his unerring ability to collide with the soft spots of the English class system, William is a true original. As a suburban bandit, he is also of tougher material than other mischievous English boys like Robert Martins's Joey, M.Pardoe's Bunkle, and John Keir Cross's Bunst.

Between the wars in England, a new sort of adventure story arose, in which boys and girls band together. The pioneer author in this genre was Arthur Ransome with his 'Swallows and Amazons' series (from 1930), following the adventures of a group of children spending independent holidays in boats, free from adult direction. Ransome himself illustrated these books (rather awkwardly and amateurishly), and the the Ransome format - full-page illustrations, lots of chapter-heading vignettes and tail-pieces, diagrams, and evocative endpaper maps - became standard for adventure stories. Later sailing stories include those of Aubrey de Selincourt in the 1940s, Gilbert Hackforth Jones in the '50s, and Peter Dawlish.

Other authors extended the range of adventures and the settings: 'What Ransome has done with boats, other … writers have done with bicycles, ponies, horse-caravans, house-boats, tents, cottages …' said Geoffrey Trease, a versatile writer who did it successfully himself. M.E.Atkinson, Malcolm Saville and David Severn were the most prominent successors of Ransome. 'Summer Holiday Mystery Adventure Cruise' could have served any of them as a title, summing up the attractions of the genre. Englishness was important in these books, which celebrated both the Anglo-Saxon middle-class way of life and the English countryside. They were often given precise topographical settings. Saville, for instance, specialized in Shropshire, and in Rye and Romney Marshes. The books were often illustrated, on the Ransome model, by artists such as Stuart Tresilian, Richard Kennedy, Joan Kiddell-Monroe, Marcia Lane Foster and, later, William Stobbs. Atkinson's books were the most elegantly produced, several being illustrated by Harold Jones, who was less of a realist than the other artists and had a line in enigmatic, elliptical vignettes.

The family holiday adventure reached its most formulaic in Enid Blyton's stories of the Famous Five, the

42.2

Four children in Sussex, an illustration
by Lilian Buchanan to Malcolm Saville's
Four-and-Twenty Blackbirds (1959).

42.3

Stuart Tresilian's dust-cover for Enid Blyton's
The Sea of Adventure, first published in 1948.

Secret Seven and various other groups of children. It gave way from the 1950s to historical fiction (Rosemary Sutcliff, Gillian Avery, Leon Garfield, Jane Gardam), and in the '60s to fantasy/myth (Alan Garner, Susan Cooper, Ursula Le Guin). Its social background - for instance, its connection with contemporary modes of holiday-making - and its depiction of adolescent group dynamics perhaps merit more investigation.

—43—

SCHOOL STORIES

For centuries the life of schoolchildren was not worth telling stories about. To a large degree it was either boring or positively unpleasant. In England, schools began to get a more attractive, even romantic, character in the middle of the 19th century. Dr Thomas Arnold, Headmaster of Rugby School (1828-42), began to teach his pupils with a new earnestness. They developed emotional bonds with him (they worked 'to please the Doctor') and with the school. The other old English public schools for boys reformed themselves along the same lines. Thomas Hughes's *Tom Brown's Schooldays* (1857) portrayed Arnold's Rugby, and inspired a whole literature of school stories.

Billy Bunter in a scrape. Several illustrators depicted Bunter, the most successful being C.H. Chapman. This is from one of his cover designs for *Billy Bunter's Own*.

Oddly enough, the stilted, artificial atmosphere of the public boarding schools tended to be most lovingly portrayed by those who were at some distance from it. F.W.Farrar, who wrote the second famous Victorian school story *Eric, or Little by Little* (1858), taught at public schools but had not been a pupil at one. Talbot Baines Reed (*The Fifth Form at St Dominics*, 1887 and many other books) ran a type-foundry; Hylton Cleaver was a sports journalist; Gunby Hadath taught at a grammar school. Perhaps it is no accident that public school fiction survived longest in burlesque form, in the Billy Bunter stories of Frank Richards (Charles Hamilton). After two world wars it was impossible to regard the public school ethos as anything but a joke.

Education for girls developed later than boys' education, but it had a bigger, more cohesive literature. The trail-blazing author was Angela Brazil, who published 53 books between 1904 and 1946 - though she had been preceded by L.T. Meade, who bagged the best of all titles, *A World of Girls*, in 1886. The other front runners were Elsie J.Oxenham (90 books, 1907-59) and

two writers who came to the fore between the wars, Dorita Fairlie Bruce (39 books, 1920-61) and Elinor Brent-Dyer (100 books, 1923-70). Not far behind were Christine Chaundler (writing 1916-49) and Ethel Talbot (writing 1918-48), with Enid Blyton contributing her 'St Clare's' and 'Malory Towers' books in the 1940s.

The appeal of these books was that they admitted their readers to the safe, controlled world of the girls' boarding school. As with the boys' school stories, team spirit and athletic prowess were important. More important were the rituals and the language of school life. The language was full of intensifiers: 'ripping', 'topping', 'spiffing', 'beastly'. On a more subtle level, readers could ponder exactly where in the moral economy to place a sneak, a sport, a slacker, a silly goose, or a pest. In Brazil's books especially, slang becomes quite baroque: 'Jubilate! What a frolicsome joke!'; 'Am I really any shakes smarter - I mean, more toned up - than I was?'

Conformity with the group, or alienation from it, are

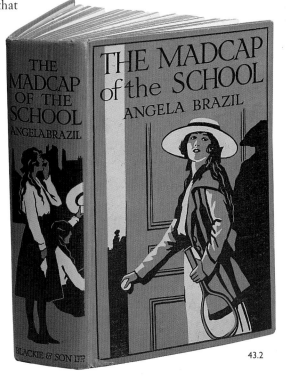

THE MADCAP of the SCHOOL

ANGELA BRAZIL

BLACKIE & SON LT?

43.2

perhaps the most important themes. Many books deal with odd girls out (tomboys, mad-caps, harum-scarum schoolgirls, like *Jill the Outsider* by Chaundler) while others feature those who excel in the group as Head Girl, House Captain, best bat. Brazil wrote on the Nicest, the Youngest and the Luckiest Girls in the school. The schools were usually well situated, on the cliff, in the forest, on the loch, by the river. Brazil, Bruce and Talbot all wrote books called *The School on the Moor*. Often they had ivy-clad stone towers. Brent-Dyer undoubtedly surpassed everyone in this respect by setting her Chalet School in the Austrian Tyrol.

While the schools themselves may have been picturesque, the books had minimal visual appeal. None of the authors made a partnership with a particular illustrator, and most of the illustration was hack work.

These books ceased to carry conviction with children after the 1940s. They were satirized, in Ronald Searle's St Trinians and by the humourist Arthur Marshall. But they still have enormous nostalgic appeal to adult collectors. Their portrayal of female bonding has not yet lost its power.

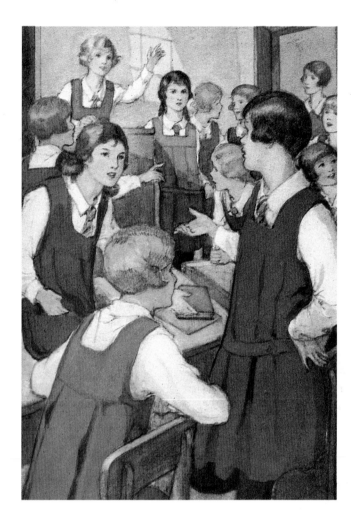

43.4

Class solidarity in 1930. An illustration by Mary S. Reeve, one of the more sensitive school story illustrators, for *The Fifth Form Rivals* (1930) by Winifred Darch.

43.3

Girls' school stories value athletic prowess as much as boys' school stories. Illustration to 'Tomboy Diana' by C. Bernard Rutley in *The Jolly Book for Girls* (undated).

43.3

43.2

Although most girls' school stories appeared as dull-looking volumes (short stories in annuals were usually better illustrated), Brazil's did have some distinction in their early editions. These often had attractive stamped binding designs.

43.5

School solidarity more briskly depicted twenty years on. The anonymous frontispiece to a 1952 edition of Elinor Brent-Dyer's *The Feud in the Fifth Remove*, first published in 1931.

43.5

ADVENTURE STORIES

To begin with, children seem to have had such an appetite for adventure that they managed to find it where it hardly existed. The first acknowledged adventure stories were Daniel Defoe's *Robinson Crusoe* (first published 1719) and Jonathan Swift's *Gulliver's Travels* (1726). But children would not have realized that the latter is an ironic criticism of the adult world, and in *Robinson Crusoe* they would have had to plough through a lot of moralizing to reach the exciting bits. However, this tale was to inspire many imitations, known as 'Robinsonades', specially written for children. J.H. Campe's *Robinson the Younger* (1779-80) and J.D. Wyss's *Swiss Family Robinson* (1812-13) were both written in German but soon translated into other languages. Captain Frederick Marryat published his shipwreck story *Masterman Ready* in 1841-2 and R.M. Ballantyne's *Coral Island* followed in 1857.

Robinson Crusoe, from the frontispiece to the third edition. The first adventure story hero.

By now, both writers and readers were prepared to enjoy adventure for its own sake. While much 19th-century children's fiction continued to push morals, adventure stories were fairly free of this. Important English writers in the second half of the Victorian age were W.H.G. Kingston, Thomas Mayne Reid, George Manville Fenn, Gordon Stables and G.H. Henty. All these now interest collectors more than children.

Though written primarily to entertain, these books did promote an ideal male personality: courageous, fit, honourable - in a word, 'manly'. One hero, in the stories of James Grant, was called 'Jack Manly'. Titles can give the flavour. The upbeat titles *Doing and Daring*; *Enterprise and Adventure*; *By Sheer Pluck* and *The Will to Win* promote manly virtue. Other titles stress the adversities in which such virtue would be needed: *The Lost Explorers*; *Held to Ransom*; *Beset by Savages*; *Britons at Bay*. Sometimes the titles refer to the geographical settings of the adventures: *By Peak and Pass*; *Up the Creeks*; *River and Jungle*; *The Lure of the Lagoon*. Stories of exploration follow the

A 'penny dreadful' (actually selling for 2 pence), published about 1890 by the Aldine Publishing Company, which specialized in bringing Wild West stories to a British audience.

tracks of real explorers, and sometimes get ahead of them: science fiction starts with Jules Verne's *Twenty Thousand Leagues under the Seas* (1870).

Most English adventure stories dramatized the experience of Empire. The American experience of wide-open spaces was also dramatized, for example by Fennimore Cooper. And Germany had a flourishing tradition of adventure stories, set mostly in the Wild West or the Orient, culminating in the work of Karl May.

These stories could all have been given to a child by a responsible parent, but there were also less respectable stories. In the 1860s English publishers like Edwin Brett began to aim sensational stories, often of criminal adventure, at young men, both through magazines like his *Boys of England* and through the cheap paperbacks called 'penny dreadfuls' (which actually sold at various prices, though the cheapest cost one penny). America followed suit with 'dime novels', like those from Beadle and Adams in New York. These too are highly collectable.

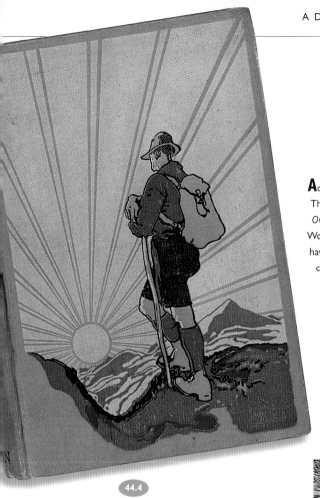

Adventure becomes real life. The cover of the 1916 *Boys' Own Annual* shows the First World War conflict that must have come too close for the comfort of most readers.

44.4

John Buchan's *The Last Secrets* (1923), in which the best-selling novelist retells some stories of real-life exploration. The cover design sums up the 'manly' ethos.

A later generation of novelists provided adventure stories that still hold their own, as classics, with adults as well as children: examples include Robert Louis Stevenson (*Treasure Island*, 1881), Rider Haggard (*King Solomon's Mines*, 1885), Rudyard Kipling (*Jungle Book*, 1894), and John Buchan (*Thirty-Nine Steps*, 1915). In the inter-war years Percy F. Westerman and W.E. Johns kept boys supplied with a steady flow of stories.

Adventure stories inevitably celebrate force, at first perhaps employing a manly fist. But soon swords, guns, tanks and aircraft come into play, over a terrain that gradually extends beyond the British Empire to cover the whole world and, indeed, the universe. Today's adventure stories tend to be epics of outer space, usually told, not in books, but through comics, television and film.

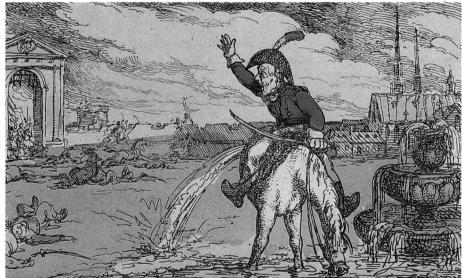

44.2

R.E. Raspe's *Adventures of Baron Munchausen* (1785). Another adult book which was read by children as an adventure story: the Baron's adventures were tall stories, enjoyed by adults because they recognized them as outrageous lies. But children took them on trust. This illustration by Thomas Rowlandson, for an edition of 1809, shows how the back half of Munchausen's horse was cut off by the falling portcullis as he passed through a town gate. He only discovered something was wrong when his horse stopped for a drink.

—45—

COMICS AND MAGAZINES

Bad Penny, an anti-heroine invented in 1966 by Leo Baxendale for *Smash*.

In a newsagent's today, you see hundreds of magazines on the racks. The periodical press is a creation of the 19th and 20th centuries, like so much else. There were a few pioneer magazines for adults in the 18th century, and likewise a few for children. By the later 19th century, there were plenty of well-illustrated children's magazines in black and white. These attempted an up-to-date appearance, but their contents consisted of a severe diet of moralizing. They were published by bodies like the Religious Tract Society. As seen in section 44, the 'penny dreadfuls' offered more thrilling and perhaps corrupting fare. In response to these came magazines like *The Boys Own Paper* and *Chums*, which looked more exciting but nonetheless provided 'healthy reading for the young'. In England, the tradition of magazines that did you good continued with Arthur Mee's *My Magazine* (1914-33, an endlessly recycled version of his *Children's Encyclopaedia*) and *Children's Newspaper* (1919–65). *Young Elizabethan* (1948-73) had an improving tone which reflected post-war confidence. Uplifting magazines tended to drop fiction in favour of fact in the 1960s and '70s (such as *How and Why*, *Finding Out*, *Look and Learn*), and have now faded away.

If up-market children's periodicals failed, down-market ones flourished. Humorous magazines for adults multiplied from *Punch* (1841) onwards, with pictorial strip narratives gradually creeping in. The comic as its connoisseurs defined it - a magazine devoted entirely to strip cartoons - came into existence in the 1890s. *Comic Cuts*, *Chips* and many imitators were aimed chiefly at adults, from the lower middle and working classes, but children would certainly have enjoyed them. Soon children got their own comics. *Rainbow* (from 1914) was the first designed exclusively for the juvenile market. It featured the Bruin Boys, and Tiger Tim (who got his own *Tiger Tim's Weekly* from 1920, and popped up all over the place in other comics).

The bouncy Tiger Tim, from the cover of his 1927 annual.

It is a characteristic of comics that they almost always try to look exactly like other comics, perhaps in order to bamboozle children into buying them all for fear of missing something they are familiar with. This similarity is the more remarkable because the comic market is dominated by a very few publishers; but it does not seem to worry them that they may have ten or more indistinguishable comics running at the same time. Since comics are both repetitive and ephemeral, dedicated collectors have to develop beady eyes and supercharged memories in order to master the vast amount of complicated material.

Pictures are said to be a universal language, and there is hardly any printed narrative in comics. Nonetheless words are a vital part of the effect, usually in speech balloons. Moreover, personal nostalgia matters to comic

45.3

Copies of *Rainbow* (11 June 1927)
and *Tiger Tim's Weekly* (14 November
1925). Almost identical, they came
from the same publisher,
Amalgamated Press.

45.4

Early black-and-white comic
of the *Comic Cuts* era. The
rock-bottom price of a half
penny (0.2p) was an
important factor in the
success of such publications.

collectors, so comic collecting respects national barriers.
Hence this section sticks to English language publications,
not attempting to explore, say, the importance of *Spirou*,
Les Pieds Nickelés, *Lisette* and *Madeleine* to the French
childish psyche. There is, however, one overwhelm-
ing international presence in comics - Mickey
Mouse, with his crew - whose popularity has been
sustained by the Disney animated films, which
translate easily into comic form. Other media,
namely radio, film and television, have always
fed into comics.

Many English children's magazines mixed
humour and adventure, and in some the adventure
continued to be conveyed in solid print (often tiny,
smudged print), as it had been in *Boys' Own Paper*. D.C.
Thomson of Dundee, a dominant comic publisher, also
issued the 'Big Five' adventure papers: *Adventure* (from
1921), *Rover* and *Wizard* (1922), *Skipper* (1930) and *Hotspur*

(1933). Their main rivals, Amalgamated Press, riposted with *Champion* (1922), *Rocket* (1923), *Triumph* (1924), *Modern Boy* (1928), *Bullseye* (1931) and *The Ranger* (1931). *Lion* came along in the 1950s and *Valiant* in the 1960s. All these were full of fighting of one kind and another, and the 1970s saw the arrival of magazines devoted entirely to war: *Warlord*, *Battle*, *Bullet*. These were all of much the same size, on rough paper, with crude colour printing. But once again 'morality' struck back. The Rev. Marcus Morris, unwilling to let the devil have the best tunes, started *Eagle* in 1950. Better produced (printed by photogravure), and informative as well as entertaining, this included the life of Christ among its strip narratives.

Eagle was one of a group edited by Morris, its companions being *Girl*, *Swift* and *Robin*. These remind us that aggressive boys were not the only audience for magazines. *The Girl's Own Paper*, from 1880, had promoted 'moral and domestic virtues'. *School Friend*, from 1919, led a group of magazines which showed sporty, plucky girls matching boys in adventurous exploits. In the 1950s and '60s a different view of the destiny of women began to be advanced, in magazines for teenage girls which dwelt on love and romance. For younger girls, magazines like *Bunty* (1958), *Judy* (1960) and *Mandy* (1967) served as an approach to *Jackie* ('For the Go-Ahead Teens', 1964), *Marilyn* ('The Great All-Picture Love Story Weekly') and *Valentine* ('Brings You Love Stories in Pictures'). These were outpaced by *Blue Jeans*, *Oh Boy!*, *My Guy*, *Mates*, *Love Affair*. And the temperature has continued to rise in the pages of *It's Bliss*, *More*, *Looks*, which cause alarm and despondency to today's parents of sexually awakened girls.

For small children, the 'Tiger Tim' generation of comics - *Chick's Own*, *Sunbeam*, *Playbox*, *Tiny Tots* - ran on with little change until exhaustion finally overtook them all in the late 1950s. Enid Blyton's *Sunny Stories* ran alongside them on this long course. By the 1950s, however, television was engrossing children, and

celebrities of the small screen featured in a new range of picture papers: *Bimbo*, *Teddy Bear*, *Toby*, *Pippin*, *Twinkle*.

All these magazines give children the kind of reading matter adults think they ought to have, or at any rate want. It is possible to make a case, however, that the great classic comics of the 1930s, notably *Dandy* and *Beano*, developed their own special culture of childhood, which ridiculed and subverted adult values. If they did so, it was despite the fact that these two comics and several others were produced by a dour, strict firm in an old-fashioned Scottish town (Thomson of Dundee), and that the undoubtedly talented artists who did the creative work usually repined in obscurity. All the same, childish fantasy was freed to run riot with characters who were rampantly outrageous like Desperate Dan, or obdurately destructive like Denis the Menace. There is nowhere else in children's literature where such excess is licensed.

45.7

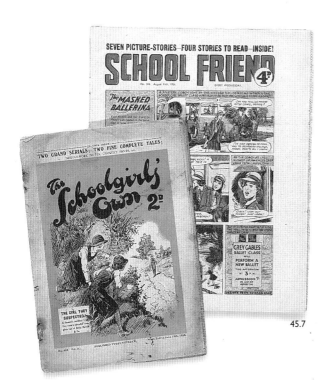

The durable tradition of schoolgirl adventure: *The Schoolgirls' Own* (13 June 1925) and *School Friend* (the second magazine so named, 11 August 1956).

Issue of *Mickey Mouse Weekly* (10 September 1938). With undiminished vigour the Disney characters continued in France in *Le Journal de Mickey* in 1972.

A group of adventure papers.

45.7

45.8

Ronnie Rich, a *Smash* character, was a millionaire, but still got into trouble with adults.

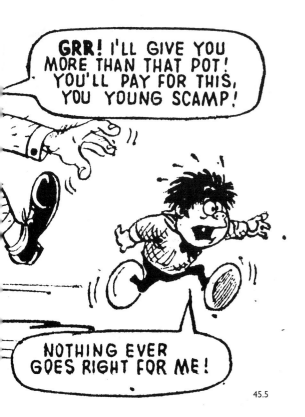

45.5

45.9

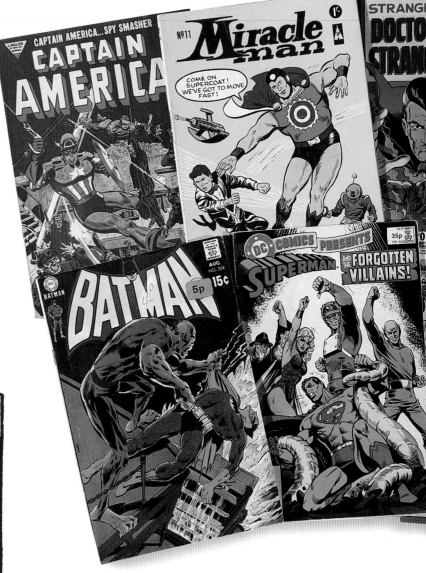

American comic books, dating from the 1950s to the 1980s. America produced many memorable strip cartoons (Mutt and Jeff, Blondie, Krazy Kat, Little Orphan Annie, Li'l Abner, Peanuts) which appeared in newspapers rather than comic magazines. Instead of magazines with a miscellany of strips, the Americans preferred full-length narratives in comic books. These introduced such invincible (and thus typically American) warriors as Superman, Batman and Wonderwoman. Although American comic books aroused denunciation in the 1950s as 'horror-comics', they bounced back, especially the products of the Marvel Comics group, several of which are shown here.

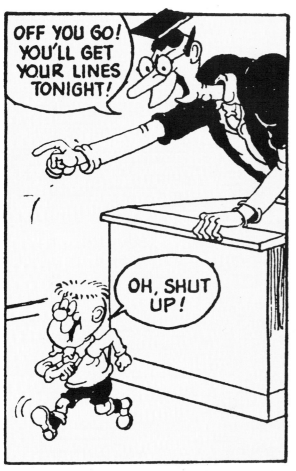

45.10

A subversive moment from 'Swots and Blots', a school saga in *Smash*. Over and over again, the vigour and fluency of the comic artists (Leo Baxendale again here) raise the discomfitures and defiances of childhood to an almost sublime level. The three *Smash* illustrations are from the issues of 19 and 26 November 1966.

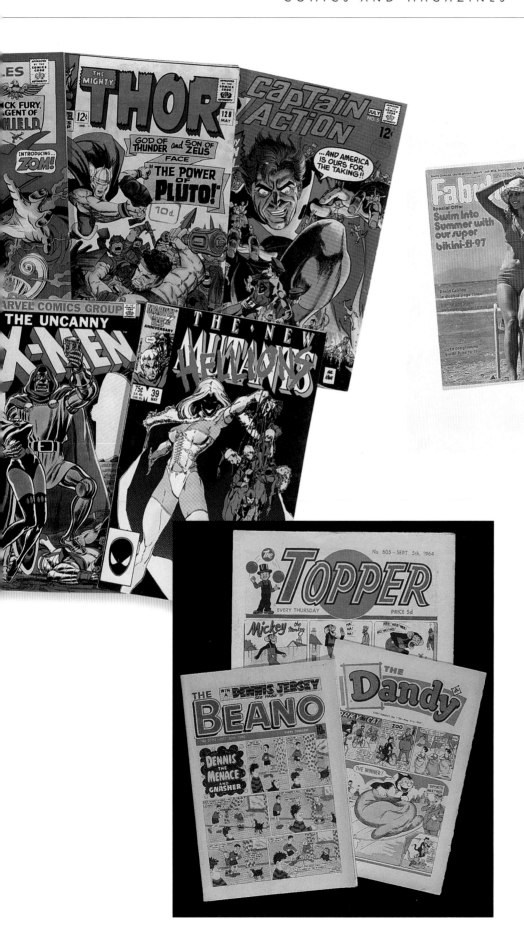

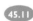 45.11

Widening horizons for girls.
While the average reader of *Judy* in
1960 was interested in hairdriers
and ballet, the reader of *Fabulous* in
1973 was interested in pop-stars
and beach-wear.

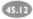 45.12

Three of the classic comics
published by D.C. Thomson.

—46—
THINGS IN LITTLE

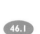

46.1

A tiny toy kitchen, German, 20th century (see illustration 34.4).

Everything in nature has its own size, from microbe to mountain, and no object is the normal size. Human beings, on the other hand, impose their own scale on the world, based on their own viewpoint from the surface of the earth, and on their own needs. Within the human scale, different sizes can attract different degrees of approval. Bigger may often seem better, small sometimes seems beautiful, but such judgements are arbitrary. Since, however, children are smaller than the normal scale which adults impose, most people feel that small is childish. This does not always apply. A certain large simplicity is appropriate for things intended for very young children to see and handle. But once children can control their movements, small-scale articles seem appropriate for them.

Miniaturization is an essential tool for humankind. 'To make sense of the rush of sense impressions that a human being experiences, it is necessary to select, summarize, abbreviate. Memory itself is a selective process. Language provides labels which simplify complex issues. In the visual domain, the representation of big things on a small scale has both practical and aesthetic value. Before building a cathedral, it is practical to make a model or draw a plan. Most art involves the representation on a small scale of aspects of the outer world. Although art can magnify (as in larger-than-life sculptures like the Statue of Liberty), most paintings and sculptures are smaller than what they represent. Is miniaturization part of the aesthetic effect of works of art? In some cases, perhaps, it hardly matters. But in others, smallness is a way of emphasizing skill. In the Renaissance, rich and learned people would assemble 'cabinets of curiosities', which were meant to summarize human knowledge in a small space, and which often included minutely detailed carvings in ivory and precious stones, and exquisitely delicate jewellery. Smallness plus costliness certainly contributed an aesthetic significance here.

Another attraction of miniature representations of the real world is that they offer an illusion of control. Children grasp at the age of 12 months that a toy object stands for something bigger in the real world. Thereafter, in relating to these smaller symbols, children can practise their relations with the world from a more advantageous position than that they usually occupy. If they collect miniature objects, they can make them into a private world which they rule - a welcome compensation if they feel that older adults rule them. Adults like miniatures for similar reasons. Men who cannot afford to collect real old cars collect model ones. Women who cannot afford a stately home might put together a miniature one in a doll's house. 'The world of miniatures' caters mostly for adult tastes.

For children, the manipulation of a tiny-scale world must have always been a pleasure, even if they had to create that world imaginatively, using sticks, stones, and berries. Constructing grottoes - spaces habitable by Lilliputian creatures - is a traditional game. Certain toys have always encouraged the making of miniature worlds: the little painted wooden villages and markets produced by carvers in the Erzgebirge region of Germany, for example. Peeping into a miniature world can be as much fun as building one, and peepshows have been a children's pleasure since the 17th century.

Tiny toys have made a big come-back in recent years. Following the Polly Pocket dolls, the 'In My Pocket concept' was seized upon by other manufacturers. Pocket-sized puppies, teddies and kitties have been joined by Teeny Weeny Families. The toy industry even has a theory to explain this. The Paris Toy Fair of 1996 proposed,

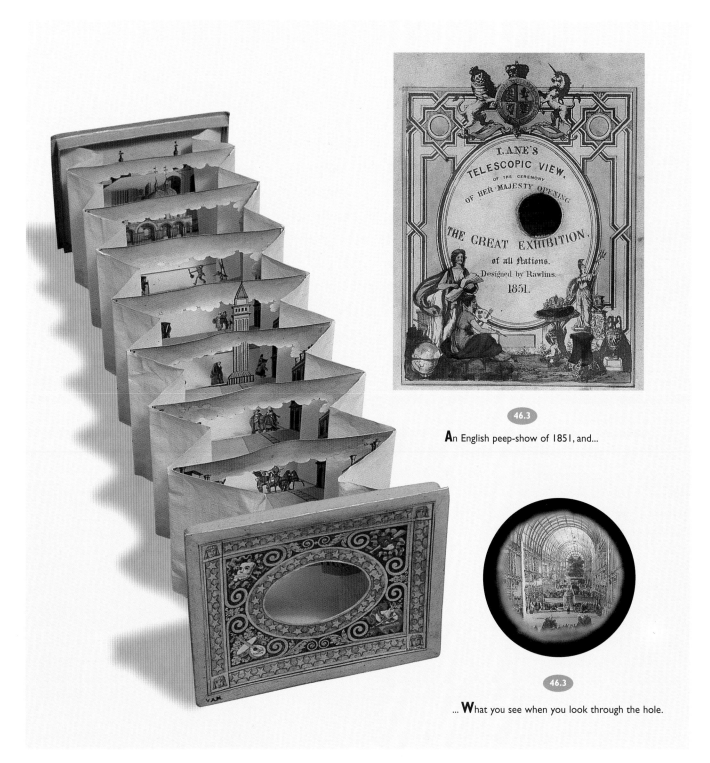

An English peep-show of 1851, and...

... **W**hat you see when you look through the hole.

under the slogan 'Les petits nomades', that 'the broken up or scattered family structure' common nowadays leads to 'frequent journeys to meet up', which necessitate 'compact toys that can be carried everywhere'. However this may be, there is no doubt that miniature spectacles please children.

Toy peepshows. Left: a view of St Mark's Square, Venice, made in Germany about 1850. This shows how cut-out illustrations are set behind each other, connected by a paper concertina, to give a three-dimensional effect. When not in use, the toy can be folded flat.

—47—
GOING TO THE FAIR

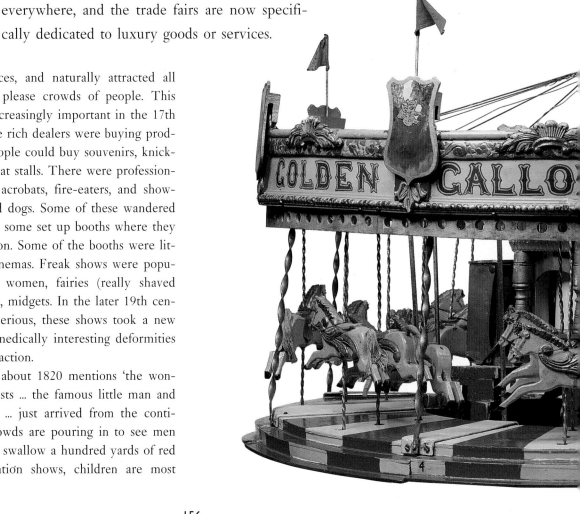

Going to the fair used to be a great treat for children, and has still not lost its appeal. Fairs originally existed not for fun, but for trade. Even in an agricultural society, no household could produce everything it needed by its own efforts. There had to be some means of exchanging products, and from earliest times local weekly markets provided a useful meeting place for this. Fairs were bigger markets. Traders came from further away, bringing products that were not available locally. To England, for instance, in the Middle Ages, they would bring spices, jewellery, silks and satins. Fairs were often held to sell a seasonal product. There were many cattle, horse and goose fairs, and there were also 'hiring fairs' where farmers would take on casual labour for the coming year. Fairs were at their most useful as trade centres in the Middle Ages. After that, better roads (and eventually railways), the growth of towns and the expansion of retail trade made them less and less important. Nowadays, large supermarkets can provide everything from everywhere, and the trade fairs are now specifically dedicated to luxury goods or services.

47.1

The fairground inspired toys. This pressed tin Ferris Wheel was made in Germany, probably in about 1910.

Fairs were meeting places, and naturally attracted all sorts of amusements to please crowds of people. This aspect of fairs became increasingly important in the 17th and 18th centuries. While rich dealers were buying products in bulk, ordinary people could buy souvenirs, knick-knacks and refreshments at stalls. There were professional entertainers: jugglers, acrobats, fire-eaters, and showmen exhibiting bears and dogs. Some of these wandered among the crowds, while some set up booths where they could charge for admission. Some of the booths were little theatres and, later, cinemas. Freak shows were popular: lion-men, pig-faced women, fairies (really shaved monkeys), bearded ladies, midgets. In the later 19th century, when science got serious, these shows took a new slant, and waxworks of medically interesting deformities became a fairground attraction.

A children's book of about 1820 mentions 'the wonderful shows of wild beasts ... the famous little man and prodigious great woman ... just arrived from the continent'. It tells us that 'crowds are pouring in to see men eat knives and forks, and swallow a hundred yards of red tape'. But as its illustration shows, children are most

eagerly 'pushing up to the stalls where toys are sold, viewing the gay rows of painted dolls, horses, whips, chairs, and bright tin tea-kettles'. Bartholomew Fair, in Smithfield, London, was particularly famous for its dolls, known as 'Bartholomew babies'. In the same illustration other children 'press up to the tempting stall of oranges, apples, nuts, gingerbread, and hot plum-pudding'. Nowadays they would go for candyfloss (invented in Paris in 1900) and hot dogs.

Above all, fairs offered the pleasures of movement, in the various fairground rides. An illustration of Bartholomew Fair in 1740 shows a primitive version of the Big Wheel. Actually it was square (like the one at Croydon illustrated in 1834), but it went round, raising and lowering gondolas with passengers in them. These contraptions would have been turned by hand, as would

the simple roundabouts that were known from the 18th century onwards. And there were swings, which you worked yourselves. In the 1870s, fairgrounds were transformed by steam power. From now on, the rides got bigger and bigger: carrousels with galloping horses or menagerie animals, the 'waltzer', the 'caterpillar', 'chairoplanes', the ghost train. Steam also powered the thundering fairground organs. Electricity brought dodgems in the 1920s.

A small group of fairground equipment makers arose: in England, Savage of King's Lynn and Anderson of Bristol; in France, Limonaire in Paris and Bayol in Angers; De Vos at Ghent in Belgium; Heyn near Dresden in Germany; Soccorsi in Italy. They developed the characteristic folk art of the fair: the carved animals, the dense scrollwork decoration, the curly lettering. Connoisseurs can distinguish their special styles. Later came Art Deco zigzags and space-age streamlining.

Not the least fascinating aspect of a fair was the way it was taken apart so that it could be transported on lumbering lorries from one fairground to another, where it would magically appear overnight. One modern version of the fairground does not travel: the pleasure park, with its frightening rides. Children love these parks, but there they miss the sense of transience which makes pleasure more intense.

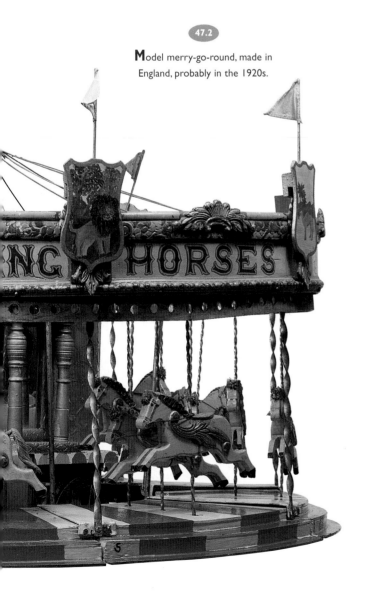

47.2

Model merry-go-round, made in England, probably in the 1920s.

47.3

A primitive form of roundabout, pushed by hand. From a children's book, *Bilder-Lust für kleine Kinder*, published in Nuremberg in about 1832.

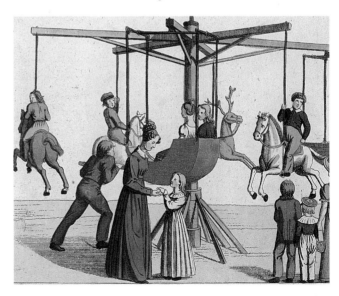

THEATRE & TOY THEATRE

48.6

Many children like acting, informally, or with much solemnity, in front of their family. Training children to act plays became an acceptable part of the education process in the early 20th century. Putting on plays specially written for children, with professional actors, is still uncommon. If children accompany their parents to the theatre, pantomime is likely to be the dramatic form that attracts them most. If they want to re-create the experience of theatre at home, they can rig up their own stage, or they can evoke the magic of drama in miniature with a toy theatre.

In England, pantomime was for many years the only enjoyable theatrical experience for children. Modern productions are usually a medley of entertaining turns held together by a thin story-line. Traditional pantomimes, however, had double stories. The first part, or 'opening', was usually in rhyming couplets and would be based on a fairytale, nursery rhyme, or other story with appeal to children. The second part would be the *Harlequinade*. Consequently, pantomimes often had titles like *Harlequin Red Riding Hood.*

48.1

Illustration showing French children playing with a theatre, from *Les bons petits garçons* (1875), by Henri Gillet.

The *Harlequinade* part was a vestigial version of the Italian *commedia dell'arte*. Introduced into England probably as comic relief between the acts of serious plays, it retained the characters of Harlequin, his beloved Columbine, her peevish father Pantaloon, and the Clown. Much of the story was conveyed in mime, sliding into slapstick. A 'transformation scene' led from the opening into the *Harlequinade*. At first this just meant that the actors changed costume, but eventually it involved spectacular effects with the scenery.

Generations of children remembered a visit to the pantomime (where people ate oranges and behaved rowdily) as a highlight of the Christmas holidays, though pantomimes were also performed at other times of year.

Children who wanted to relive the theatrical experience could do so with a toy theatre. On a miniature, table-top stage, with a decorative proscenium arch, they could perform plays with little actors made of cut-out cardboard, about 2 inches high. Toy theatres were not unlike peepshows, which were around in Europe from the 17th century, but they seem to have been invented in about 1811 by William West, a London stationer. He produced sheets of characters for various plays, at first

48.2

Monsieur Louis as the pantomime Clown, published by Redington. Toy theatre publishers printed large souvenir pictures of star actors, as well as the small characters for use in their theatres.

48.3

Cover of an illustrated children's book, probably of the 1860s, which evokes a typical pantomime. Harlequin, Pantaloon and Clown are in the middle. The other characters are no doubt wearing the masks, or 'big heads', that were a feature of pantomime.

48.6

perhaps as souvenirs (for whole groups of figures are shown together), but later clearly for use in toy theatres.

Other early publishers were I.K. Green, A. Park and Hodgson & Co. In the next generation the firms of Skelt and Webb were prominent, followed by John Redington and his successor Benjamin Pollock, whose shop in Hoxton kept going up to the 1930s.

Pantomimes always loomed large among the plays available from toy theatre shops, but also on sale were melodramas that had done well on the adult stage, adaptations of popular stories and even some Shakespeare. The favourite play with children was *The Miller and his Men*, which was about a gang of robbers in Bohemia and ended thrillingly with an explosion.

By the end of the 19th century, adults began to collect toy theatre sheets, inspired by Robert Louis Stevenson's 1884 essay, 'A Penny Plain and Twopence Coloured'. This phrase alludes to the fact that toy theatre sheets were sold ready-coloured, or more cheaply uncoloured.

The earliest (and now rarest) sheets tend to be the best designed. Drawing and engraving styles became cruder as time passed, and some late sheets printed by lithography (unlike the earlier copper or steel engravings) were very smudgy. Today it would be hard to assemble a good collection to match those that are treasured in museums and libraries. But reprints and new versions preserve the lasting charm of the toy theatre.

48.4

A sheet of splendidly posturing characters from the play *The Miller and His Men*, first published by Hodgson & Co in 1822. Characters were shown in different poses appropriate to different scenes in the plays.

48.5

A toy theatre constructed for an English family, and much more artistically made than the cardboard theatres. It is equipped for only one play, *The Yellow Dwarf*, a popular extravaganza in mid-Victorian theatre. The characters are operated from below, so there is a complicated system of slits in the stage floor.

48.6

48.6

Hand-made theatre characters. Once you had a toy theatre, you could design your own characters and scenery for any play you liked. These characters were made for *The Haunted Castle* in 1887, and come from a toy theatre that belonged to the Mertens family in London, who put on Christmas shows at home every year.

—49—
PUPPETS

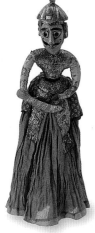

49.1
Indian puppet representing Rama Pratap Singh, from a set of early twentieth-century puppets from Rajasthan.

W e do not know from where puppets originated. They were to be found in Ancient Greece and Rome, and they are recorded in India and China at least from the 2nd century BC, and may have existed there several centuries earlier. In the West, the various techniques of puppetry have been used in all sorts of ways, according to the inspiration of individual puppeteers. In Asia, however, where life did not develop along a rising line of industrial progress, traditions remained powerful and age-old methods of puppetry survive even today. The plays which the puppets perform tend to be closely linked to religious myths and observances.

In India, the chief sources for puppet plays are the great Hindu epic poems, the *Ramayana* (the adventures of Rama) and the *Mahabharata.* The dramatized versions of these have been passed down orally among puppeteers. The stories contain hosts of characters (gods, demons, giants, nobles, priests, monkeys) so a puppeteer may need hundreds of puppets, and the plays can go on for many hours or indeed days, at fairs, festivals and family ceremonies like weddings. The puppeteers regard their craft almost as a religious vocation, and observe rituals in both making and disposing of puppets. In India, all the traditional types of puppet are used: string-puppets, rod-puppets, hand-puppets and shadow-puppets.

Related to the Indian puppet traditions are those of Java, Bali, Malaysia and Thailand. All use shadow puppets. Javanese puppetry (*wayang*) also has three-dimensional rod puppets (*wayang golek*) as well as shadow figures (*wayang kulit*). The puppets have an abstract, formalized quality. This recoil from representationalism may show Islamic influence, but the plays used in Java mostly derive from the Hindu epics. Performances are accompanied by music played by a gamelan orchestra, led by the puppeteer.

China has a long puppet tradition, in which all four types of puppets are used. For three-dimensional figures the heads are of most importance: they are carved from camphor wood, and painted, following the stylized conventions of the Chinese operatic tradition. Puppets performed traditional plays related to those in the live theatre, but under Communist rule a new political repertory has been introduced.

The Japanese puppet tradition, *bunraku*, developed in Osaka from the 17th century. The puppets are unusually large, more than a metre high, and fairly realistic, but are extremely complicated to move, each needing three operators: one for the head and right arm, one for the left arm, and a third for the feet. The operators are in view of the audience, though dressed all in black. The 'Japanese Shakespeare', Chikamatsu Monzaemon (1653-1724), wrote over a hundred plays for the puppet theatre.

In Europe, the only puppet tradition as durable as those of the East is Punch and Judy. The English Punch and the French Polichinelle obviously derive from Pulcinella, a character (though not a central one) in the Italian *commedia dell'arte*. Quite how the tradition evolved is probably beyond discovery now. Punch, however,

49.2
Javanese shadow puppet. The more privileged members of the audience (usually men) watch the play from the puppeteer's side of the screen, while the rest (usually women), on the other side of the screen, see the shadows, the 'soul' of the puppets.

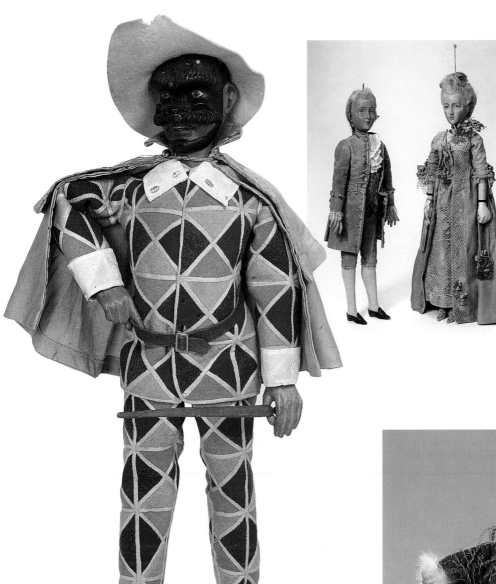

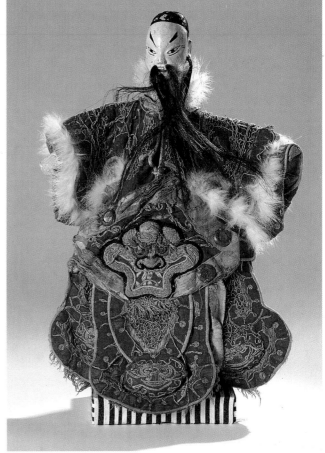

49.3

Chinese hand puppet. One of a group, which have carved heads and canvas 'bodies' over which a costume is placed. The costume of this puppet, a warrior, is particularly fine and represents armour. The centre of hand puppet-making in China was Fukien province in the south, where most of the Museum's puppets were made in the 1920s.

49.3

49.3

An 18th-century Italian marionette theatre, with twelve puppets, is one of the Bethnal Green Museum of Childhood's most prized exhibits. The theatre probably came from an aristocratic palace in Venice, though we do not know its exact origin. The beautifully made puppets are among a very few such groups to survive in museums; pictured here are Arlecchino, and a noble man and woman.

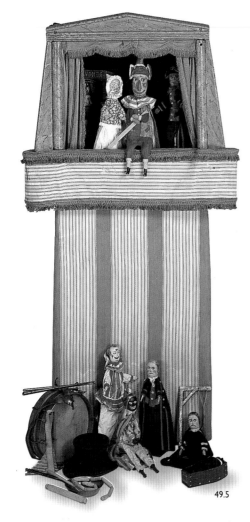

49.5

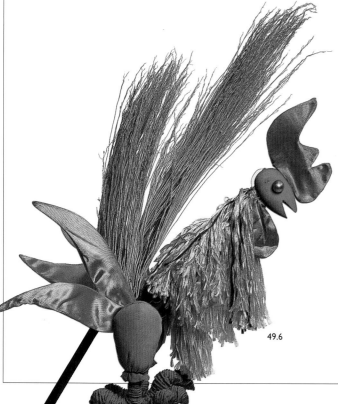

49.6

turned out to be a subversive and street-wise character. He does what hand-puppets do best, fighting. And he fights everyone, from his wife, through all the agents of an orderly society in the shape of the doctor, the beadle, and the hangman, until he finally worsts the devil. He shares irrepressible vitality with other European folk heroes. In France, Polichinelle was eventually eclipsed by Guignol, a rowdy silk-worker from Lyons. In Germany there is Kasperle, in the Netherlands Jan Klaasen, in Russia Petrushka, in Turkey Karagöz, to mention only some of these resourceful tricksters from the underclass.

From the overclass - though reduced to popular level - comes the puppet tradition of Sicily. Its stories are based on medieval romances dealing with the struggles between Christianity and Islam. The puppets, chivalrous knights, are big, heavy and clothed in metal armour, and do little but fight. Performances are full of thuds, clatter and shouting. Oddly, a similar tradition survived in Liège in Belgium.

In Europe, puppetry gained admittance to the mansions of the rich, for a time at least. In the 18th century it was a court entertainment in France and Germany, and operas were written for performance by puppets. On the whole, though, it flourished chiefly on the street corner and in fairgrounds. With the 20th century, it was rediscovered as an art form, and as an educational influence. Its history continues not as tradition, but as a series of individual artistic enterprises. Some of these are adults' pleasures, rather than children's, but children have always been a big part of the audience for puppetry. They play with puppets, which have been available as toys for a century, and finger-puppets are almost entirely a children's pleasure.

The relation between puppets and their operators can contribute significantly to the effect of a show. Sometimes operators are entirely concealed, so the audience must imagine that the puppets both move and speak by themselves. Sometimes there is a commentator who mediates between audience and spectacle. Other times, as in many forms of Asian puppetry, the operators are fully visible, and their movements are as much part of the performance as those of the puppets. Some of the most beguiling uses of puppetry in recent years have been by actors in mime, or 'physical theatre', where there can be piquant contrasts of scale, and almost magical effects as apparently inert sticks and rags suddenly borrow life from a human performer.

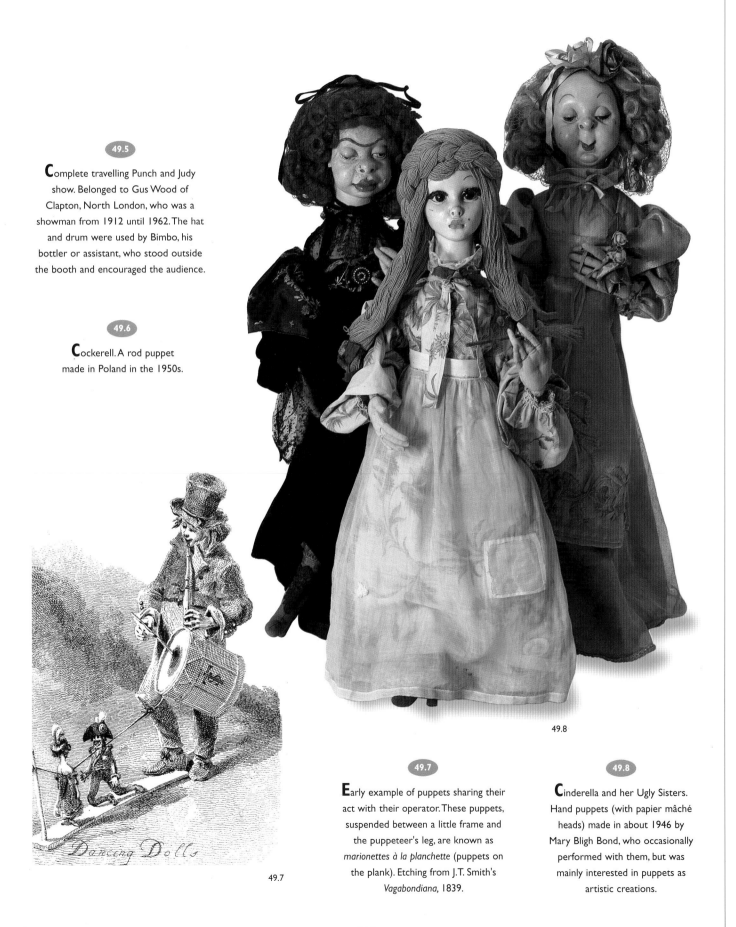

Complete travelling Punch and Judy show. Belonged to Gus Wood of Clapton, North London, who was a showman from 1912 until 1962. The hat and drum were used by Bimbo, his bottler or assistant, who stood outside the booth and encouraged the audience.

49.6

Cockerell. A rod puppet made in Poland in the 1950s.

49.7

49.8

49.7

Early example of puppets sharing their act with their operator. These puppets, suspended between a little frame and the puppeteer's leg, are known as *marionettes à la planchette* (puppets on the plank). Etching from J.T. Smith's *Vagabondiana*, 1839.

49.8

Cinderella and her Ugly Sisters. Hand puppets (with papier mâché heads) made in about 1946 by Mary Bligh Bond, who occasionally performed with them, but was mainly interested in puppets as artistic creations.

—50—

PARTIES AND PARLOUR GAMES

Price 2d. Complete.

"Something to Read" Office, 173, Fleet Street, and all Booksellers.

50.1

How to party in about 1880.
The cover of a book of party games.
Father Christmas presides.

The word 'party' basically means a group of people (like a political party). In the early 18th century the phrase 'party of pleasure' meant a social gathering, and by the end of the century the word on its own was used in this sense. Community celebrations have doubtless existed since the beginning of time, but 'parties' belong to the advanced age of civilization when drawing rooms and parlours had emerged as sites for family gatherings. Such genteel surroundings demanded pastimes that were festive but not too rowdy. Occasions for celebration are often seasonal, so the history of the party has a lot to do with Christmas.

In the early decades of the 19th century, the best Christmas jollifications took place on Twelfth Night (January 6). A custom associated with this day throughout Europe involved the choosing of a 'King' and 'Queen' to preside over the revels. The traditional way of choosing was by baking a cake with a bean and a pea in it. When the cake was sliced and eaten, whoever got the bean became King, and the pea marked out the Queen. The custom still prevails in France, where all the confectioners sell cakes (galettes) for Twelfth Night. These contain charms which children like to collect. In England 'Twelfth Cakes' became large and lavishly decorated by the 1820s. Probably people could not, or did not want to, eat them at one go, so a new method of choosing the King and Queen was adopted. A series of playing-card-sized illustrations of characters, including King and Queen, were put in a hat and then everyone drew one. Those who did not get King or Queen had to act the character they did draw, such as Jolly Jack Tar, or Lady Stuck-Up. Twelfth Night parties were for adults just as much as for children.

By the 1840s parties specially for children had developed, but were still new enough for Thackeray to write to *Punch* in 1849, teasingly denouncing 'the awful spread of Juvenile Parties' which he said would 'operate most injudiciously upon the health, morals and comfort of soci-ety in general'. In the 1850s, *Punch* was still mocking little boys for aping the manners of their elders at parties. Little boy: 'What a bore! Just as I was going to pop the question to Jenny Jones, here's my nurse come for me!' But by the 1870s, children's parties were acceptable to everyone.

Then, as now, you could get professionals to manage your party. The toyshop owner W.H. Cremer had a sideline in parties: 'The best artists only employed. Decorations supplied to harmonize with the appointments of the drawing-room or the village school'. Cremer offered ventriloquists, magicians, Punch and Judy, lantern slides, fireworks, special lighting effects ('the art of illumination has been Mr. Cremer's study for upwards of twenty years'), and toys to send 'the little ones away pleased and satisfied'. Party kit is particularly ephemeral, and it would be good to see what sorts of hats, masks, wigs, beards, streamers and noisemakers Cremer had on hand in 1873.

You could, if you wished, organize your own party games. The earliest how-to-do-it books, like *Mince Pies for Christmas* (1804) and *Parlour Amusements* (1820) rather tamely offered only verbal games: riddles, forfeits, rebuses. But these 'games involving mental exertion' were soon joined by active games: hot cockles, diving for apples, snapdragon, hunt the slipper, blind man's buff, hide and

The envelope cover of a sheet of Twelfth Night characters, published by A. Park, London, in about 1840. This sketches the essentials of a party. In an atmosphere of love and beauty, adults could expect to be entertained with 'The Song', 'The Dance', and 'The Droll Story'. Notice the child who plays 'A Pleasant Game'.

How to party in about 1920.

seek, musical chairs, postman's knock, blowing a feather, and many others less well-known. You could find details in children's play compendiums with names like *The Girl's Own Book, Every Little Boy's Book, The Illustrated Boy's Own Treasury, The Home Book for Young Ladies*. These, often undated, were constantly reprinted (one proudly announced that it had gone through 22 editions and 90,000 copies) and enlarged (*The Boy's Modern Playmate* in 1891 amounted to 884 pages). Such books not only described games but other home-made entertainments: amateur dramatics, charades, card tricks, hand shadows, and illusions.

Birthday parties, which now seem more desired by children than Christmas parties, were not so common in the 19th century. By 1913 Gladys Crozier's book on parties was recommending a wide range: at Easter, May-day, summer holidays, Hallowe'en, with cotillon dances, obstacle races, hay-party games, and even visits to London Museums. Some children love parties: Thackeray's daughter Annie revelled in the 'brilliantly wonderful' children's parties organized by Dickens. But Eleanor Farjeon cringed at the memory of Edwardian parties she had blushed and wept through.

— 51 —
TOYS THAT MOVE

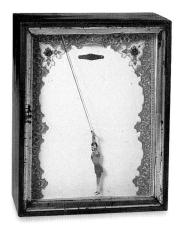

S ection 10 described some simple toys which could be made to move by the human hand, with some help from gravity. This section deals with toys that appear to move by themselves - though a human hand always has to start them off. They all contain mechanical devices, sometimes very complicated ones, but mostly using clockwork. The source of power for clockwork is usually a spring. A very simple toy that makes use of this, with nothing else but a trigger (the catch of the box) is the Jack-in-a-Box, the exact origin of which remains a mystery.

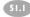

S and toy. Falling sand (operating like water) turns a wheel in the back of the box, which in turn agitates the figure in the front, 'Leotard, the French trapeze artist'. This toy was made by Brown, Blondin & Co of London in about 1860.

Power could be supplied, as it was for early industrial machinery, by air or water. The windmill is almost the only toy worked by air. The Middle Ages knew both whirling blades on the end of sticks, and fliers which could be launched into the air from a bracket like that used with some tops, where motion is imparted by pulling away a wound string. A variant of the windmill is seen in the traditional German Christmas pyramid, where hot air rising from burning candles turns horizontally set blades which rotate a tiered structure containing carved wooden figures representing the Christmas story. Compressed air can cause a flattened flexible tube to spring out straight: hence the jumping frogs or spiders, activated by pressing a rubber bulb. Few toys have used water power, presumably because it is messy indoors, but it has been used recently in outdoor play equipment. Sand toys, popular in the 19th century, use falling sand just as if it were water to power a wheel.

Air and water were the power sources for the earliest attempts to make moving models, such as those

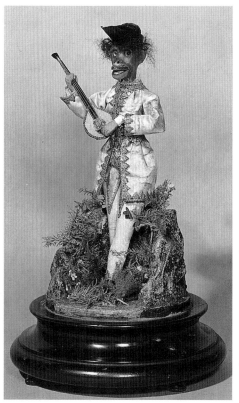

described by Hero of Alexandria in the second century BC. These were advanced science for their day. Clockwork mechanisms, known as early as the 15th century, were what made moving toys possible. Some early clocks were powered by descending weights, and this method is used for some toys. More compact is the coiled spring, which is tightened up by winding and then gradually straightens itself out. Mechanical clocks in cathedrals and town halls made in the late Middle Ages still offer a fine spectacle as, on the hour, little figures start into motion. In museums there are many precious clocks, made for princely owners, which incorporate moving figures.

The 18th century saw the arrival of mechanical figures on a table-top scale, which were designed not just to amuse but to astonish because they were so lifelike. Among the prodigies were Jacques de Vaucanson's flute-player and excreting duck; Baron von Kempelen's chess-player; Pierre Jacquet-Droz's three figures which write, draw and play a keyboard,

51.2

51.3

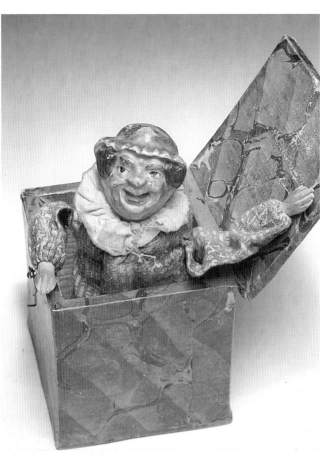

Monkey musician, maker unknown,
late 19th century.

51.3

I9th-century Jack-in-a-Box.

51.4

Monkey musicians (restored),
maker unknown, late 19th century.

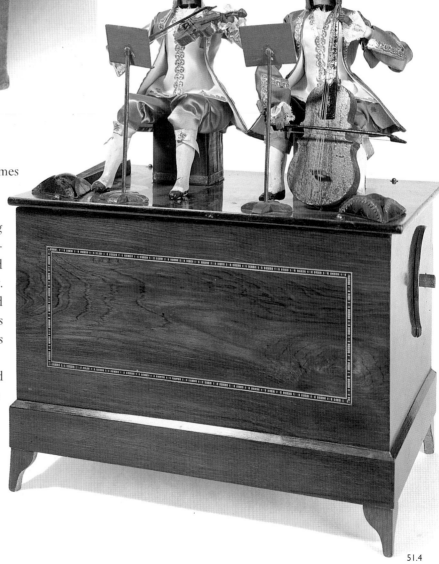

still preserved at Neuchatel; and James Cox's silver swan at the Bowes Museum. Automata of this sort became part of show-business, often being included in the act of conjurors and illusionists like Eugene Robert-Houdon and Neville Maskelyne in the 19th century. These figures were carefully dressed and positioned so that no machinery was visible, and the lifelike movements seemed all the more amazing.

Soon automata were being produced as luxury consumer goods, not as toys for children but as curiosities for adults. A pioneer in the mid-19th century was Théroude, who lived in the Marais district of Paris, where later makers tended to establish their workshops. The great age of Parisian automata was the final years of the 19th century

51.4

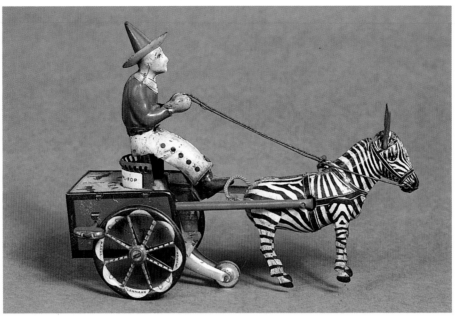

51.5

While automata were a pleasure for rich adults, cheap and cheerful clockwork toys were popular with children. Their heyday came with the widespread use of 'tin plate' (rolled iron or steel coated with a thin layer of tin, used chiefly for food packaging) in the mid-19th century. This material could be easily cut, shaped and joined but, when formed into toys, was tough and rigid. It was the material used for the trains, boats and cars that were so popular at the turn of the century (see section 36), and many makers used it for moving novelty toys too.

Most famous are the 'petits bonhommes' of the firm of Fernand Martin, which operated from 1878 to 1934. Martin made simple but stylish everyday figures, which

and on up to the First World War. Big names among makers were Jean Roullet (and his son-in-law successor Ernest Décamps), Blaise Bontems, Gustave Vichy and Leopold Lambert. Parisian automata of this period were widely exported. Many survived, and appear regularly in the auction houses, selling for thousands (sometimes tens of thousands) of pounds apiece.

In principle an automaton can mimic anything in the human or animal world. The automata of the Parisian golden age, however, inhabit a rather limited, if charming, world that evokes the easy frivolity of the Belle Epoque. Clowns, musicians, acrobats, diseuses, dancers, conjurors and street-sellers are characteristic inhabitants of this world, in which negroes and monkeys also figure prominently, these last often smoking. Musical boxes were often combined with moving figures to enhance the pleasure with sound. The tradition of automata is cherished in Paris. Deep in the Musée des Arts et Métiers is a room full of automata, to which each day white-coated attendants come to wind up the automata and make them perform.

51.5

Lehmann toy, 'Zikra', a cart pulled by a zebra. 1927.

51.6

The Great Billiard Player, made by H. Kienberger of Nuremberg c.1911. Many other makers also made versions of this popular clockwork toy.

51.6

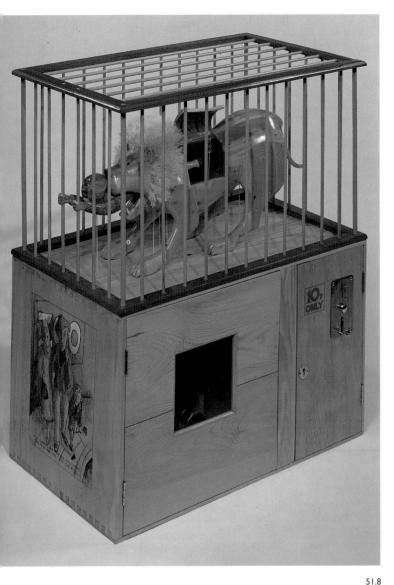

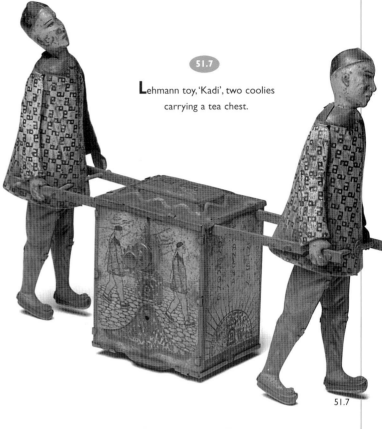

51.7

Lehmann toy, 'Kadi', two coolies carrying a tea chest.

51.7

51.8

Modern automaton: 'Albert and the Lion'. Based on the verses by Marriott Edgar, made famous as a recitation by comedian Stanley Holloway. This was made by Michael Howard in 1983.

51.8

moved amusingly and, even when still, had a perky, caricatured air. The early ones were often powered by twisted rubber bands, the later by spring clockwork. Little figures pulling or pushing carts (from a luggage porter to a rickshaw driver) were Martin's strongest line, along with animals, birds and insects.

In Germany, the firm of E.P.Lehmann produced similar little toys. Among his best known were the miller who climbs a pole and then comes down with a sack on his head, and the monkey who climbs a string. Many makers followed the example of Martin and Lehmann, and alternative materials, notably plastics, were used as they became available.

Automata became fashionable again, at least in Britain,

in the 1980s. A generation of craft toymakers who had been inspired by Sam Smith rediscovered the fun of movement in toys and began to design accordingly. Paul Spooner, Peter Markey, Frank Egerton, Ron Fuller, Tony Mann, Robert Race, Michael Howard and Tom Wilkinson are among the automatists who work chiefly in wood, while Lucy Casson uses tin. Attitudes to machinery have changed. The inner works of the automata are often exposed, since audiences, no longer amazed by toys that move, prefer to know how it is done. In our machine age, it is not the verisimilitude but the clumsiness of automata that appeals. They can express a critical view of mechanization too, as in the unforgettable machines of Eduard Bersudsky.

—52—
MAGIC LANTERNS

A grotesque figure against a black background, from a long slide. This kind of comic slide, apparently especially liked by children, had its own squashy style, which was kept up throughout the Victorian period and makes it hard to date such slides.

Today almost every home in every developed country has at least one box of moving images, flickering in the corner of a room. In the age of television and video, children's eyes and brains are capable of registering and decoding a welter of visual stimuli which would have left a medieval child confounded. All the same, children are still fascinated by the comparatively simple devices which led up to the present visual explosion, perhaps because they can 'see the joins' in the illusions, and feel they can understand how it was done.

To make a box of flickering images, two things have to combine: a method of transmitting motionless images in other ways than by printing them on paper, and a method of making images move. Let us take the first. The magic lantern, which projects pictures on to a screen, is generally reckoned to have been invented in about 1646 when how it worked was described in a book by a Jesuit priest, Athanasius Kircher. We have to wait until 1672 before we get reports of people actually using magic lanterns, and the name (in Latin *laterna magica*) was devised in 1674. What was needed was a source of light, and a way of concentrating it into a strong beam which would penetrate over a reasonably long distance. The only sources of light at that time were sunlight, candles or oil lamps. Most of the early illustrations of magic lanterns show them emitting neat little puffs and coils of oily smoke. The way of concentrating the light was by a concave mirror and a condensing lens.

Once you had a strong beam, you could shine it through a semi-transparent picture and (using lenses to focus it) throw an image

on to a distant flat surface. The many technical improvements in later centuries did not change the basic principles. Improvements were made on lenses, and also on light sources. Besides those already mentioned, there were in due course paraffin lamps, gas and electricity. But in the heyday of the magic lantern, the late Victorian period, the favoured method was limelight - the same method used for spotlights in the theatre. A burning jet of mixed hydrogen and oxygen was trained on a piece of lime, which glowed white-hot and emitted a piercing light. Since magic lantern operators had to lug around canisters of oxygen and hydrogen, or even make the gases themselves by home chemistry, they were apt to blow themselves up.

In its earliest days, the magic lantern was often regarded as a mysterious occult device, able to summon up ghosts and spirits. Through the 18th century, consequently, it was often used to give frightening shows of spooks, known as 'phantasmagoria'. But also in the 18th century it became a popular entertainment. Travelling showmen would carry a lantern on their back from village to

52.2

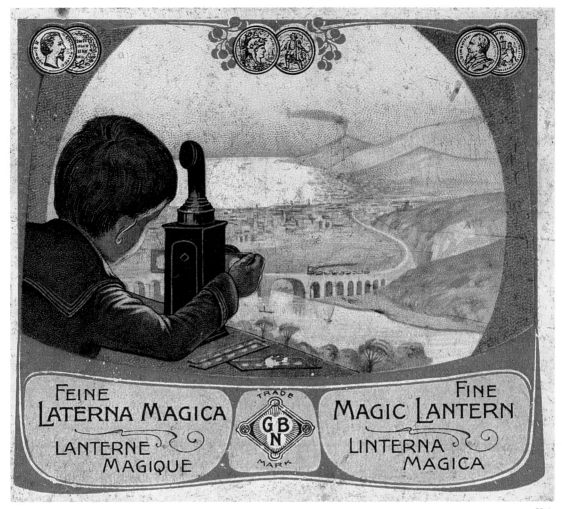

52.4

The approach of the movies. This German magic lantern, made by Ernst Planck about 1900, can take either slides or continuous film.

The magic lantern as a pastime for small children: illustration from *Album der kleinen Freunde*, about 1870.

52.4

This label, on the box lid of a magic lantern made by Bing of Nuremberg in about 1904, shows how the magic lantern was vigorously marketed throughout Europe as a children's toy. This lantern came with an oil lamp and twelve slides.

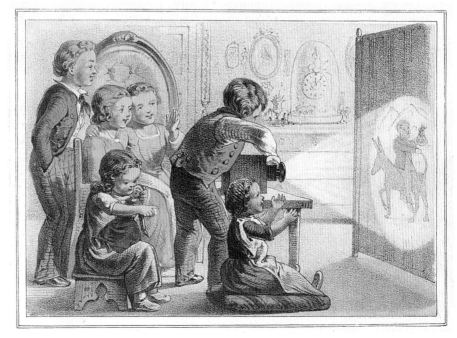

52.3

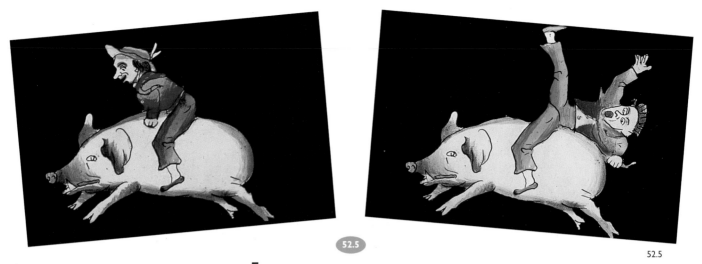

52.5

52.5

From a slipping slide. By pulling part of the slide
along, the riding boy's body can be hidden, while a new
upper picture depicts him falling off the pig.

village, bringing glimpses of romance to simple people. In the 19th century, the magic lantern entered the church, the lecture room and the home, and was enormously popular in the 1880s and '90s. There were many firms specializing in lanterns and their slides, though both could be made at home with a little ingenuity. Most middle-class homes had a lantern, and there might be a toy one as well for the children, notwithstanding the danger of the burning light.

To start with, the only way to produce a slide was to paint on a piece of glass. Such slides were often copied from prints or book illustrations, but could nonetheless have the bold brevity of folk art. The ones most likely to be original (though these followed a rigid convention) were those showing squashed but perky caricature figures against a black background. Later, slides were produced by chromolithography or transfer printing. These were more tasteful then the hand-painted slides, but sometimes seem pallid beside them. But they include charming scenes of child life and reproductions of illustrations from favourite books. From about 1850

photographs could also be printed on slides as positive transparencies. These were often tinted in a way that probably seemed more realistic then than it does now, following the invention of colour photography.

In church and Sunday School the magic lantern was used to show religious stories, like the life of Christ or of the Old Testament heroes, and scenes from the mission field. Temperance societies like the Band of Hope pulled no punches in their lantern shows with dramatic moral tales of how drink degraded. Such sequences, accompanied by rhyming verse ('It was Christmas Day in the workhouse...'), are among the best remembered of Victorian shows. They were often illustrated by posed photographs where real people struck attitudes against backgrounds that were (sometimes all too obviously) set up in studios. Sometimes, however, candid photographs of street life and slum life were put on to slides. A great stand-by was views of interesting places - sometimes faraway geography, sometimes places near at hand like English cathedral cities. Eventually, at the end of the century, slides carrying news stories about disasters and

52.6

Small transfer-printed slide for a children's magic lantern – much more demure than the hand-painted slides.

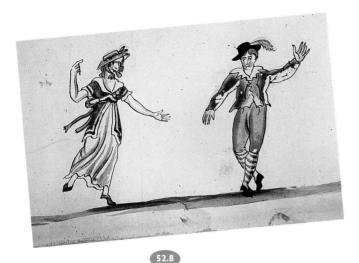

52.8

From an early hand-painted slide, where the artist has painted on the clear glass as if it were white paper. These figures are from a long slide representing dancers. The dancers' costumes look as if they were specially designed, so it seems likely that the slide-artist copied them from a print.

52.7

A mid-19th century phenakistiscope. This device, invented in 1832, uses 'persistence of vision' to simulate movement. Illustrations of figures at different stages in movement (here a skipping boy and a rocking horse) are printed on a disc with slits. By spinning the disc in front of a mirror and peeping through the slits, the boy and the horse seem to move.

political events were promptly supplied for public lantern showings. Art history professors in Germany adopted the magic lantern to illustrate their lectures in the last quarter of the 19th century.

In the home the accent was more on fun and entertainment. In all lantern shows, public or private, the slides that everyone liked best were those that introduced movement by various cunning tricks. With the simple long slide, you could impart a minimal movement just by pulling it past the lens, revealing different parts of the picture in succession. Individual slides (in their attractive varnished wooden frames) could be fitted with two or more layers of glass which could be moved in different directions: by slipping the glass to and fro, by a lever, or by winding a handle which would rotate the glass by ratchets or a pulley and string. Thus parts of the picture could move.

Eventually moving films came along. The principle behind these is 'persistence of vision': when the human eye sees a sequence of slightly different images flashed before it very quickly, the brain interprets these as continuous movement. This principle lay behind several popular Victorian toys: the simple thaumatrope, which anyone could make with a bit of card and string, the zoetrope, invented in 1834, which spins pictures in a drum, the phenakistiscope, and the elaborate praxinoscope, which does it all with mirrors and could be attached to a magic lantern so that a brief moving sequence could be projected.

Photographic technology in due course found ways of taking still photographs of movement in very quick succession on to reels of film, which could be played back equally quickly through a projector so as to produce moving pictures. Thus the movies were born.

RADIO, FILM, TV, VIDEO

An abiding image associated with fairy tales is that of the ancient woman ('Mother Goose'), seated at the chimney-corner, who tells old tales to the younger generations. For children of the 19th century, this storyteller gradually yielded her place to the printed book. In the 20th century, as new communications developed, storytellers returned. Radio broadcasting started in Britain, under the auspices of the BBC, in 1922. On 23 December that year came the first 'Children's Hour'. British children got into the habit of pausing every day at 5.00pm to listen to the voices of adults, coyly called 'Uncles' and 'Aunts', reading them stories.

The programmes soon became more varied, with drama, features and outside broadcasts. The 'Toytown' plays (see section 23) were among the most popular and long-lasting. Many classics of literature were serialized in dramatic form alongside current favourites among children's books, such as the comedy of Anthony Buckeridge's *Jennings and Darbishire*, and the historical romance of Rosemary Sutcliffe's *Eagle of the Ninth*. The presiding genius in the early days was Derek McCulloch (Uncle Mac), and later the velvet-voiced David Davis, who unhappily saw the end of Children's Hour on 27 March 1964. Perhaps the most striking feature of Children's Hour was the sense of occasion it generated. Radio made everyone keep to the same time. The book illustrated in 53.1 emphasises that 'Children's Hour is run promptly to time, as are all the other BBC programmes'. So Children's Hour became a national ritual. 'Listen With Mother', for younger children, was an equally compelling ritual in the early afternoons.

Going to the cinema also had an element of ceremony about it (though continuous performances of films were common, which meant that you often saw the end of a film before its beginning). But films usually addressed the whole family rather than children as a spe-

53.1

Electronic learning toy for younger children. There is a thrusting market for these toys, which are more colourful than computers for adults.

cial group, and did not intrude over the sacred threshold of home. Children's television at first copied the rituals of radio. Developed in the 1930s, it started up seriously after the Second World War, and really took off after the televising of the 1953 Coronation. As with radio, tea-time was the moment for children. Drama figured prominently, from the classics to Billy Bunter. A family serial, 'The Appleyards', was the forerunner of innumerable adult soaps, though family life did not remain a strong theme in children's programmes. Children's television made considerable use of puppets: Muffin the Mule, Mr Turnip, Sooty, Andy Pandy and many others. Gradually, however, as life became less ceremonious so did television. Greater choice of programmes and channels meant that there were no longer hallowed moments for children. Their programmes got mixed up with all the rest - and with advertisements which had a powerful effect on juvenile consumers.

The arrival of video players in the 1980s widened children's choice still more, for now they could see films whenever they felt like it. Younger children never seemed to tire of their favourites, and harrassed parents used video as an 'electronic pacifier'. Disney films dominated the market for younger viewers; older children often managed to get hold of violent and pornographic material.

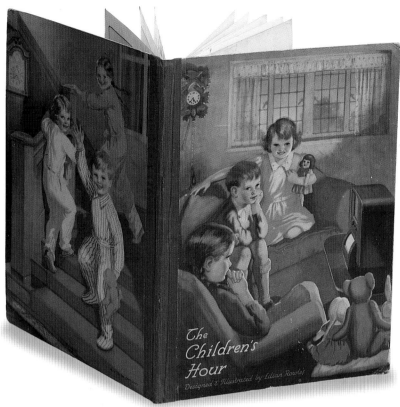

Cover of Lilian Rowles's *The Children's Hour*, 1920s. This evokes the 'pause in the day's occupations,/ That is known as the Children's Hour' (Longfellow), and

Cover of a *TV Comic Annual*, early 1950s, showing Packi the Little White Elephant, Muffin the Mule, Billy Bean, Bengo the dog, Lenny the Lion, Bom the Little Toy Drummer, Larry the Lamb, and Coco the Clown.

Electronic technology invaded the world of games. First came handheld games, booming from the mid-80s; then games played with a console plugged into the back of the television; then games played on a personal computer, much enhanced by the arrival of CD-ROM in the 1990s. Some people were attracted by the technology, though they tended to be snidely regarded as 'spotty nerds in anoraks'. The equipment in itself was no more attractive than any other plastic gadget, even though advertisements might extol 'a highly styled, supremely comfortable joystick'. All kinds of real-life sports, such as football and golf, were adapted as video games, but on the whole the content of the games depended heavily on the old board-game principle of a race, dominated by chance and interrupted by obstacles. These games were denounced (as radio and television had been) as addictive, and likely to cut children off from real relationships and coarsen their morals. But underneath the accelerating technology and the jittery style of computer graphics, these games were just telling stories. When the dust settles, the many instant crazes may seem less interesting than the longer-term success, through various media, of fantasy role-play games based on dragons, dungeons, swords, serpents, wizards and quests.

WHEN DOES CHILDHOOD END?

54.1

Detail from *The cry of the children from the brickyards of England* (1871), by George Smith. The dark side of child labour.

We all look for patterns in our individual lives, and in life in general. That we get older is an inescapable fact, and it is tempting to see ourselves as passing through a series of stages. In the Ancient World, the Middle Ages, and for some time after, thinking in this way would have been regarded as scientific. Some people saw human life with three stages, like the life of plants: growth, maturity, decline. Some saw four stages, which seemed neatly to match the four seasons, the four elements (air, fire, earth, water), and the four 'humours' or bodily fluids. Some saw seven stages, and this scheme remains most familiar to us today because of Jaques's speech on the 'seven ages of man' in Shakespeare's *As You Like It*. Nine, ten or twelve stages were also proposed. Scholars worked hard at defining these life cycles, and of course childhood had to be defined at the very start. However, the definitions were complicated, and became much more so when translated from one language into another. There is no longer much to be learned from them. But pictorial renditions of the stages of life (figures of various ages shown on a rising and descending staircase) survived in popular prints right up to the present century.

It might seem logical that the end of childhood should come with sexual maturity. When children become capable of begetting or bearing the next generation of children, surely they have grown up? But the age of physical puberty varies considerably, not only between people in different environments, but between individuals with different make-ups. And adults have gone to a lot of trouble to make laws and rules that keep adolescent sexuality under control until it is convenient for it to be exercised. Anthropologists who have studied 'rites of passage' in various societies do confirm the existence of rites relating to sexual maturing, but conclude that these mark 'social puberty' rather than 'physical puberty'.

In Western societies, dependence on parents and older kin seems to be a defining characteristic of childhood. Dependence is socially conditioned in many ways, but above all it is determined by economic factors, by paying your way. Does childhood end when earning life begins?

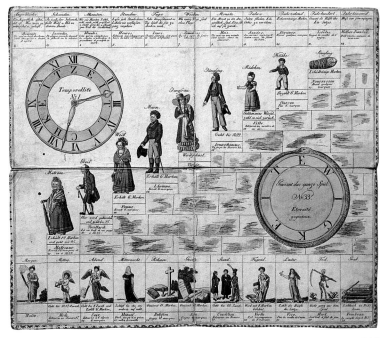

54.2

54.4

The answer must in many cases be yes, but it is generally agreed that working and earning can start too soon. A five-year-old child put to work has not ceased to be a child.

Children have been protected from work by school. Over the 19th century, a framework of law was established which compelled children to attend school for longer and longer, and prohibited them to an ever greater extent from participation in work.

For most people now, it is the end of schooling which marks the end of childhood.

In a sense we never leave our childhood behind. Since Freud's explorations of human psychology, it has been accepted that the experiences of childhood, particularly those beyond the reach of conscious memory, cast a long shadow over adult life. Again and again we rehearse the feelings of our early years. Perhaps there is a moral here for a Museum of Childhood. It should, certainly, reflect the pleasures of childhood to children themselves. But it can also give adults a chance to revisit, with more than mere nostalgia, areas of their personality to which, perhaps, they rarely attend.

54.3

 German board game, *c.*1830 which adapted the 'stages of life' motif from popular prints. Here figures from baby to aged man and woman are posed on a descending staircase. The game leads the players through time to eternity.

 Sex education pamphlet published by the Catholic Truth Society, 1955. An example of adults attempting to control how children grow up.

 While it is not desirable for children to work at too early an age, a life of labour must be held before them as a desirable goal. This pamphlet, of about 1845, is a late example of a long European tradition of pictorial representations of trades.

 An icon for the Bethnal Green Museum of Childhood? The Bethnal Green curator who began it all said: 'My Museum would grow round ... the telling of a story'. This illustration is from *Tiny Tots* (1916).

54.5

AUTHOR'S NOTE

This book skims the surface of a large expanse of knowledge, which is deliberate. On one level the book is intended as an introduction to the Bethnal Green Museum of Childhood, giving as wide an impression as possible of what is to be found there, and providing a commentary in terms accessible to the 'average visitor'. (I remain convinced that such notions are useful, and that the world must not be reduced to special interest groups targeting special interest groups.) Although this book does not go into specialist detail it is equipped with a book list of standard works on each topic, which will give signposts for further exploration.

Both the breadth of the survey, and the references, are necessary to the second aim of the book: to stake out the territory which should be the concern of a museum of childhood worth the name. The Museum at Bethnal Green is not just a toy museum, nor just a children's book research library, nor just a social history museum specializing in childhood. It is all three at once, and its area of professional concern reaches out to touch art history, material culture studies, economic and social history, bibliography, literary criticism, sociology, anthropology, ethnography, and folklore. Of course, the Museum's staff cannot claim to be experts in all these subjects, but we try to be knowledgeable enough to recognize the lie of the land which we cross.

It would be a vain hope to represent every aspect of the Museum within this one book. Widely as it ranges, it hardly covers anything outside Europe and America. This is a pity, for we have a good section in the Museum dealing with what we still rather uncertainly call 'ethnic toys', meaning toys which reflect the local craft traditions of a nation or region. This is an area which will deserve a thoroughly informed treatment on another occasion.

Few museum staff nowadays can be unaware that they are implicated in the construction of discourses on, or representations of, such deconstructible issues as the past, gender and power. These three issues are especially pressing for a museum of childhood, but this book does not seem to be the appropriate place to analyse them. I hope that in constructing the book I have proceeded with enough self-consciousness and self-criticism to avoid its collapsing around my ears.

It has been a great advantage to the Museum of Childhood to have grown up as part of the Victoria and Albert Museum, one of the world's great museums of decorative arts, and a cultural repository which can support research in many directions. As a national museum, it exercises responsibilities, exacts standards, and wields influence at the highest level, and I hope that its Museum of Childhood has learned to play a national role. I am grateful for support to successive Directors of the V&A: currently Dr Alan Borg; Dame Elizabeth Esteve-Coll before him; and especially to Sir Roy Strong, who in 1974 re-created the Bethnal Green Museum as the Museum of Childhood and who was the Director under whom I served my apprenticeship.

While research in many academic institutions is, in the humanities at least, often a personal quest, in museums research becomes a corporate task as it is based on collections. Growing while people come and go, the collections are magnets to which knowledge is attracted. Most of our fellow departments in the V&A have been collecting and knowledge-gathering for at least a century; at Bethnal Green we have been at it for only a quarter of that time. But since a lot has been achieved in that time, it is therefore only right for me to thank past and present members of staff whose ideas or researches have filtered into this book. In alphabetical order: Elizabeth Aslin, Ruth Bottomley, Tessa Chester, Pauline Cockrill, Janet Davies, Jim Fordham, Rosemary Gill, Peter Glenn, Caroline Goodfellow, Catherine Howell, Sally Jollans, Vera Kaden, Peter Kinsey, Sue Laurence, Noreen Marshall, Barbara Morris, Elizabeth Murdoch, Halina Pasierbska, Jane Broughton Perry, Arthur Sabin, Imogen Stewart and Montague Weekley.

Special thanks for photography go to Susan Smith, who organized it; to James Stevenson and his staff in the V&A Studio, especially to Pip Barnard and Graham Brandon; and to Isobel Sinden and her staff in the V&A Picture Library.

The Museum is fortunate in having many friends who support its work. Some who may recognize their fingerprints on this book are: Brian Alderson, Clive Ashwin, Francine Baker, Elizabeth Bonython, Johanna Braithwaite, Monica Burckhardt, Shirley Bury, Mary Cadogan, Deirdre Campion, Edith Danos, Douglas Dodds, Faith Eaton, Christopher Frayling, John Gould, Catherine Haill, Christina Hardyment, Monica Hastings, John Heywood, Anne Hobbs, Sue Lambert, Marketa Luskacova, Robert Nathan, John and Elizabeth Newson, Julia Nicholson, Philip Pacey, John Physick, Mary Ann Pinto, Linda Pollock, the late Anne and Fernand Renier, Kim Reynolds, Patrick Rylands, Maria Saekel-Jelkmann, David Schutte, Brian Shepherd, Simon Tait, Sandra Morton Weizman, Irene Whalley. I testify, as is obligatory on such occasions, that all the mistakes are mine, not theirs.

Thanks to the many other staff and friends who contribute to the life and work of the Museum in the many vital areas not directly connected with collections, especially to Ruth Baker, the Museum Secretary.

My wife Carol has given not only personal support, but also, as an exhibition designer, professional support to the Museum over the years, and this book is dedicated to her.

FURTHER READING

This list chiefly consists of general surveys. It also occasionally includes sources for quotations or details in the text.

1 • INTRODUCTION: PLEASURE AND PAIN

The history of childhood: Hugh Cunningham, *Children and childhood in Western society since 1500* (1995). The seminal work by Philippe Ariès, *L'enfance et la vie familiale sous l'ancien régime* (Paris 1960), was translated into English as *Centuries of childhood* (1964), and is still in print. Other significant works in the debate which followed were Edward Shorter, *The making of the modern family* (1976); Lawrence Stone, *The family, sex and marriage in England 1500–1800* (1977); Linda Pollock, *A lasting relationship: parents and children over three centuries* (1987).

For the psycho-historians, see Lloyd de Mause, ed. *The history of childhood* (1974).

For pictorial and material evidence see Ingeborg Weber-Kellermann, *Die Kindheit* (Frankfurt am Main 1979) and *Die Familie* (Frankfurt am Main 1976); Sally Kevill-Davies, *Yesterday's children: the antiques and history of childcare* (Woodbridge 1991).

On childhood in the Middle Ages: Pierre Riché and Danièle Alexandre-Bidon, *L'enfance au Moyen Age* (Paris 1994), accompanied an exhibition at the Bibliothèque Nationale; its bibliography includes preceding work.

2 • WARMTH

First baths: Natalie Boymel Kampen, 'Before Florence Nightingale: the prehistory of nursing in painting and sculpture', in Anne Hudson Jones, *Images of nurses: perspectives from history, art and literature* (Philadelphia 1988); Barbara Hanawalt, *The ties that bound* (1986), p.172.

On infancy in general: Jacques Gélis, *History of childbirth: fertility, pregnancy and birth in Early Modern Europe* (Cambridge 1991; first published in French 1984); Mary Spaulding and Penny Welch, *Nurturing yesterday's child: a portrayal of the Drake Collection of Pediatric History* (Philadelphia 1991); Daniel Beekman, *The mechanical baby: a popular history of the theory and practice of child rearing* (1979); Christina Hardyment, *Dream babies: child care from Locke to Spock* (1983); Diana Dick, *Yesterday's babies: a history of babycare* (1987).

Quotation from *'Our Children'* … *By the author of 'Little Helps for our Little Ones'* (London, Darton and Hodge 1864).

3 • FOOD

Elisabeth Badinter, *The myth of motherhood: an historical view of the maternal instinct* (1981); George D. Sussman, *Selling mothers' milk: the wet-nursing business in France 1715–1914* (1982); Valerie Fildes, *Breasts, bottles and babies: a history of infant feeding* (Edinburgh 1986) and *Wet nursing: a history from Antiquity to the present* (Oxford 1988); Marie-Claude Delahaye, *Tétons et tétines: Histoire de l'allaitement* (Paris 1990).

Feeding bottles and so on: Haskell and Lewis (see section 5, below); Kevill-Davies (see section 1); *Cow & Gate collection of feeding bottles* (illustrated pamphlet, Cow & Gate Ltd, Trowbridge, Wiltshire, n.d.).

4 • SLEEP

Kevill-Davies (see section 1); Friedrich von Zglinicki, *Die Wiege: volkskundlich – kulturgeschichtlich – kunstwissenschaftlich – medizinhistorisch. Eine Wiegen-Typologie* (Regensburg 1979).

On the 'faithful dog': Jean-Claude Schmitt, *The holy greyhound* (Cambridge 1983).

5 • MOVEMENT

On mobiles: Harriet Janis, 'Mobiles', *Arts & Architecture* (February 1948), pp.26ff; Arnauld Pierre, *Calder: la sculpture en mouvement* (Paris 1996).

Rattles: Diana Rothera, *Antique rattles: some examples from the collection 1748–1920* (privately printed, Cambridge 1970); Ingrid Schäfer, *Klingendes Spielzeug: Kinderrasseln aus aller Welt* (Duisburg 1991); Arnold Haskell and Min Lewis, *Infantilia: the archaeology of the nursery* (1971) (also prams). Prams: Heinz Sturm-Godramstein, *Kinderwagen gestern und heute* (privately printed, Frankfurt am Main 1972); Jack Hampshire, *Prams, mailcarts and bassinets: a definitive history of the child's carriage* (Speldhurst 1980).

6 • SOUND AND SONG

Leslie Daiken, *The lullaby book* (1959); Iona and Peter Opie ed., *The Oxford dictionary of nursery rhymes* (Oxford 1951). For foreign nursery rhymes: chapter 1 in Bettina Hürlimann, *Three centuries of children's books in Europe* (1967).

7 • INDOOR SPACES

Antony and Peter Miall, *The Victorian nursery book* (1980); Edward Gelles, *Nursery furniture* (1982); Colin White, *The world of the nursery* (1984); Ingeborg Weber-Kellermann, *Die Kinderstube* (Frankfurt am Main 1991).

Hermann Muthesius, 'Die Kinderzimmer' in his *Das englische Haus* (Berlin 1904–5) – English translation as *The English house* (1979); Jill Franklin, *The gentleman's country house and its plan 1835–1914* (1981); Monique Eleb-Vidal and Anne Debarre-Blanchard, *Architectures de la vie privée: maisons et mentalités XVIIe – XIXe siècles* (Brussels 1989).

Pauline Flick, 'Nursery wallpapers in Victorian times', *Country Life* (4 December 1969); Marilyn Oliver Hapgood, 'Artists' wallpapers for children (1860–1980)' in her *Wallpaper and the artist* (New York 1992).

8 • OUTDOOR GAMES

Paul Portmann, *Children's Games: Pieter Brueghel the Elder* (Berne 1964); *Kinderspelen op tegels* (exhibition catalogue, Tegelmuseum It Noflik Sté, Otterlo 1979); Sandra Hindman, 'Pieter Bruegel's *Children's Games*, Folly, and Chance', *Art Bulletin*, 63 (1981), 447–75; Edward Snow, '"Meaning" in *Children's Games*: on the limitations of the iconographic approach to Breugel', *Representations*, 1:2 (1983), 27-60; Simon Schama, 'In the republic of children' in *The embarrassment of riches: an interpretation of Dutch culture in the Golden Age* (1987).

Roger Caillois, *Jeux et sports*, Encyclopédie de la Pléiade (Paris 1967); D.W. Gould, *The top: universal toy, enduring pastime* (Folkestone 1975); Brian Jewell, *Sports and games* (Speldhurst 1977); Nigel Viney and Neil Grant, *An illustrated history of ball games* (1978); Jennifer Brain, *Children's games: traditional European children's playthings,* (information pack, Bethnal Green Museum of Childhood 1984).

Robert A. Georges, 'Recreations and games' in Richard Dorson, ed. *Folklore and folklife: an introduction* (Chicago 1972). For a more recent perspective: Robert A. Georges and Michael Owen Jones, *Folkloristics: an introduction* (Indiana U.P. 1995), pp.119, 243ff.

J.A.R. Pimlott, *The Englishman's holiday: a social history* (1947, reprint 1977): quotation in caption 7.10, p.121.

9 • DOLL PLAY

Von Boehn (see section 31); David Cohen, *The development of play* (2nd ed. 1993); Hilary Page, *Playtime in the first five years* (2nd ed. 1953).

10 • MOVABLE TOYS

Patrick Murray, *Toys* (1968); Ehrhardt Heinold and Hans Jürgen Rau, *Holz-Spielzeug aus aller Welt* (Weingarten 1983); Monica Burckhardt, *Le jouet de bois de tous les temps, de tous les pays* (Paris 1988).

Marion Millet, *Working wooden toys* (1985); Raymond and Vincent Humbert, *Jouets en bois* (Paris 1989).

On origin and diffusion: 'Les jouets' in Roger Caillois, *Jeux et Sports* (see section 8).

11 • SOFT TOYS

Jürgen and Marianne Cieslik, *Button in ear: the history of the teddy bear and his friends* (Jülich 1989); John Axe, *The magic of Merrythought – A collector's encyclopaedia* (Cumberland, Maryland 1986).

On comfort and softness: Witold Rybczynski, *Home* (1988).

12 • TEDDY BEARS

Patricia N. Schoonmaker, *A collector's history of the teddy bear* (Cumberland, Maryland 1981); Pauline Cockrill, *The ultimate teddy bear book* (1991) and *The teddy bear encyclopaedia* (1993).

13 • BLOCK TOYS

Harriet M. Johnson, *The art of block building* (New York 1933); Eugene F. Provenzo and Arlene Brett, *The complete block book* (Syracuse, U.S.A. 1983); *Building block art* (Please Touch Museum, Philadelphia 1986, exhibition catalogue). See also Noschke and Knerr (section 37).

14 • TOYS AS GIFTS

Ingeborg Weber-Kellermann, *Das Weihnachtsfest: eine Kultur- und Sozialgeschichte der Weihnachtszeit* (Lucerne 1978); J.M. Golby and A.W. Purdue, *The making of the modern Christmas* (1986). See Falkenburg (section 50).

15 • TOY SHOPS

Anthony Burton, 'On toy-shops and toy-sellers', *V&A Album 3* (1984), pp.116–27; Kenneth D. Brown, *The British toy business: a history since 1700* (1996).

16 • PICTURES FOR CHILDREN

For brief introductions in English to popular prints see: *French popular imagery: five centuries of prints* (Arts Council exhibition catalogue, Hayward Gallery, London 1974); *Die verkehrte Welt ... The topsy-turvy world: moral satire and nonsense in the popular print* (Goethe-Institut tri-lingual catalogue of an exhibition in Amsterdam, Paris, London and New York, 1984). Then Jean Adhémar, *Imagerie populaire française* (1968), and Wolfgang Brückner, *Populäre Druckgraphik Europas: Deutschland* (1969). These two are part of a series, initially published by Electa, Milan, which also includes volumes on Italy (by P. Toschi), the Low Countries (Maurits de Meyer), Scandinavia (V.E. Clausen), Russia (Catherine Claudon-Adhémar) and others. There is a large earlier literature on popular prints. England is not well covered, but see: Louis James, *Print and the people 1819–1851* (1976); Tom Gretton, *Murders and moralities: English catchpenny prints 1800–1860* (British Museum 1980).

On children's prints specifically: *Bilderbogen – Kinderbogen: populäre Druckgraphik des 19. Jahrhunderts* (exhibition catalogue, Historisches Museum am Hohen Ufer, Hannover 1980); Heiner Vogel, *Bilderbogen, Papiersoldat, Würfelspiel und Lebensrad: Volkstümliche Graphik für Kinder aus fünf Jahrhunderten* (Würzburg 1981).

On babylike figures: Jan Baptist Bedaux, 'From normal to supranormal. Observations on realism and idealism from a biological perspective' in Richard Woodfield ed., *Gombrich on art and psychology* (Manchester 1996).

17 • PICTURES BY CHILDREN

On art education in general: Gordon Sutton, *Artisan or artist* (1967); Richard Carline, *Draw they must* (1968).

On Cizek: *Franz Cizek, Pioneer der Kunsterziehung 1865–1946* (exhibition catalogue, Historisches Museum, Vienna 1985).

For the psychologists' approach to child art: Rhoda Kellogg, *Analyzing children's art* (Palo Alto 1970).

On primitivism: Colin Rhodes, *Primitivism in modern art* (1994).

For the Drummond album: Susan Lasdun, *Making Victorians: the Drummond children's world 1827–1832* (1983).

18 • CHAPBOOKS

General introduction: Victor E. Neuberg, *Popular literature: a history and guide* (1977); Leslie Shepherd, *The history of street literature* (Newton Abbot 1973).

On dissemination: Margaret Spufford, *Small books and pleasant histories: popular fiction and its readership in seventeenth-century England* (1981); Laurence Fontaine, *History of pedlars in Europe* (1996).

Some detailed bibliographies of chapbook publishers have been compiled, such as S. Roscoe and R.A. Brimmell, *James Lumsden & Son of Glasgow* (Private Libraries Association, Pinner 1981); Roger Davis, *Kendrew of York and his chapbooks for children* (Elmete Press, Wetherby 1988).

On pedlar dolls: see King (section 31).

19 • CHILDREN'S PUBLISHING BEGINS

F.J. Harvey Darton, *Children's books in England: five centuries of social life* (3rd ed., rev. Brian Alderson 1982); Mary V. Jackson, *Engines of instruction, mischief and magic: children's literature in England from its beginnings to 1839* (1989); S. Roscoe, *John Newbery and his successors 1740–1814: a bibliography* (Five Owls Press, Wormley 1973).

For a European perspective: Paul Hazard, *Books, children and men* (Boston 1975, first published in French 1932, first tr. Marguerite Mitchell 1944); Bettina Hürlimann (see section 6); *Friedrich Justin Bertuch (1747–1822) – bewundert, beneidet, umstritten* (exhibition catalogue, Gutenberg Museum, Mainz 1985).

20 • SPLASHES OF COLOUR

Iona and Peter Opie, *A nursery companion* (Oxford 1980); Marjorie Moon, *John Harris's books for youth 1801–1843* (rev. ed., Folkestone 1992); *Benjamin Tabart's Juvenile Library* (St Paul's Bibliographies, Winchester 1990).

21 • COLOUR PRINTING

Ruari McLean, *Victorian book design and colour printing* (rev. ed. 1972) and *Joseph Cundall: a Victorian publisher* (Private Libraries Association, Pinner 1976); Joyce Irene Whalley and Tessa Rose Chester, *A history of children's book illustration* (1988); Simon Houfe, *The dictionary of British book illustrators and caricaturists 1800–1914* (rev. ed., Woodbridge 1981); Alan Horne, *The dictionary of 20th-century British book illustrators* (Woodbridge 1995).

For European coverage an essential resource is: *Die Bilderwelt im Kinderbuch: Kinder- und Jugendbücher aus fünf Jahrhunderten* (exhibition catalogue, Kunst- und Museumsbibliothek und Rheinisches Bildarchiv, Cologne 1988).

22 • MOVABLE BOOKS

Peter Haining, *Movable books: an illustrated history* (1979); *Moveable books* (Renier Collection Occasional List No.3, Bethnal Green Museum of Childhood, 1988); *Apriti ... Libro! Libri animati dal 1540 ai giorni d'oggi* (exhibition catalogue, Biblioteca Comunale di Calderara di Reno 1996).

23 • STORY BOOK HEROES

Margery Fisher, *Who's who in children's books: a treasury of the familiar characters of childhood* (1975); Valentino Baldacci and Andrea Rauch, *Pinocchio: images d'une marionette* (Paris 1982, first published in Italian 1981); Robert Phillips: *Aspects of Alice: Lewis Carroll's dreamchild as seen through the critics' looking-glasses 1865–1921* (1972); John Batchelor, 'Dodgson, Carroll, and the emancipation of Alice' in Gillian Avery and Julia Briggs, eds. *Children and their books* (Oxford 1989); Roger Lancelyn Green, *Fifty years of Peter Pan* (1954); Catherine Haill, *Dear Peter Pan ...* (Theatre Museum, London 1983); *Bécassine: hommage à une jeune héroïne de 90 ans* (exhibition catalogue, Musée de la Poupée, Paris 1995); Staffan Bergsten, *Mary Poppins and myth* (Stockholm 1978); Margaret Blount, *Animal land: the creatures of children's fiction* (New York 1977); George Perry with Alfred Bestall, *A bear's life: Rupert* (1985); Charles M. Schulz, *Peanuts jubilee: my life and art with Charlie Brown and others* (New York 1975).

Quotations: Vaughan, *Something in linoleum* (1994), p.40; Samuel, *Times Literary Supplement* (8 March 1996), p.15.

24 • HOW CLOTHES MARK US OUT

General books on children's dress: Doris Langley Moore, *The child in fashion* (1953); Phillis Cunnington and Anne Buck, *Children's costume in England 1300–1900* (1965); Elizabeth Ewing, *History of children's costume* (1977) – quotation, p.31; Ingeborg Weber-Kellermann, *Der Kinder neue Kleider: Zweihundert Jahre deutsche Kindermoden* (Frankfurt am Main 1985); Clare Rose, *Children's clothes* (1989).

Examples of the 'miniature adults' thesis: Pearl Binder, 'Children and their clothes' in *Muffs and morals* (1953); Peter Fuller's essay, 'Childhood in historical perspective' in Martin Hoyles, ed. *Changing childhood* (1979).

25 • CLOTHES FOR USE AND COMFORT

Stella Mary Newton, *Health, art and reason: dress reformers of the 19th century* (1974); Eric W. Pasold, *Ladybird, Ladybird: a story of private enterprise* (Manchester 1977); Alice Guppy, *Children's clothes 1939–1970: the advent of fashion* (Poole 1978).

Alan Mansfield, 'Dress of the English schoolchild', *Costume* no.8, 1974; Phillis Cunnington and Catherine Lucas, *Charity costumes of children, scholars, almsfolk, pensioners* (1978).

Quotations: Langley Moore – see section 24, p.21; Binder, 'The Young Idea' in *The peacock's tail* (1958) p.136.

26 • BEST AND FANCY DRESS

Marie Schild, *Children's fancy costumes* (1886).

27 • LEARNING THROUGH PLAY

Educational pioneers like Pestalozzi, Froebel, Montessori are treated in general studies of educational history, such as James Bowen, *A history of western education: Volume III The Modern West, Europe and the New World,* (1981); there are also many commentaries on them individually.

28 • DEVELOPMENTAL TOYS

A wide survey of the subject is Hein Retter, *Spielzeug: Handbuch zur Geschichte und Pädagogik der Spielmittel* (Weinheim and Basel 1979). On Vitali: *Antonio Vitali, Spielzeugdesigner, creator of toys* (Weingarten 1994). The history is not yet well covered in English, but for the theory see John and Elizabeth Newson, *Toys and playthings in development and remediation* (1979). A useful current awareness tool is the International Toy Research Association's newsletter (Centre for Research on Toys and Educational Media, University of Halmstad, Box 321, 301 18 Halmstad, Sweden).

29 • DOLL'S HOUSES

Leonie von Wilckens, *Mansions in miniature: four centuries of dolls' houses* (1980, originally published in German, 1978); Constance Eileen King, *The collector's history of dolls' houses, doll's house dolls and miniatures* (1983); Vivien Greene with Margaret Towner, *The Vivien Greene dolls' house collection* (1995).

30 • SHOPS

Constance Eileen King, *The encyclopedia of toys* (1978); Johanna Kunz and Ulrike Schneiders, *Schöne alte Puppenstuben* (Weingarten 1991).

31–33 • DOLLS

Max von Boehn, *Puppen und Puppenspiele* (Munich 1929); translated by Josephine Nicoll as *Dolls and puppets* (1932); Dorothy S., Elizabeth A. and Evelyn J. Coleman, *The collector's encyclopaedia of dolls* (New York 1968, vol. 2 1986) and *The collector's book of dolls' clothes* (New York 1975); Manfred Bachmann and Claus Hansmann, *Das grosse Puppenbuch* (Leipzig 1971); Constance Eileen King, *The collector's history of dolls* (1977); Jürgen and Marianne Cieslik, *Dolls: European dolls 1800–1930* (1979); Barbara Krafft, ed. *Traumwelt der Puppen* (Munich 1991); Caroline Goodfellow, *The ultimate doll book* (1993).

James Sully, 'Dollatry', *Contemporary Review*, 72 (1899), pp. 58–72; Michel Manson, 'Diverses approches sur l'histoire de la poupée du XVe au XVIIe siècle' in Philippe Ariès and Jean-Claude Margolin, eds. *Les jeux à la Renaissance* (Actes du XXIIIe colloque international d'études humanistes, Tours 1980, Paris 1982); Christiane Gräfnitz, *Deutsche Papiermaché Puppen 1760–1860* (Duisburg 1994); Mary Hillier, *The history of wax dolls* (1985); Myla Perkins, *Black dolls 1820–1991: an identification and value guide* (Paducah KY 1993); Renate Höckh, ed. *Künstlerpuppen im 20. Jahrhundert* (Niedernhausern 1992).

There is a large literature on individual makers and types of doll.

34 • HOUSEHOLD TOYS

Eva Stille, *Doll kitchens 1800–1980* (Westchester PA 1988); Sabine Reinelt, *Puppenküche und Puppenherd in drei Jahrhunderten* (Weingarten, 1985).

For feminist approaches: Ruth Schwarz Cowan, *More work for mother; the ironies of household technology from the open hearth to the microwave* (New York 1983).

35 • HORSES

Patricia Mullins, *The rocking horse, a history of moving toy horses* (1992); Marguerite Fawdry, *English rocking horses* (Pollock's Toy Theatres, London 1986); Tony Stevenson and Eva Marsden, *Rocking horses: the collector's guide to selecting, restoring and enjoying new and vintage rocking horses* (1993).

Hobby-horses: Lucas Wüthrich, 'Windrächenlanze und Steckenpferd: Kinderturnier und Kampfspielzeug um 1500', *Zeitschrift für schweizerische Archäologie und Kunstgeschichte*, 38 (1981), 279–89.

36 • TRANSPORT TOYS

For works on tin toys in general see section 51. Surveys which see toys in relation to real transport amd to scale-modelling are Guy R. Williams, *The World of Model Trains* (1971); *The World of Model Ships and Boats* (1971); *The World of Model Aircraft* (1973); *The World of Model Cars* (1976).

Picture books on trains: Allen Levy, *A Century of Model Trains* (1974); Udo Becher, *Early Tin Plate Model Railways* (1980). Histories: Gustav Reder, *Clockwork, steam and electric* (1969); Pierce Carlson, *Toy Trains: A history* (1986).

On boats: Jacques Milet and Robert Forbes, *Toy Boats 1870–1955: a pictorial history* (New York 1979); Jac and Frédéric Remise, *Les Bateaux* (Paris 1981).

Tinplate vehicles: Rudger Huber, *Blechspielzeug: Autos-Motorräder* (Munich 1982).

Die-cast vehicles: Patrick Trench, *Model Cars and Road Vehicles* (1983).

Aircraft: Alf Mayer-Ebeling, *Fliegendes Spielzeug – spielerisches Fliegen* (Frankfurt, published by Lufthansa, 1993); Frédéric Marchand, *Avions-jouets des origines à 1945,* vol.1 (Paris 1993).

There are detailed/catalogues/firm-histories/ price-guides to most of the well-known makers.

37 • CONSTRUCTIONAL TOYS

Annette Noschka and Günter Knerr, *Bauklötze staunen: Zweihundert Jahre Geschichte der Baukästen* (exhibition catalogue, Deutsches Museum, Munich 1986); Helmut Schwarz, Ansgar Henze, Marion Faber, *Eisenzeit: Geschichte des Metallbaukastens* (Schriften des Spielzeugmuseums, Nürnberg, vol. 1, 1995); Bert Love and Jim Gamble, *The Meccano system, and the special purpose Meccano sets 1901–1979* (Hornby Companion series, vol. 6, 1986); *The art of Lego* (exhibition catalogue, Clwyd County Council 1988).

38 • WAR TOYS

A general history of war toys is still awaited. For the effect of war toys on today's children, see essays by Peter K. Smith and Gisela Wegener-Spöhring in Jeffrey H. Goldstein, ed. *Toys, play and child development* (Cambridge 1994); for reflections on museum displays of war toys see *Childhood – Playtime? International Symposium on the Research and Documentation in Museums of Cultural Aspects of Toys, Children and Youth*: Cologne, 20–23 June 1993 (Cologne 1995).

Most books on toy soldiers are aimed at adult collectors, containing details of modern specialist suppliers and how to make soldiers up into

dioramas. For the history, see John G. Garrett, *Model soldiers: a collector's guide* (2nd ed. 1965) and *The world encyclopaedia of model soldiers* (1981); Erwin Ortmann, *The collector's guide to model tin figures* (1974).

On paper soldiers the exhaustive work is Edward Ryan, *Paper soldiers: the illustrated history of printed paper armies of the 18th, 19th & 20th centuries* (1995).

For French royal toys see Claudette Joannis, 'Les jouets princiers dans les collections publiques françaises', *Revue du Louvre*, 35 (1985), 105–14.

39 • TABLE GAMES

Frederic V. Grunfeld, *Games of the world* (New York 1979); F.R.B. Whitehouse, *Table games of Georgian and Victorian days* (Royston 1971); R.C. Bell, *The boardgame book* (New York 1979) and *Games to play* (1988); Caroline Goodfellow, *A collector's guide to games and puzzles* (1991).

H.-R. d'Allemagne, *Le noble jeu de l'oie en France de 1640 à 1950* (Paris 1950); Alain R. Girard and Claude Quétel, *L'histoire de France racontée par le jeu de l'oie* (Paris 1982).

Georg Himmelheber, *Spiele: Gesellschaftsspiele aus einem Jahrtausend*, vol. xiv of Kataloge des Bayerischen Nationalmuseums (Munich 1972); Leonie von Wilckens, *Spiel, Spiele, Kinderspiel* (exhibition catalogue, Germanisches Nationalmuseum, Nuremberg 1986).

Linda Hannas, *The English jigsaw puzzle 1760 to 1890* (1972) and *The jigsaw book* (1981).

40 • ARTISTIC TOYS

The works which legitimize cribs in art history are R. Berliner, *Denkmäler der Krippenkunst* (Augsburg 1926–30) and *Die Weihnachtskrippe* (Munich 1955). There is extensive further literature.

On silver toys: Victor Houart, *Miniature silver toys* (1981).

On artists' dolls see in Barbara Krafft, ed. *Traumwelt der Puppen* (Munich 1991).

On Wiener Werkstätte toys: *Traum der Kinder, Kinder der Träume* (exhibition catalogue, Galerie bei der Albertina, Vienna 1984); *Schallaburg 1987: Spielzeug/Spiel und Spielereien* (exhibition catalogue, Schallaburg 1987).

41 • FAIRY TALES

Peter Burke, *Popular culture in early modern Europe* (1978); R. Darnton, *The great cat massacre and other episodes in French cultural history* (New York 1984); Marina Warner, *From the beast to the blonde: on fairy tales and their tellers* (1994).

Italian folk tales, selected and retold by Italo Calvino (1982); *Beauties, beasts and enchantment: classic French fairy tales*, ed. and tr. Jack Zipes (New York 1989); *The complete tales of the Brothers Grimm*, ed. and tr. Jack Zipes (New York 1992).

42 • OLDER HEROES AND HEROINES

Mary Cadogan and David Schutte, *The William companion* (1990); Geoffrey Trease, *Tales out of school* (1948); Marcus Crouch, *Treasure seekers and borrowers* (1962) and *The Nesbit tradition: the children's novel 1945–1970* (1972).

43 • SCHOOL STORIES

Isobel Quigly, *The heirs of Tom Brown: the English school story* (1982); P.W. Musgrove, *From Brown to Bunter: the life and death of the school story* (1985); Mary Cadogan and Patricia Craig, *You're a brick, Angela! the girl's story 1839–1985* (1986); Kimberley Reynolds, *Girls only? Gender and popular children's fiction in Britain 1880–1910* (1990).

44 • ADVENTURE STORIES

Eric Quayle, *The Collector's Book of Boys' Stories* (1973); E.S. Turner, *Boys Will Be Boys* (1976); Michael Anglo, *Penny Dreadfuls* (1977); Martin Green, *Dreams of Adventure, Deeds of Empire* (1980); Kevin Carpenter and Bernd Steinbrink, eds., *Ausbruch und Abenteuer: deutsche und englische Abenteuerliteratur* (exhibition catalogue, Universität Oldenburg 1984).

Erwin Wackermann, *Münchhausiana: Bibliographie der Münchhausen-Ausgabe und Münchhausiaden* (Stuttgart 1969); Bernhard Wiebel, *Münchhausen: ein amoralisches Kinderbuch* (exhibition catalogue, Schweizerischer Jugendbuch-Institut, Zurich 1996).

45 • COMICS

Kirsten Drotner, *English children and their magazines 1751–1945* (1988); George Perry and Alan Aldridge, *The Penguin book of comics* (new ed. 1971); Denis Gifford, *The complete catalogue of British comics* (Exeter 1985) and *Encyclopedia of comic characters* (1987).

46 • THINGS IN LITTLE

Historic miniature objects – furniture: Georg Himmelheber, *Kleine Möbel* (exhibition catalogue, Bayerisches Nationalmuseum, Munich 1979); Guy and Elyane Vendeuvre, *Du XVIe siècle à 1930 le mobilier miniature* (Paris 1987); silver toys: Miranda Poliakoff, *Silver toys and miniatures* (V&A n.d.); Victor Houart, *Miniature silver toys* (New York 1981).

For wooden toys: Manfred Bachmann, *Holzspielzeug aus dem Erzgebirge* (Dresden 1984).

Collectors and makers of contemporary miniatures are catered for by many books and magazines. Light years away from these, for a postmodern critical discourse see Susan Stewart, *On longing: narratives of the miniature, the gigantic, the souvenir, the collection* (1993).

Pocket toys: *UK Toy News* (UKTN character toys IN MY POCKET Special, Sept/Oct 1995). Paris 1996 Fair: *Toy Trader* (April 1996), p.35.

47 • GOING TO THE FAIR

David Braithwaite, *Fairground architecture* (1968); Geoff Weedon and Richard Ward, *Fairground art* (1981); Florian Dering, *Volksbelustigungen* (Nördlingen 1986); *Il était une fête foraine, de 1850 à 1950* (exhibition catalogue, Parc de la Villette, Paris 1995).

Jeux, jouets et fête foraine (exhibition catalogue, Musée du jouet, Poissy 1993).

48 • THEATRE AND TOY THEATRE

A.E. Wilson, *Christmas pantomime: the story of an English institution* (1934); Gerald Frow, *'Oh, yes it is': a history of pantomime* (1985).

George Speaight, *The history of the English toy theatre* (1969); Peter Baldwin, *Toy theatres of the world* (1992).

49 • PUPPETS

René Simmen, *The world of puppets* (1975, first published in German 1972); David Currell, *The complete book of puppet theatre* (1985); Wolfgang Till, *Puppentheater: Bilder, Figuren, Dokumente* (Handbuch des Puppentheatermuseums im Münchener Stadtmuseum, Munich 1986); Paul Fournel, ed., *Les marionettes* (Paris 1988).

Asian puppets: wall of the world (exhibition catalogue, University of California at Los Angeles Museum of Cultural History, 1976).

George Speaight, *Punch & Judy: a history* (1970); Michael Byrom, *Punch and Judy: its origin and evolution* (1978) and *Punch in the Italian puppet theatre* (1983); Robert Leach, *The Punch & Judy show: history, tradition and meaning* (1985).

50 • PARTIES AND PARLOUR GAMES

Bridget Ann Henisch, *Cakes and characters: an English Christmas tradition* (1984); Regine Falkenberg, *Kindergeburtstag: Ein Brauch wird ausgestellt* (exhibition catalogue, Museum für Deutsche Volkskunde, Berlin 1984).

W.H. Cremer, *Toys of the little folks* (1873), pp.53–6 give his party programme; Anne Thackeray Ritchie, *Chapters from some memoirs* (1894), p.79; Eleanor Farjeon, *A nursery in the nineties* (1980), pp.336ff, 389ff.

51 • TOYS THAT MOVE

Mary Hillier, *Automata & mechanical toys* (1976); Annette Beyer, *Faszinierende Welt der Automaten* (Munich 1983).

The classic books defining the field for tin toy connoisseurs are by David Pressland: *The art of the tin toy* (1976); *Penny toys* (1991); *Pressland's great book of tin toys* (1996). At a less exalted level: Jack Tempest, *Collecting tin toys* (1994); Athelstan and Kathleen Spilhaus, *Mechanical toys* (1989) is useful because it explains, in the words of its subtitle, 'How old toys work'.

Among histories of firms, see especially Frédéric Marchand, *The history of Martin*

mechanical toys (Editions L'Automobilist, Paris 1987); Jürgen and Marianne Cieslik, *Lehmann toys: the history of E.P. Lehmann – 1881–1981* (1982).

On modern British automata: Rosemary Hill, *Automata* (exhibition catalogue, South Bank Centre, London, and John Hansard Gallery, Southampton 1992).

52 • MAGIC LANTERNS
Olive Cook, *Movement in two dimensions: A study of the animated and projected pictures which preceded the invention of cinematography* (1963); C.W. Ceram, *Archaeology of the cinema* (1965); Franz Paul Liesegang, *Dates and sources: a contribution to the history of the art of projection and to cinematography* (Magic Lantern Society of Great Britain, London 1986); Steve Humphries, *Victorian Britain through the magic lantern* (1989). See also other publications of the Magic Lantern Society of Great Britain, such as *The ten-year book* (1986); *Magic images, the art of hand-painted and photographic lantern slides* (1990).

Jac Remise, Pascale Remise, Régis Van de Walle, *Magie lumineuse: du théâtre d'ombres à la lanterne magique* (Paris 1979).

Ernst Hrabalek, *Laterna magica, Zauberwelt und Faszination des optischen Spielzeugs* (Munich 1985).

53 • RADIO, FILM, TV, VIDEO
Ian Hartley, *Goodnight Children … Everywhere: an informal history of children's broadcasting* (1983); Stephen Kline, *Out of the Garden: Toys, TV, and children's culture in the age of marketing* (1993); John Somers, 'Stories in cyberspace', *Children's Literature in Education*, 26 (1995), 197–209.

54 • WHEN DOES CHILDHOOD END?
J.A. Burrow, *The ages of man* (1986); Elizabeth Sears, *The ages of man* (Princeton, 1986); Samuel C. Chew, *The pilgrimage of life* (1962); *Die Lebenstreppe* (exhibition catalogue, Städtisches Museum Haus Koekkoek, Kleve 1983).

Arnold van Gennep, *The rites of passage* (1960, first published in French 1908).

John R. Gillis, *Youth and history* (1974); Michael Mitterauer, *A history of youth* (1992, first published in German 1986).

Eric Hopkins, *Childhood transformed: working-class children in nineteenth-century England* (Manchester 1994); Roger Sawyer, *Children enslaved* (1988); Alec Fyffe, *Child labour* (1989).

CHILDHOOD IN MUSEUMS

If a museum tried to represent the entire experience of children in the past, it would probably have to include most of human life. The Bethnal Green Museum of Childhood spreads its net wide in including important and developing collections of toys, children's books and children's dress, together with more cautiously selective collections of other childhood artifacts, aiming at international (though primarily Eurocentric) coverage. So far as we know, no other museum can compare with this. Others which try to represent a broad range of children's experience but within local limits are the Museum of Childhood of the Edith Cowan University, Subiaco, Western Australia; the childhood gallery at Glenbow Museum, Calgary, Canada; the childhood gallery at the Rheinisches Freilichtmuseum, Kommern; and the Kinderwelt-Museum, Schloss Walchen, in the Salzkammergut, Austria.

CHILDREN'S BOOKS are a well-developed field of study, particularly in relation to current reading for children. Whilst the children's books collections at Bethnal Green (100,000 items) are part of a museum, almost all other collections of historic children's books are run as parts of library systems. There are two other major collections in Britain, the Opie collection at the Bodleian Library, Oxford, and the holdings of the British Library, London. Smaller collections (the first three with published catalogues) are at Wandsworth Public Libraries, Manchester Metropolitan University, Reading University, and Birmingham Public Libraries. (See Tessa Rose Chester, *Children's books research: a practical guide to techniques & sources* and *Sources of information about children's books*, both Thimble Press, Stroud 1989.) A library and enquiry centre for current publications is maintained by Young Book Trust at Book Trust, 45 East Hill, Wandsworth, while a further source of assistance is the Children's Literature Research Centre at the Roehampton Institute.

The major collections in American include the Osborne Collection of Early Children's Books of Toronto Public Library, the Baldwin Library of the University of Florida (the published catalogues of these two are basic reference tools), the De Grummond Children's Literature Research Collection at the University of Southern Mississippi, and the Kerlan Collection at the University of Minnesota. Some countries maintain specialist centres for the study and exhibition of children's books, such as the International Youth Library in Munich, the Swiss Children's Book Institute in Zurich, the Swedish Institute for Children's Books in Stockholm.

EDUCATION MUSEUMS are fairly thin on the ground, but include in Britain the Museum of the History of Education at the University of Leeds; the British Schools Museum (Jill Grey collection), Hitchin; the Scotland Street School Museum of Education, Glasgow. France leads the world with the rich holdings of the Musée National de l'Education (part of the Institut National de Recherche Pédagogique, of Paris), with its exhibition galleries in the Maison des Quatres Fils Aymon, Rouen. Nineteenth-century schoolrooms are reconstructed in a host of history museums worldwide, and obsolete school buildings have often been preserved as museums recording local educational provision (such as the Ragged School Museum, Tower Hamlets, London; school-house museums at Bourges and Champigny in France). Other education museums worth noting are the Schulmuseum of Erlangen-Nuremberg University, and the Comenius Museum in the Wallenstein Palace, Prague.

TOY MUSEUMS, on the other hand, are many, since toys are the most attractive and collectable form of the material culture of childhood. Many of the rare early toys celebrated in the first histories of toys came to rest in a variety of history and art museums. But it is true to say that, throughout the world, most specialist toy collections

have been made by private individuals, often becoming privately run toy museums. Also, many have been taken into public ownership in one way or another. The V&A's toy collection at Bethnal Green is unusual in having been created under the auspices of a national museum, and is paralleled perhaps only by the Toy Department of the Musée des Arts Décoratifs in Paris.

Other toy museums in London are Pollock's Toy Museum, the London Toy and Model Museum in Bayswater, and the Cabaret Mechanical Theatre (a collection of automata) in Covent Garden. In Edinburgh The Museum of Childhood (formerly the collection of Patrick Murray) has seniority. Others include the Museum of Childhood, Beaumaris, Anglesey; the Sussex Toy and Model Museum, Brighton; the Cockermouth Doll and Toy Museum; the former Barry Elder doll collection in the Judges Lodgings Museum, Lancaster; the Llandudno Doll Museum; The Rotunda (Vivien Greene's dolls' house collection), Oxford; the Museum of Childhood, Ribchester; the Precinct Toy Collection, Sandwich; the House on the Hill Toy Museum, Stansted; the Museum of Childhood at Sudbury Hall, Derbyshire; the Warwick Doll Museum.

Overseas one should look first to Germany, where the toy industry began. The Spielzeugmuseum at Sonneberg, in Thuringia, is highly rated; not far away is the doll and toy museum of Neustadt-bei-Coburg. In the Erzgebirge region is the toy museum at Seiffen. The Nuremberg Toy Museum (formerly Lydia Bayer's collection) and the toy collection at the Altonaer Museum, Hamburg, are notable. Other collections include the doll museum at Hanau-Wilhelmsbad (the Gertrud Rosemann collection); the Juliane Metzger collection in the Niederrheinisches Museum für Volkskunde und Kulturgeschichte, Kevelaer; the H.G. Klein collection in the Rheinisches Freilichtmuseum, Kommern; the Norddeutsches Spielzeugmuseum (Ernst collection), Soltau, and the toy museum in Rothenberg ob der Tauber. In Austria the Gabriele Folk collection now forms a toy museum as part of Salzburg city museums. In France there is the toy museum at Poissy, near Paris; the Tomi Ungerer collection within Strasbourg city museums. In Monaco the Musée National houses the De Galéa

collection of dolls and automata. In Italy there is Museo della Bambola, Rocco Borromeo, Angera. In Belgium there are toy museums at Brussels and Mechelen; in Holland at Deventer; in the Czech Republic in Prague castle; in Denmark in Copenhagen, and in Spain, at Figueres and Valencia. In Switzerland there is the Swiss Children's Museum at Baden, the Swiss Museum of Games at Château de La Tour-de-pelz and the Zurich toy museum. For fuller information see Traute von Mendelssohn, *Puppen und Spielzeug Museumsführer* (1989). In the U.S.A. there are many private toy museums, whose owners may well dissipate their holdings back again into the very flourishing American toy collecting market, so it is best to mention only two major museums: the Strong Museum in Rochester, N.Y., and the Washington Dolls' House and Toy Museum, founded by Flora Gill Jacobs.

PUPPET MUSEUMS are rare in England. Probably the largest permanent display is at Bethnal Green – the collecting is the responsibility of the Theatre Museum (another branch museum of the V&A). Abroad, puppet collections tend to be where there has been a strong tradition of puppetry. In France, for example, there is the Musée international de la Marionette at Lyons, the Musée de Picardie at Amiens, the Musée des Arts et Traditions Populaires in Paris; in Sicily, the Museo Internationale della Marionetta, Palermo; in Belgium, the Musée de la Vie Wallone, Liège; in the Czech Republic, the Narodni Museum, Prague; in Holland there is the puppet museum at The Hague; in Hungary, they appear in the theatre museum, Budapest; in Spain, the theatre museum, Barcelona; in Germany, there are major collections in the Stadtmuseum, Munich and the Staatliche Kunstsammlungen, Dresden. See Currell, and Fournel, in section 49 above.

CHILDREN'S MUSEUMS – namely places for active, playful learning about the world in general – have flourished in America and are now being widely imitated worldwide. Their educational methods have influenced all museums' attitudes to their child visitors. They are not listed here, as children's museums do not put the collection of the material culture of childhood at the forefront of their work.

ILLUSTRATION ACKNOWLEDGEMENTS

All illustrations are of material at the Bethnal Green Museum of Childhood, except for items listed below.

Bodleian Library, Oxford: 1.1, 14.3. *By permission of the British Library:* 7.2, 7.6. *A.P. Burton:* 7.8, 12.9, 14.4, 27.1. *Other Victoria and Albert Museum departments: Apsley House:* 8.3; *National Art Library:* 1.2 (reproduced from Max Geisberg, *The German single-leaf woodcut 1500–1550,* New York 1974), 2.1, 2.2, 3.1 (repr. from R. van Bastelaer, *Les estampes de Peter Bruegel l'ancien,* Brussels 1908), 3.2 (as for 3.1), 5.10, 7.3, 7.4, 7.5 (repr. from

T. Hugo, *Bewick's woodcuts,* 1870), 7.6, 8.2, 8.5 (repr. from W. Fred, *Die Wohnung,* Bielefeld & Leipzig 1903), 8.6 (repr. from *Das Interieur,* vol. 3, 1902, p.106), 8.7 (repr. from *L'art décoratif,* vol. 13, 1911, p.243), 8.8 (repr. from *Idem,* vol. 8, 1906, p.211), 9.1, 9.2, 9.3, 15.1, 15.2, 15.3, 24.6 (as for 3.1), 35.1, 35.2, 35.3, 38.3, 47.3, 48.1, 49.7, 50.2, 52.3; *Prints, Drawings and Paintings Department:* 4.4, 8.4, 17.1, 17.3, 24.1; *Sculpture Department:* 2.5; *Theatre Museum:* 15.6, 48.4.

Photo credits: 28.2 John Gould; 28.3 Peter Boeticher, Basel.

Grateful acknowledgement (with apologies for any unintentional omissions) is made for the use of copyright material: 6.5 Quentin Blake/Random House; 6.8 Dan Jones/Puffin Books; 21.4 the late Edward Ardizzone/Oxford University Press; 21.5 Lisbeth Zwerger/Neugebauer; 22.5 Rod Campbell/Blackie; 22.7 Raymond Briggs/Hamish Hamilton; 23.11 David McKee/Andersen Press; 23.12 Express Newspapers; 25.4 Jan Ormerod/Puffin Books.